THE ROYALS

THEIR LIVES, LOVES AND SECRETS

CONTENTS

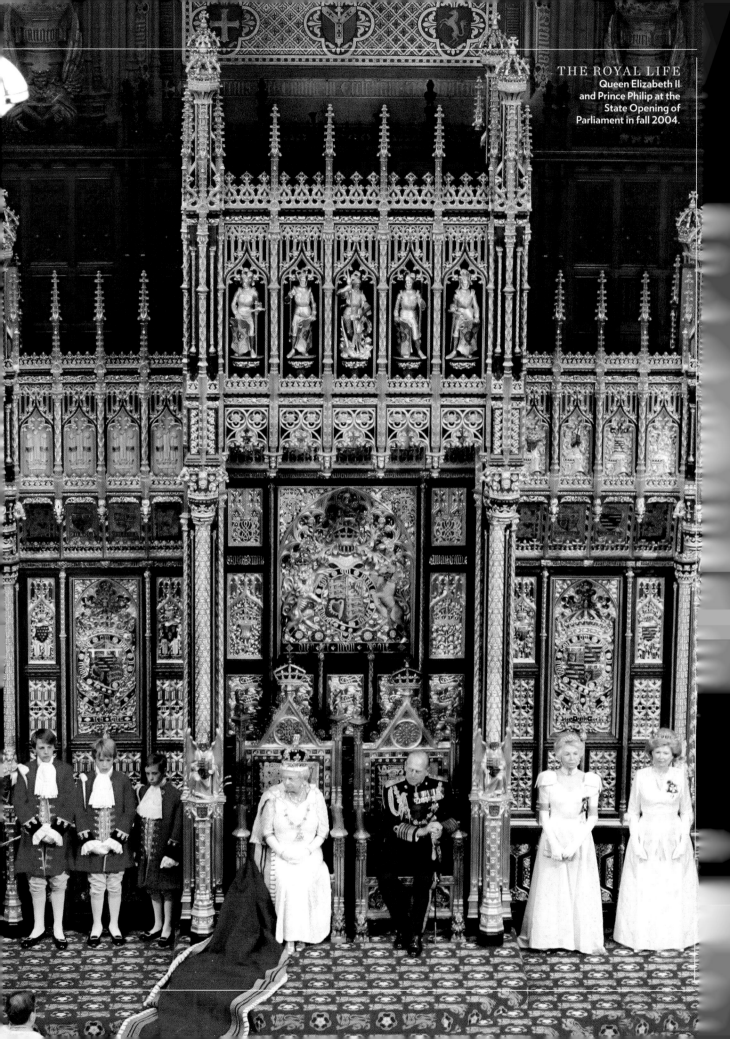

THE ROYAL LIFE
Queen Elizabeth II
and Prince Philip at the
State Opening of
Parliament in fall 2004.

THE ROYALS

their lives, loves

For all their wealth and power, the world's remaining royal families are relics of another age. Living in a world where celebrating Grandma's birthday means having a parade and inviting the entire country, the Windsors will forever represent the glory days of the British Empire. The Grimaldis, ensconced in a pink palace where Grace Kelly came to live as a bride, are reminders of her once-upon-a-time love affair with Monaco's Prince Rainier. And in Japan, Emperor Akihito's dynasty were once believed to be descended from gods. In reality, members of these regal clans are all too mortal: Witness all the riveting human drama that goes on behind the pageantry and pomp. Throw in decades of

and secrets

extravagant weddings, ignominious divorces and irresistible scandals, and you have a beat that has yielded some of the most memorable stories in PEOPLE's 36-year history.

In all that reporting, there is a constant thread: To be royal is to live a life of incredible privilege. But it also means dwelling under a microscope, where missteps become headlines. Members of a royal house learn early that they are bound by duty and tradition; those who marry into the fold can find it hard to adapt. Outsiders who diss the in-laws (Diana) or spend like a Trump (Fergie) are often ostracized by the royal inner circle for tarnishing the crown.

Despite all their perks, it's not hard to empathize with those whose personal flaws can become matters of state. Even today, failed attempts to produce an heir can end dynasties, a bad marriage can divide a kingdom, and a tragedy, such as Diana's 1997 death, can rock the realm.

PEOPLE's first royal cover, on Nov. 11, 1974, featured Prince Charles: "He's Turning 26 Without a Future Queen in Sight." Diana Spencer, whom he wed in 1981, was the main image on our cover 57 times, more than any other subject. Now the romance of their son Prince William, 27, and Kate Middleton, 28, is hot copy. Only time will tell whether they will have a happy ending. In the meantime, we offer you a peek into the lives of royals around the world. Enjoy the view.

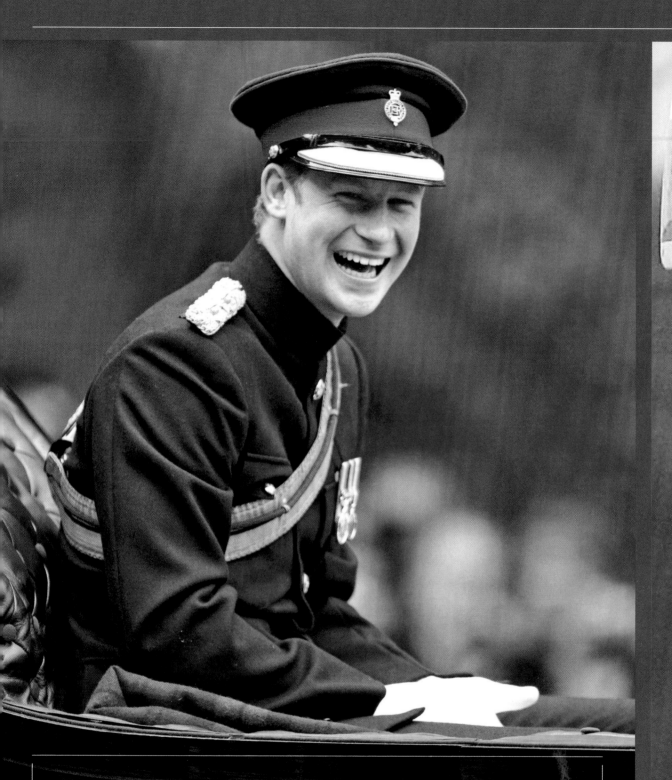

William & Harry
BOYS *to* MEN

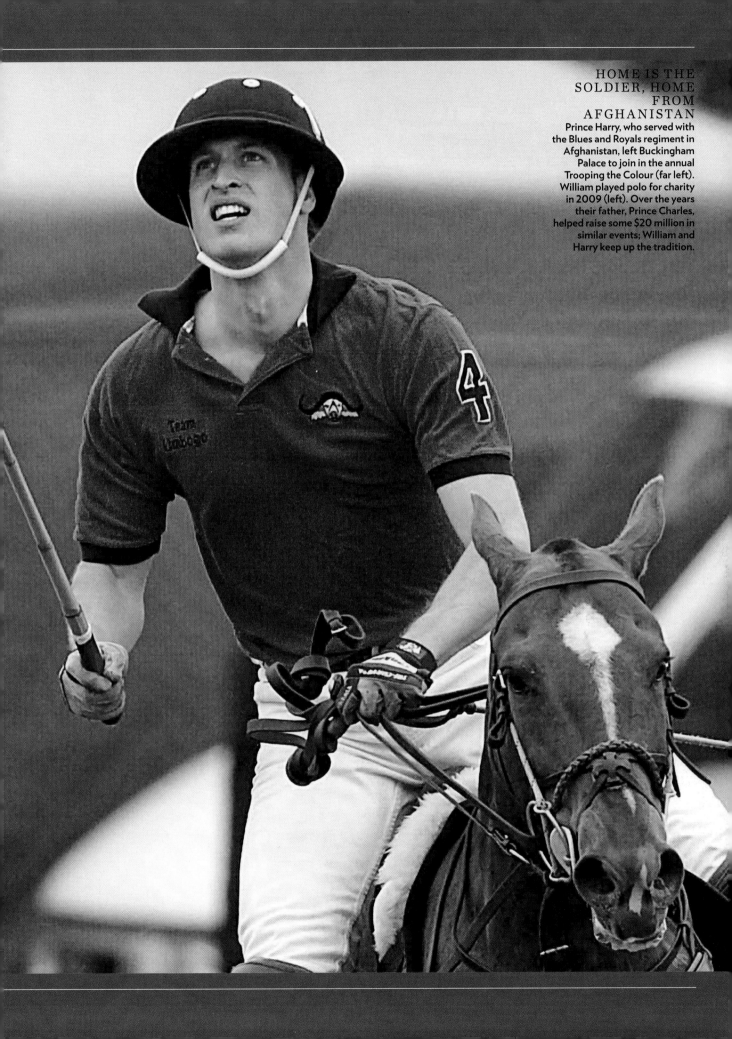

HOME IS THE
SOLDIER, HOME
FROM
AFGHANISTAN
Prince Harry, who served with
the Blues and Royals regiment in
Afghanistan, left Buckingham
Palace to join in the annual
Trooping the Colour (far left).
William played polo for charity
in 2009 (left). Over the years
their father, Prince Charles,
helped raise some $20 million in
similar events; William and
Harry keep up the tradition.

BROTHERS IN BOWLERS
No, they're not *that* old school: The hats, suits and brollies make up the traditional outfit, dating back to World War I, worn by officers in the annual Combined Cavalry Old Comrades Association Parade.

It's a tricky job, growing up in the spotlight. There are privileges and pitfalls. It's even tougher if, say, you're saddled with the job of shoring up the foundations of a majestic but musty institution, royalty, for a new generation. So how are Great Britain's Princes William, 27, and Harry, 25, doing?

So far, so very good.

Much of the credit goes to their late mother, Princess Diana, who, by exposing them to everything from hamburgers and bus rides to amusement parks and her work with the poor, sought to crack the shield of royal life and make them comfortable in the modern world. It worked: Although William and Harry have ridden their share of polo ponies and willingly don swank uniforms for ceremonial events, both have made clear their priorities lie elsewhere. "The last thing I want is to be mollycoddled or wrapped up in cotton wool," said William after entering the Royal Military Academy at Sandhurst. Harry, a fellow Sandhurst graduate, went further: An officer in the Blues and Royals, he snuck out of the country in 2007 to join his unit in Afghanistan. "There is no

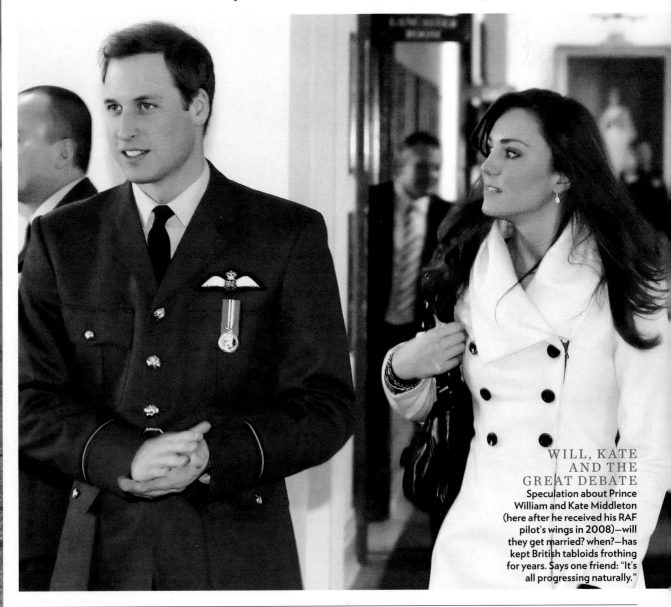

WILL, KATE AND THE GREAT DEBATE
Speculation about Prince William and Kate Middleton (here after he received his RAF pilot's wings in 2008)—will they get married? when?—has kept British tabloids frothing for years. Says one friend: "It's all progressing naturally."

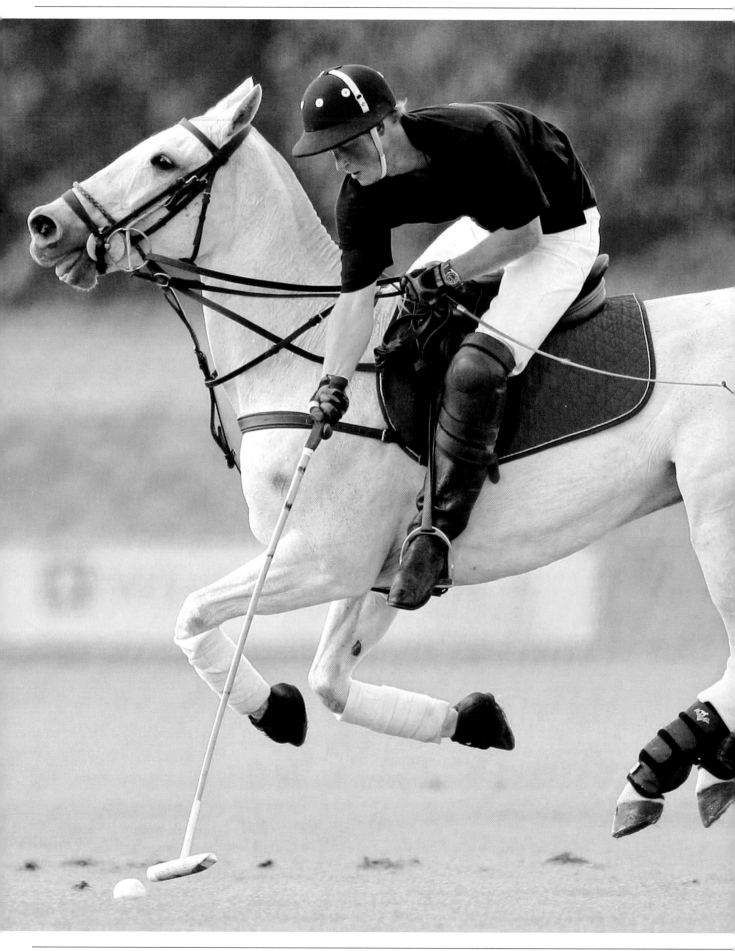

MY KINGDOM
FOR A PONY
Happy in the saddle, Harry
(in 2008) and William are
regulars at the Beaufort
Polo Club in Tetbury.
Other events in a possible
princely pentathlon?
Soccer, rugby, cricket and,
of course, grouse shooting.

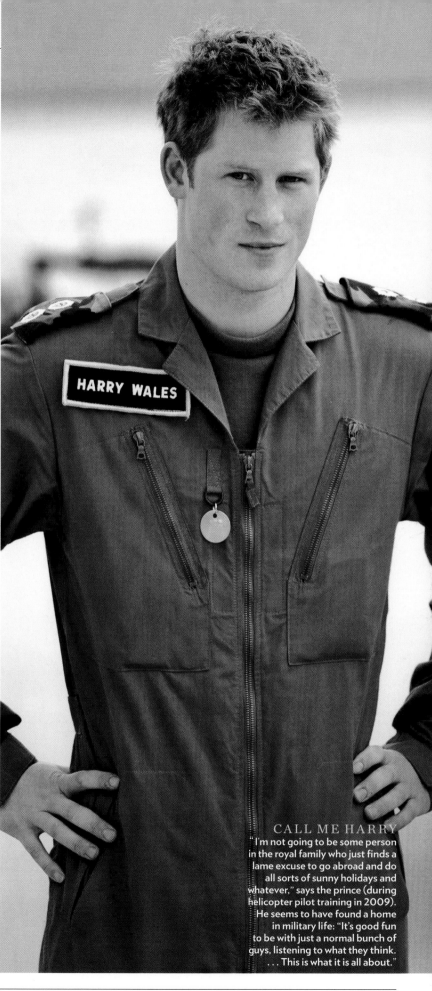

CALL ME HARRY
"I'm not going to be some person
in the royal family who just finds a
lame excuse to go abroad and do
all sorts of sunny holidays and
whatever," says the prince (during
helicopter pilot training in 2009).
He seems to have found a home
in military life: "It's good fun
to be with just a normal bunch of
guys, listening to what they think.
. . . This is what it is all about."

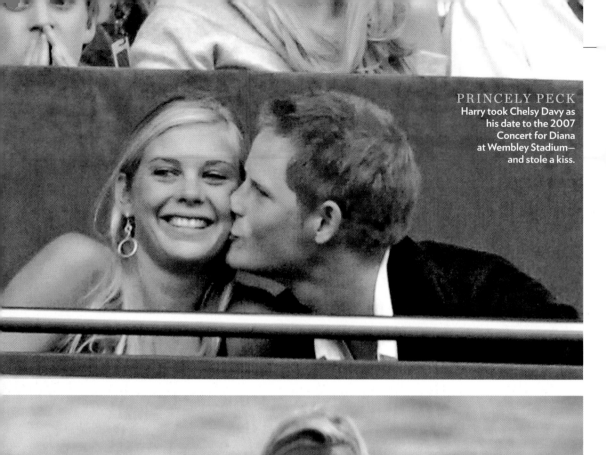

PRINCELY PECK
Harry took Chelsy Davy as his date to the 2007 Concert for Diana at Wembley Stadium—and stole a kiss.

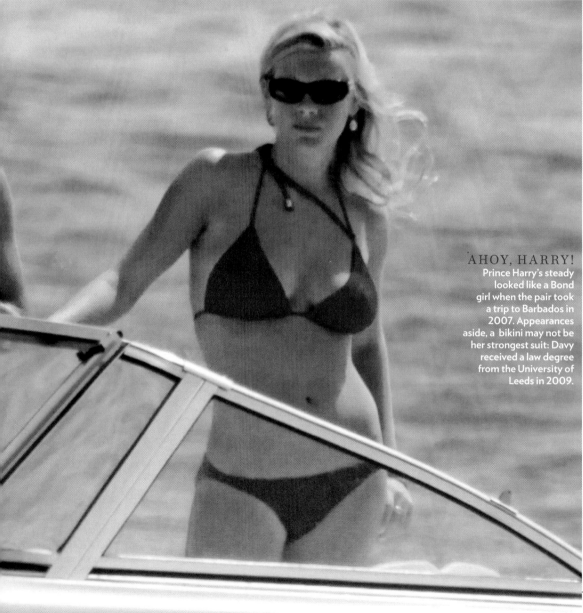

AHOY, HARRY!
Prince Harry's steady looked like a Bond girl when the pair took a trip to Barbados in 2007. Appearances aside, a bikini may not be her strongest suit: Davy received a law degree from the University of Leeds in 2009.

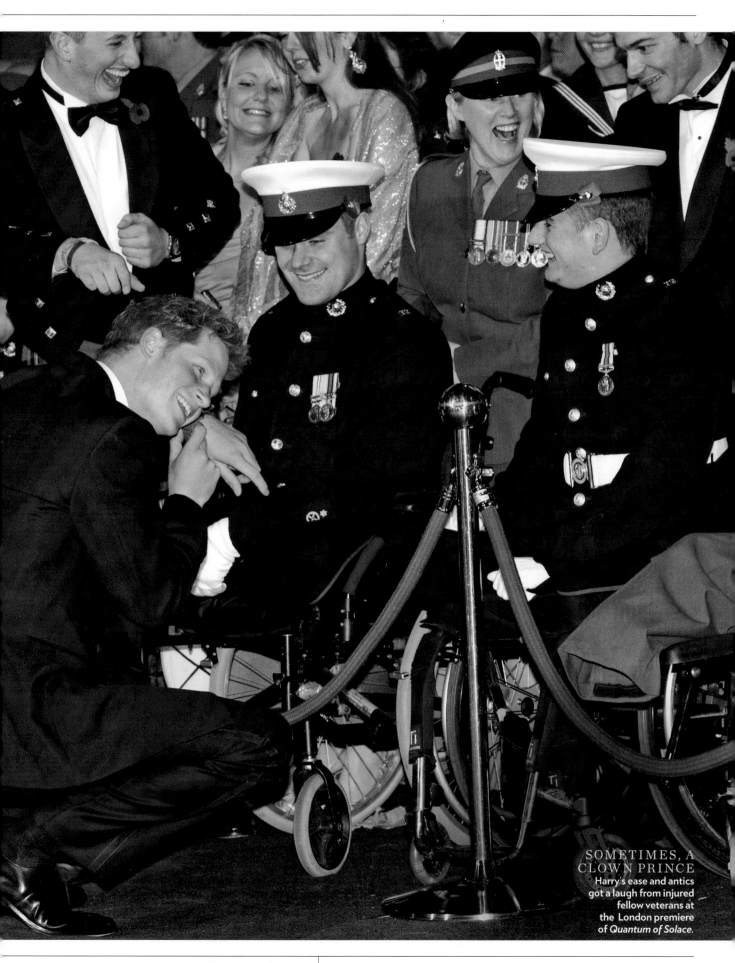

SOMETIMES, A
CLOWN PRINCE
Harry's ease and antics
got a laugh from injured
fellow veterans at
the London premiere
of *Quantum of Solace*.

THE ROYALS | 13

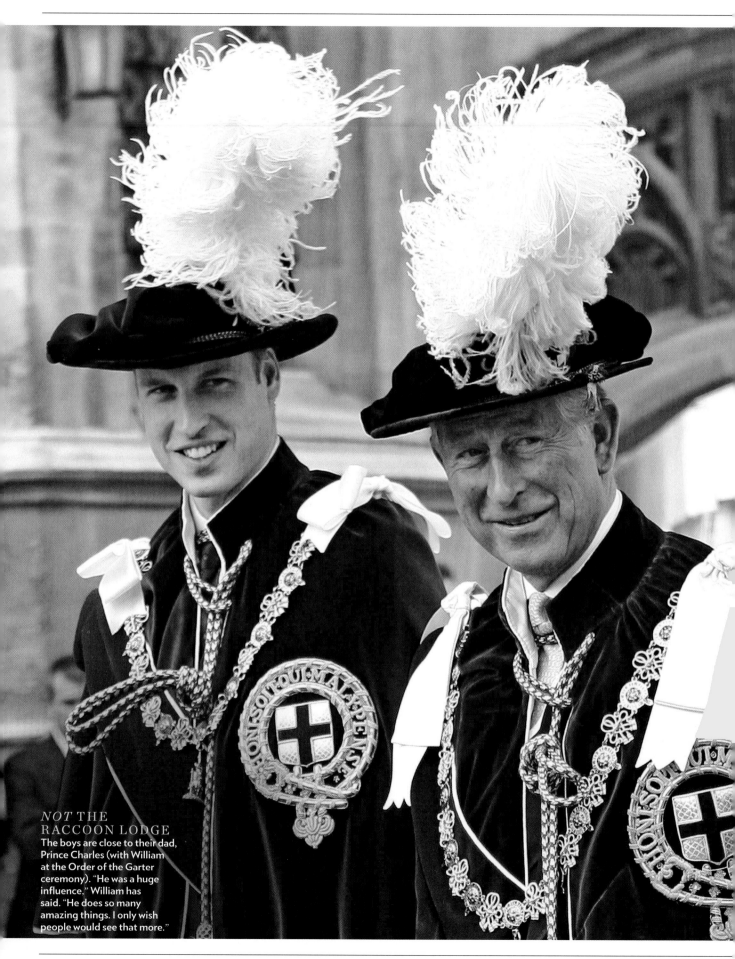

NOT THE
RACCOON LODGE
The boys are close to their dad,
Prince Charles (with William
at the Order of the Garter
ceremony). "He was a huge
influence," William has
said. "He does so many
amazing things. I only wish
people would see that more."

way," he said when publicity derailed an earlier deployment plan, "that I'm going to sit on my arse back home while my boys are out fighting for their country."

Inadvertently, Diana may have also taught her boys more than a little about romance. After her marriage to Prince Charles soured, says writer Robert Lacey, "they saw their mother didn't get much joy from playing the field." Coincidence or not, it's a startling fact that two of the world's most eligible bachelors are each with the first serious girlfriend either has ever had: Harry has dated Zimbabwean Chelsy Davy, 24, for six years (with one brief break), and William—again, with one brief break—has been seeing Kate Middleton, 28, a fellow St. Andrews grad, since year 2002.

The winning Middleton's lengthy tenure and clear acceptance by the royal family has led to endless, nay, numbing, speculation about an engagement. Surprisingly, William

may *not* be getting pressure on the home front; after all, the last round of royal marriages didn't work out so well. "It's the opposite of Charles and Diana, when the family pressure and the common wisdom was that it had to be done quickly," says Lacey. Notes royals author Ingrid Seward: "The Queen's idea is to have these girlfriends in the fold as much as you can. She likes them to get used to the regimented life of a royal."

Still, with time, William and Kate's romance seems only to grow deeper. "He looks after her and she looks after him," says someone close to the couple. "It's lovely to see." (One night, when she was locked out of her flat, she phoned dial-a-prince for help.) A few years ago William famously said he couldn't imagine getting married before he turned 28.

He'll be 28 on June 21, 2010.

Along with their military service, the princes have shown other signs of maturity. They have taken on more royal duties—in early 2010

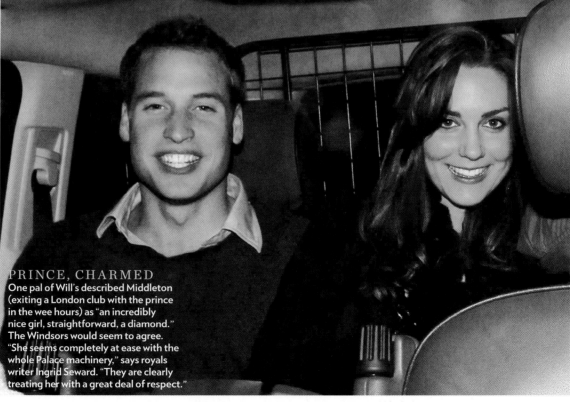

PRINCE, CHARMED
One pal of Will's described Middleton (exiting a London club with the prince in the wee hours) as "an incredibly nice girl, straightforward, a diamond." The Windsors would seem to agree. "She seems completely at ease with the whole Palace machinery," says royals writer Ingrid Seward. "They are clearly treating her with a great deal of respect."

William made his first solo trip as a representative of the Queen, to New Zealand—and become increasingly involved in charitable work. For both one of the most noted rites of passage was their decision to hold, in 2007, on the 10th anniversary of their mother's death, a memorial service at the Guards Chapel in London. In front of 500 guests, William read a somber passage from the Bible, and Harry, surprising many with his poise, spoke simply from the heart. "We both think of her every day, we speak about her and laugh together at the memories," said Harry. "Her beaming smile greeted us from school. She kissed us last thing at night. She was, quite simply, the best mother in the world. We miss her."

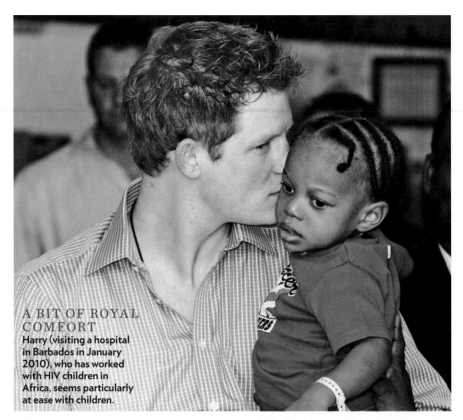

A BIT OF ROYAL COMFORT
Harry (visiting a hospital in Barbados in January 2010), who has worked with HIV children in Africa, seems particularly at ease with children.

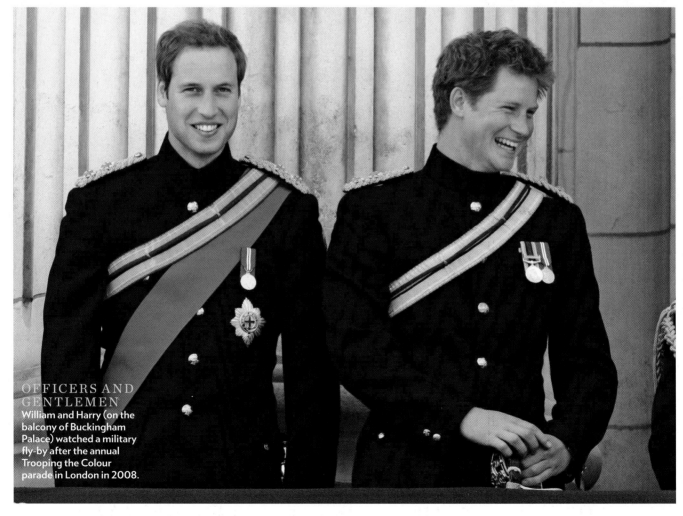

OFFICERS AND GENTLEMEN
William and Harry (on the balcony of Buckingham Palace) watched a military fly-by after the annual Trooping the Colour parade in London in 2008.

THE ROYALS

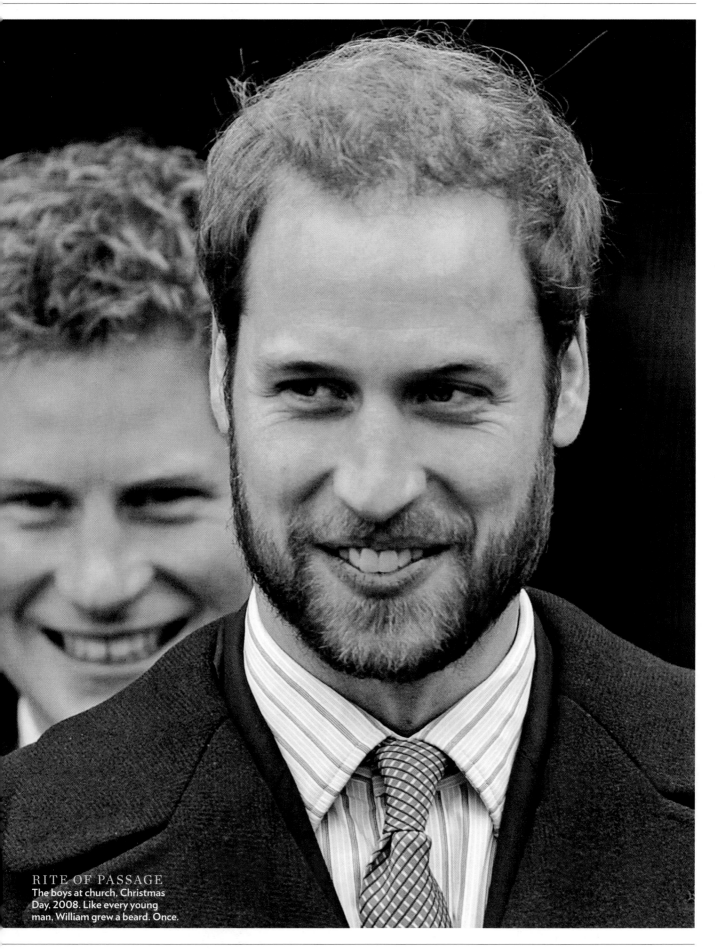

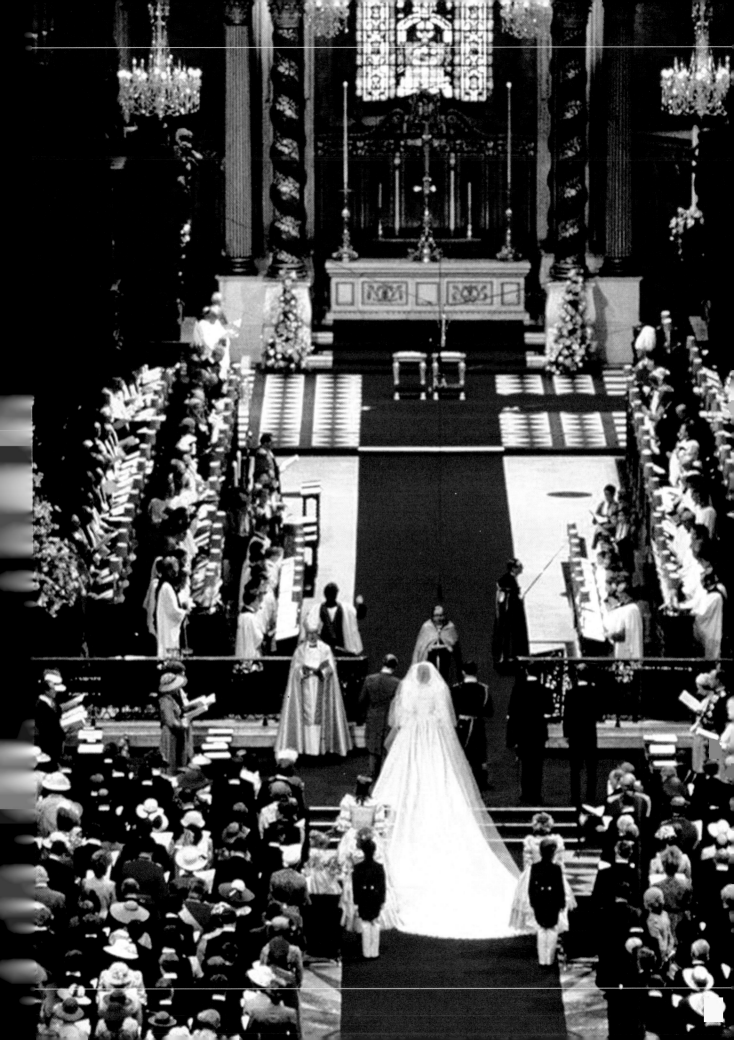

WEDDINGS

ENGLAND, 1981
Prince Charles and Diana Spencer took their trip to the altar at St. Paul's Cathedral while three quarters of a billion watched on television.

A dashing prince, a bride with a Cinderella story, and the pageantry and pomp of an ancient ruling house: A great royal wedding is a storybook affair. No matter the twists and turns of the marriages that followed, these legendary unions captured hearts around the world

Lady Diana Spencer & Prince Charles

JULY 29, 1981

t was, as Archbishop of Canterbury Robert Runcie put it, "the stuff of which fairy tales are made." What's clear is that the wedding of Prince Charles and Lady Diana Spencer transformed the House of Windsor, and perhaps Great Britain, forever. At 20, the bride was an English rose; her prince, 32, was suave if not conventionally handsome. There was a tiara laden with diamonds and even a glass coach. Around the world 750 million watched on TV. "No Hollywood production could have matched what I saw today," said actor Richard Burton. The pageantry at St. Paul's Cathedral on July 29, 1981, marked the creation not just of a princess but of a superstar. And for a generation of women, the wedding would be a touchstone: What would it have been like to step into Di's embroidered silk slippers that day?

Years later the Princess of Wales herself would expose the dark side of the fairy tale, claiming that even as she walked down the aisle, she knew that Charles had never stopped loving Camilla Parker Bowles, seated among his family and friends. She also would blame the groom and his chilly family for the bulimia that began during their engagement and plagued her for years. (By her wedding day, the waist on Diana's gown had been taken in six inches.)

Somehow, even that harsh reality fails to diminish the romance of the event itself. Many who knew Diana saw only giddiness as she prepared for the moment that Britain would mark with bonfires, fireworks and commemorative bric-a-brac galore. During top-secret fittings for the wedding party at the atelier of designers David and Elizabeth

BUCKINGHAM PALACE
Though only 20 when she wed a prince 12 years her senior, Lady Diana Spencer did not promise to "obey" him; that traditional vow was omitted at the couple's request.

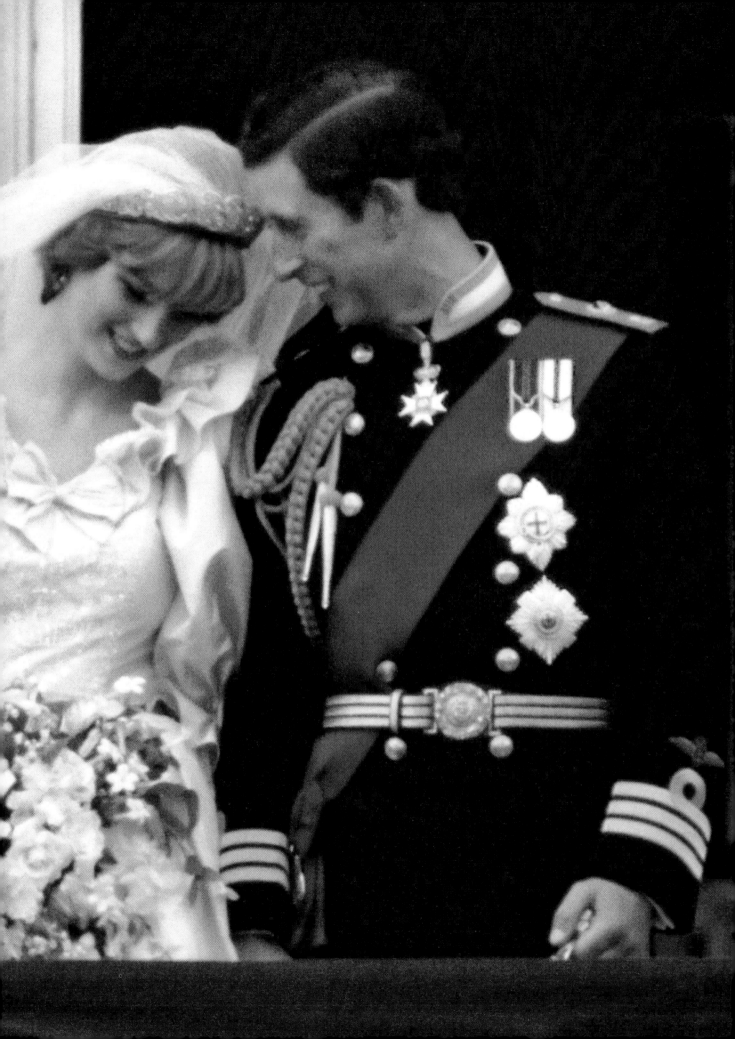

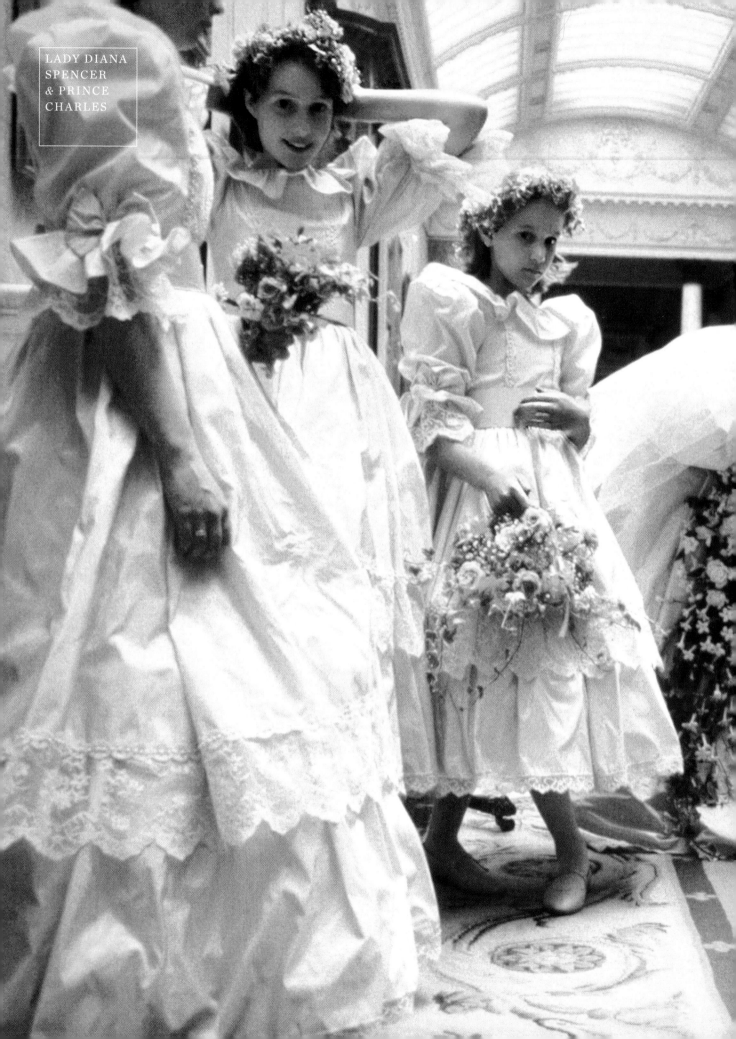

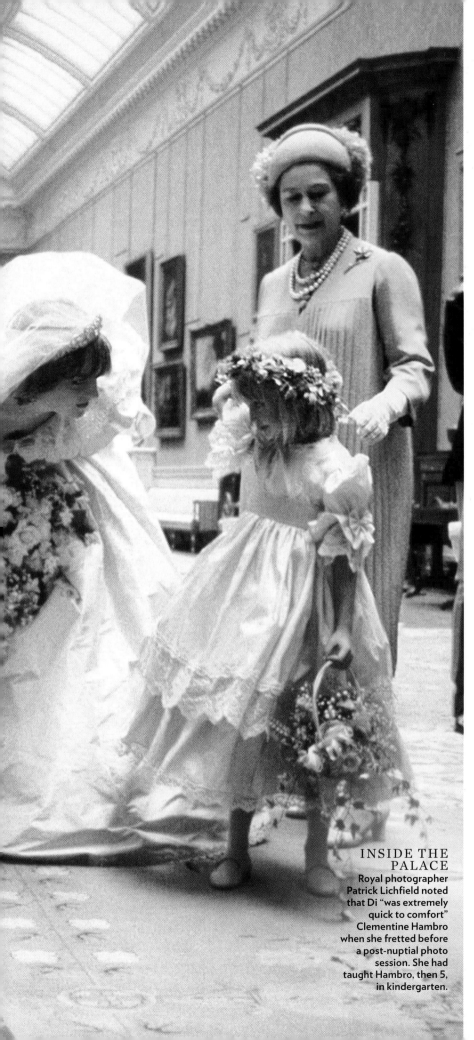

Emanuel, "we used to have a great time," Sarah-Jane Gaselee, an 11-year-old bridesmaid, later told authors Jayne Fincher and Judy Wade. "She and Charles were really in love as far as I could see. . . . I saw them cuddling on the sofa, and during the rehearsals they had their arms linked and they were skipping down the aisle."

Their unlikely courtship had begun a year earlier on a bale of hay in Sussex, where Diana and the prince were guests at a country house. Di, 19, had offered condolences on the death of Charles's great-uncle Lord Mountbatten, prompting him to take a second look at the "jolly" sister of ex-girlfriend Sarah Spencer. Soon the erudite prince was wooing the lightly educated blue blood who had

"During the rehearsals [Di and Charles] had their arms linked and they were skipping down the aisle"

—SARAH-JANE GASELEE

more royal ancestors than the Windsors themselves.

Before an intimate supper at Windsor Castle on Feb. 6, 1981, Charles proposed, and Diana dissolved into giggles. The ring came later: She plucked it from a selection sent by Garrard, the royal jeweler, choosing the $63,000 bauble because "it was the biggest," she once joked.

The Waleses' wedding was destined to be defined by its imperial scale. Gold-embossed invitations went to more than 2,500 guests. By July nearly 6,000 gifts had arrived at St. James's Palace. Among the pile: sapphires from a Saudi prince and a ton of peat from a British district council.

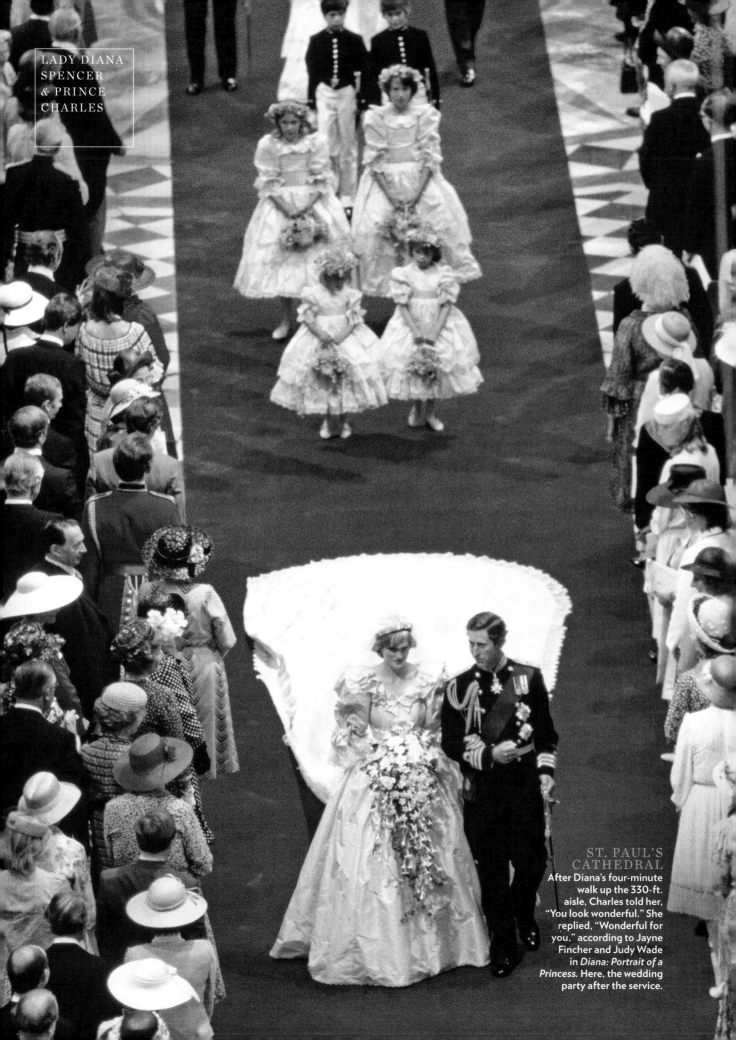

ST. PAUL'S
CATHEDRAL
After Diana's four-minute
walk up the 330-ft.
aisle, Charles told her,
"You look wonderful." She
replied, "Wonderful for
you," according to Jayne
Fincher and Judy Wade
in *Diana: Portrait of a
Princess.* Here, the wedding
party after the service.

DETAILS *of the* DAY

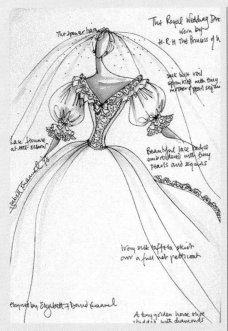

THE BRIDAL GOWN

The design team of Elizabeth and David Emanuel produced at least one backup copy of Diana's crinolined wedding gown, made from 40 yards of silk spun on Britain's only silk farm. "She wanted the dress to be something that people would love to watch," said Elizabeth. Hand-stitched over a three-month period, the gown Diana wore on her wedding day was trimmed with vintage lace and had a tiny diamond-studded golden horseshoe sewn into the waistband for good luck. After the princess was killed in 1997, the gown was placed on display at a museum at Althorp, her family's estate.

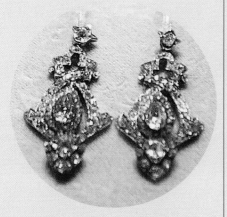

THE FAMILY JEWELS

Along with the Spencer tiara that anchored her veil, Di's borrowed finery included these elegant diamond earrings loaned by her mother, Frances Shand Kydd.

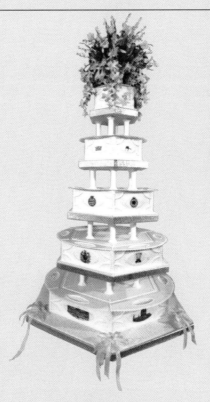

THE WEDDING RECEPTION

Held at Buckingham Palace, the 1 p.m. "breakfast" for about 100 featured lamb, fish and a chicken dish, *Suprème de Volaille Princesse de Galles.* Strawberries and Cornwall cream were served along with champagne. Weighing in at 168 lbs., the wedding cake made by David Avery, a chief cook at the Royal Naval Cookery School, was five tiers of rum-laced fruitcake robed in marzipan and icing.

THE RING

One of the most famous (and frequently imitated) baubles worn by a Windsor, the knuckle-dusting engagement ring chosen by Diana—an 18-carat sapphire set in white gold encircled by 14 diamonds—now belongs to her older son, Prince William, who asked for it as a keepsake after she died.

THE HONEYMOON

After 2½ days at Earl Mountbatten's estate, Broadlands, the newlyweds cruised the Mediterranean on *Britannia.* On Aug. 19 at Balmoral, the cozy-looking pair met the press.

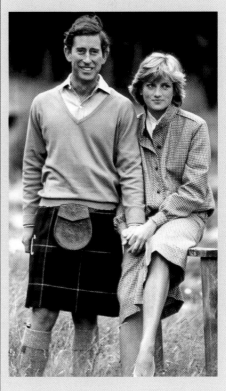

LADY DIANA
SPENCER
& PRINCE
CHARLES

PRINCE
EDWARD

PRINCE
ANDREW

SARAH-
JANE
GASELEE

LORD
NICHOLAS
WINDSOR

EDWARD
VAN
CUTSEM

INDIA
HICKS

CATHERINE
CAMERON

WHERE *are they* NOW?

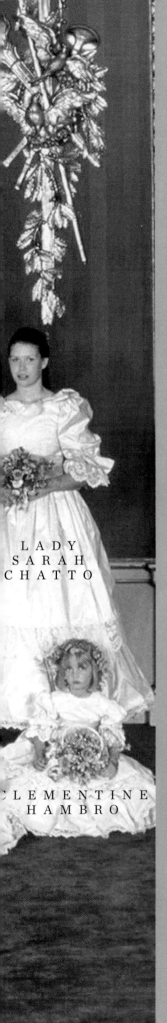

LADY
SARAH
CHATTO

CLEMENTINE
HAMBRO

Edward van Cutsem

A banker married to heiress Tamara Grosvenor, van Cutsem, 36, is a chum of Prince William's.

Lord Nicholas Windsor

In the past, Windsor, 39, has battled depression; now a Catholic, he became the first royal to be married in the Vatican.

Sarah-Jane Gaselee

Then an 11-year-old whose family knew Prince Charles, Gaselee, 39, is living a quiet life as a mom.

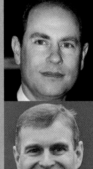

Prince Edward

Formerly a film-company exec, he is now 46 and married to Sophie Countess of Wessex and is father of Lady Louise Windsor, 6, and Viscount Severn, 2.

Prince Andrew

Dad to Princesses Beatrice, 21, and Eugenie, 20, the divorced Andrew, 50, is still very close to ex-wife Sarah Duchess of York.

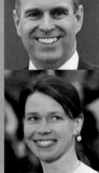

Lady Sarah Chatto

Princess Margaret's child, now 46, wed actor Daniel Chatto in '94; their sons are Samuel, 13, and Arthur, 11.

Catherine Cameron

Charles's goddaughter Cameron, 35, has worked for a London literary agency.

India Hicks

Author and style maven Hicks, 38, lives in the Bahamas with former ad exec David Flynt Wood and their four children.

Clementine Hambro

A pupil of Diana's and the youngest bridesmaid, Hambro, 33, married barrister Orlando Fraser, son of Lady Antonia Fraser, and has two children.,

Two nights before the nuptials, the Queen gave a ball for Charles and his betrothed and 800 guests at Buckingham Palace. Spirits were high: According to Diana's biographer Andrew Morton, "Princess Margaret attached a balloon to her tiara; Prince Andrew tied another to the tails of his dinner jacket."

When the big day dawned, a million spectators had begun to line the route from the Mall to Ludgate Hill. Inside Clarence House, where Diana and her bridesmaids collected in her dressing room, the bride was "sitting in front of a TV, dressed in her jeans, and the tiara was being put on her head," bridesmaid India Hicks told Fincher. "She started to shoo anyone who got in the way of the TV screen out of the way because,

"Diana was in her jeans, and the tiara was being put on her head ..."

—INDIA HICKS

obviously, she was very interested to see [footage about herself] on television. It was all very new and exciting."

As it was to the millions who soaked up every detail from Diana's meringue-confection dress and its 25-ft. train to the couple's slight stumbles during their vows. (Diana would pledge herself to "Philip Charles Arthur George," transposing the first two names and prompting Prince Andrew to say with a laugh, "She's married my father.")

By the time the wedding procession wound back to Buckingham Palace, Diana's charisma had already taken hold. Riding in a coach surrounded by cavalrymen, the bridal couple were cheered by pensioners and punk rockers, Yankee tourists and British bobbies. When Charles obeyed the crowd's calls to "kiss her, kiss her" as the two stood on the palace balcony, few could imagine that anything could ever separate the new princess from her prince.

Grace Kelly & Prince Rainier III *of* Monaco

APRIL 19, 1956

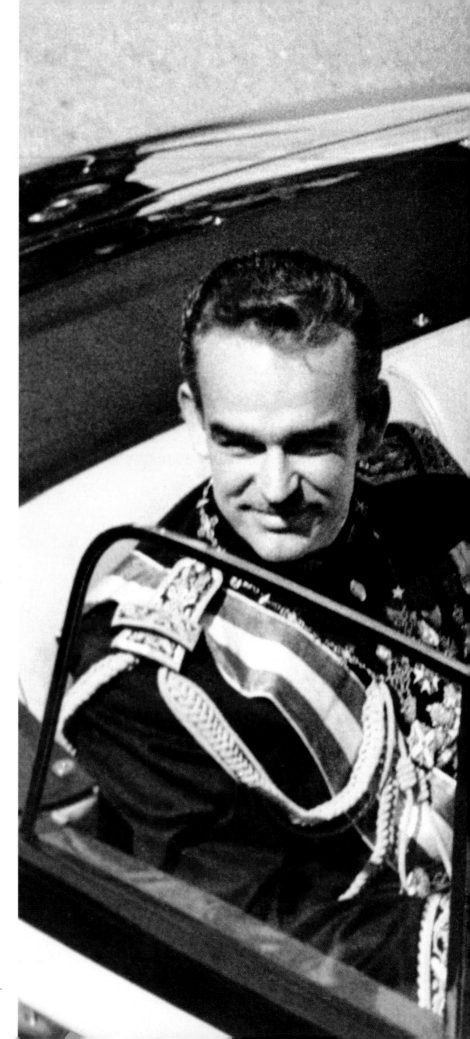

I certainly don't think of my life as a fairy tale," Grace Kelly once said. But to the rest of the world, the marriage of one of Hollywood's most beautiful stars to the ruler of a tiny Mediterranean principality was pure enchantment. Prince Rainier III of Monaco was a dapper 31-year-old bachelor when he met the 25-year-old Kelly—fresh from an Oscar win for 1954's *The Country Girl*—during the Cannes Film Festival. Smitten, Rainier kept her in his sights until he received an invitation to her family's Philadelphia home the next year. Two weeks later the couple were engaged. The jaded movie star admitted being swept off her feet. "I barely know him," she confided. "I don't know what will happen."

If their courtship was fast but conventional, the wedding was anything but. Grace and Rainier's 1956 nuptials set the gold standard for royal unions to come: 1,600 journalists and a broadcast to 30 million viewers worldwide. The couple exchanged vows before 1,100 guests, including Hollywood royalty Ava Gardner, Gloria Swanson and Cary Grant. On her honeymoon cruise in the Mediterranean, bridesmaid and fellow actress Rita Gam recalled, Grace wrote her to say "it took her a week to recover from that extraordinary day." Kelly settled into a traditional role as royal consort and became a devoted mother to three children. She died, age 52, in a car crash in 1982, and Monaco—and its Prince— were never the same. Biographer Jeffrey Robinson later asked Rainier about remarrying and was told, "How could I? Everywhere I go, I see Grace."

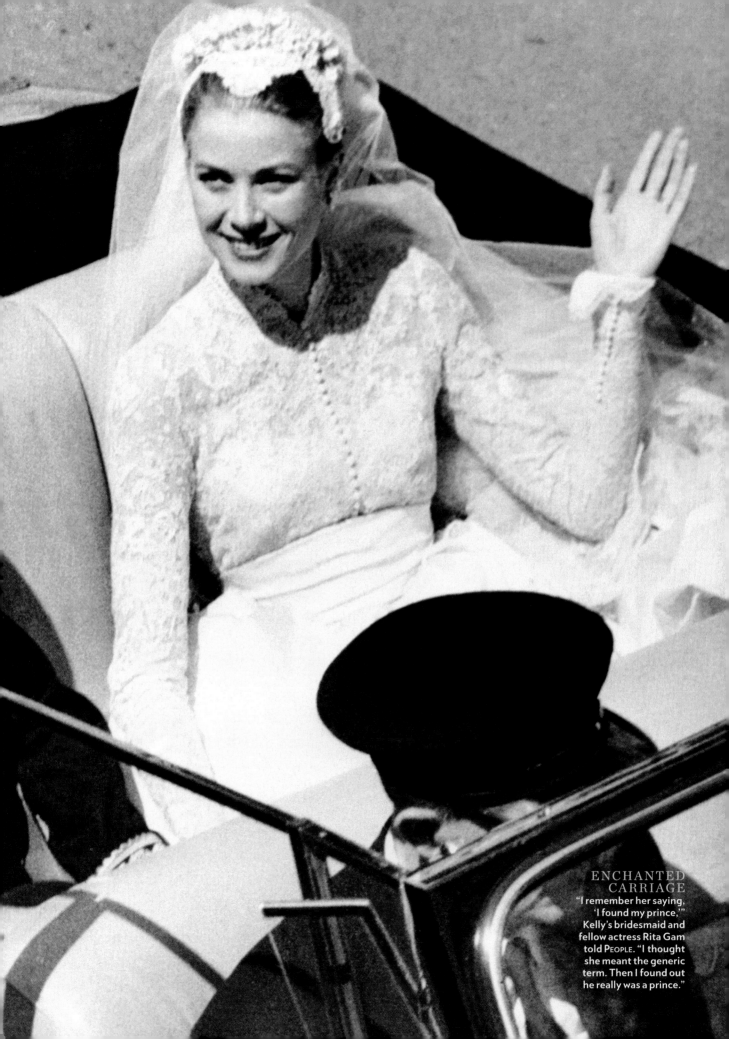

ENCHANTED
CARRIAGE
"I remember her saying,
'I found my prince,'"
Kelly's bridesmaid and
fellow actress Rita Gam
told PEOPLE. "I thought
she meant the generic
term. Then I found out
he really was a prince."

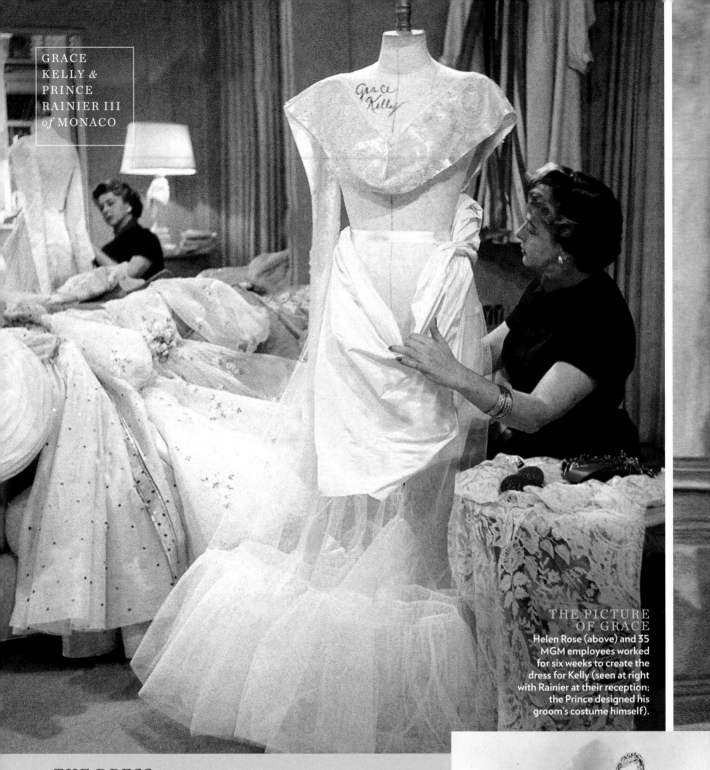

THE PICTURE OF GRACE

Helen Rose (above) and 35 MGM employees worked for six weeks to create the dress for Kelly (seen at right with Rainier at their reception; the Prince designed his groom's costume himself).

THE DRESS

As a gift to Kelly, MGM directed its wardrobe department to create a bridal gown for the Princess-to-be. Led by legendary designer Helen Rose, who had dressed Kelly for films such as *The Swan* and *High Society*, Hollywood costumers painstakingly worked with yards of silk gauze and rose-point lace with seed-pearl details to construct the upper portion of the ivory gown. The silk-laden skirt was made of peau de soie, faille and tulle and enhanced by petticoats. To complete the look, Rose added lace and pearl touches to Kelly's prayer book, shoes and headdress. Designs were kept top secret until two days before the ceremony; within hours of the release of sketches, New York garment companies were copying the design. But if her outfit was regal, Kelly walked down the aisle with one humble touch: Hidden inside her left shoe was a single penny for luck.

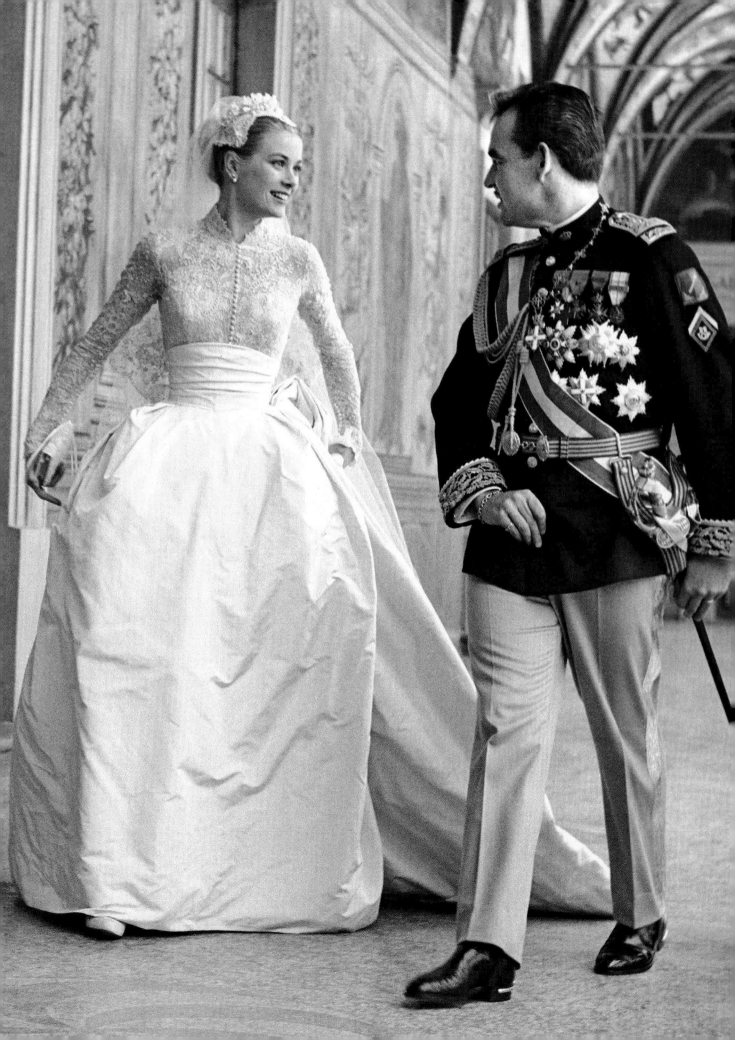

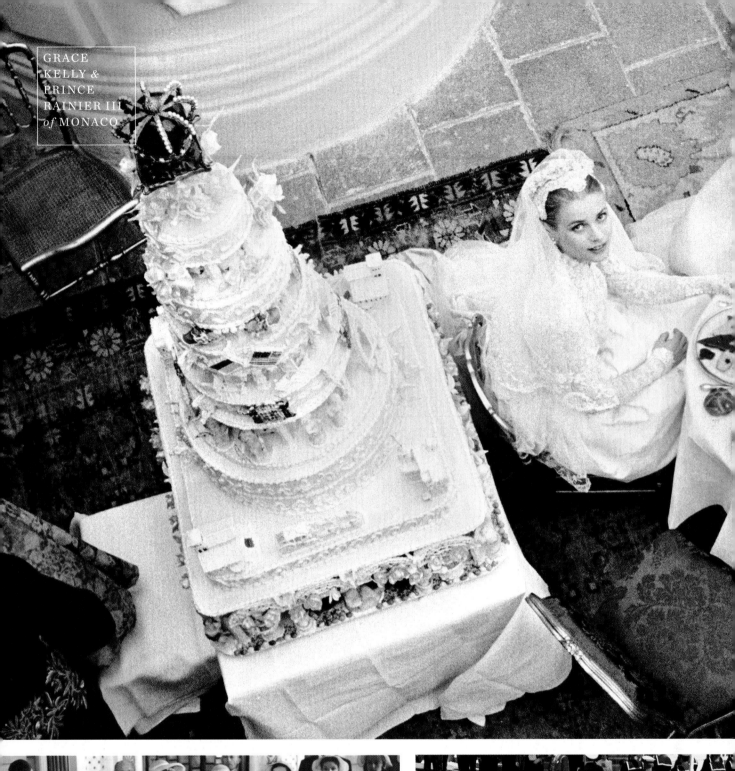

GRACE
KELLY &
PRINCE
RAINIER III
of MONACO

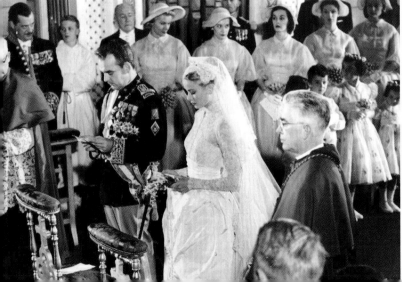

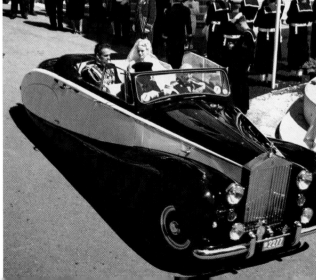

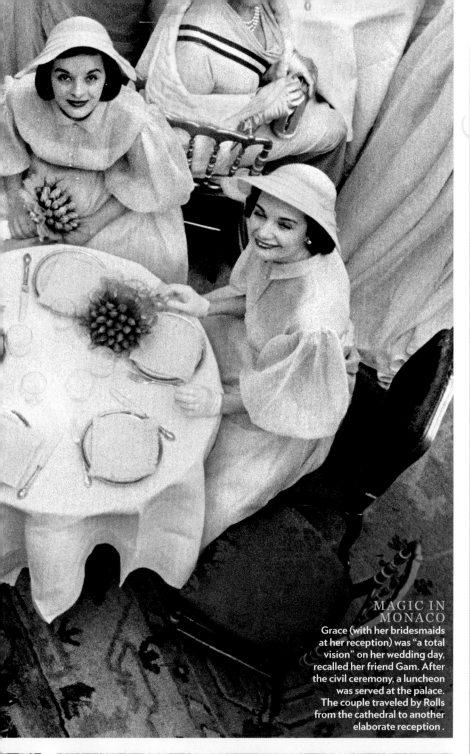

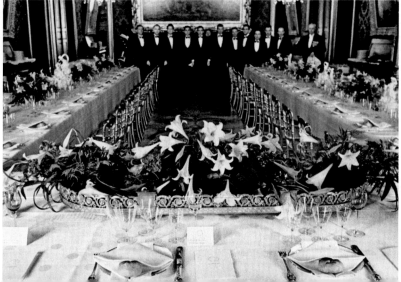

MAGIC IN MONACO

Grace (with her bridesmaids at her reception) was "a total vision" on her wedding day, recalled her friend Gam. After the civil ceremony, a luncheon was served at the palace. The couple traveled by Rolls from the cathedral to another elaborate reception.

DETAILS
of the DAY

■ Before the wedding a 65-member bridal party—and Kelly's black poodle, Oliver—crossed the Atlantic on the ocean liner *Constitution*. To pass the time, the movie star and her friends played shuffleboard and charades. When the ship entered Monaco's harbor, it was greeted by a flotilla of paparazzi and the Prince, who sailed out to meet her.

■ Mobbed by thousands of well-wishers and journalists, the bride and groom legally wed in a civil ceremony April 18 at the Grimaldi palace. Crews from MGM filmed the service, which had to be reenacted for the cameras.

■ The following morning the Bishop of Monaco presided over a Roman Catholic wedding mass at St. Nicholas Cathedral in Monte Carlo, which houses the ancestral tombs of the Grimaldi dynasty.

■ Kelly's six bridesmaids were Rita Gam, high school pal Maree Frisby, college roommate Judith Balaban, drama school friends Sally Parrish and Elizabeth Thompson and modeling friend Carolyn Scott. Her sister Margaret was matron of honor.

■ Bridesmaids wore yellow organdy dresses, hats and gloves. Flower girls sported dresses from Neiman Marcus and shoes from JCPenney.

■ The six-tier wedding cake was decorated with Monacan and American flags and topped with a crown.

■ Gifts included a Rolls-Royce; a gold-and-bone hatchet; and a $224,000 set of diamond earrings, bracelet and necklace from Monaco and Monte Carlo's casino. Director Alfred Hitchcock, who would later make *Psycho,* sent a unique bridal gift: a shower curtain.

■ For the honeymoon the newlyweds sailed the Mediterranean on Rainier's *Deo Juvante II,* the Prince's gift to his bride.

Princess Elizabeth & Philip Mountbatten

NOVEMBER 20, 1947

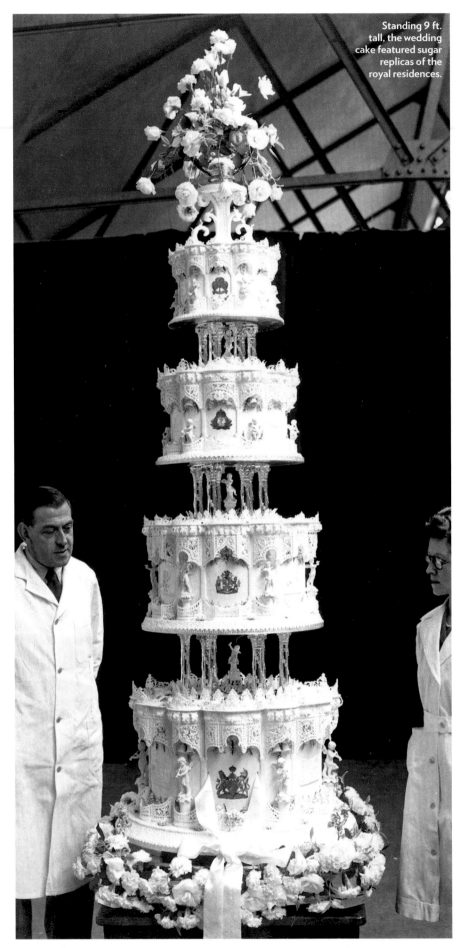

Standing 9 ft. tall, the wedding cake featured sugar replicas of the royal residences.

Before she became Queen Elizabeth II, of the United Kingdom of Great Britain, Head of the Commonwealth and Defender of the Faith, she was simply "Lilibet," a young girl madly in love. More than half a century ago, the sheltered 21-year-old heir to the British throne wed her distant cousin Philip Mountbatten, 26, born Philippos Schleswig-Holstein-Sonderburg-Glucksburg, the nephew of the deposed King of Greece and a royal in his own right. Although the pair met when the princess was 13, it wasn't until her late teens that Elizabeth developed a crush on her dashing relative, who served in the Pacific during World War II. In 1946 Philip visited Elizabeth at Balmoral, after which she told her father, King George VI, that she intended to marry. The Palace announced an engagement a year later.

The wedding that followed lifted the spirits of a war-weary Britain and marked its future Queen's arrival on the world stage. Spectators lined the bridal route from Buckingham Palace to Westminster Abbey, where the couple exchanged vows before 2,500 guests. After the ceremony the pair and 150 others dined on a wedding breakfast of fish and partridge at the palace. Philip, who had been given the title Duke of Edinburgh, then cut the wedding cake with his sword.

Fifty years later, in 1997, the Queen said this of her husband: "He has quite simply been my strength and stay all these years, and I owe him a debt greater than he would ever claim."

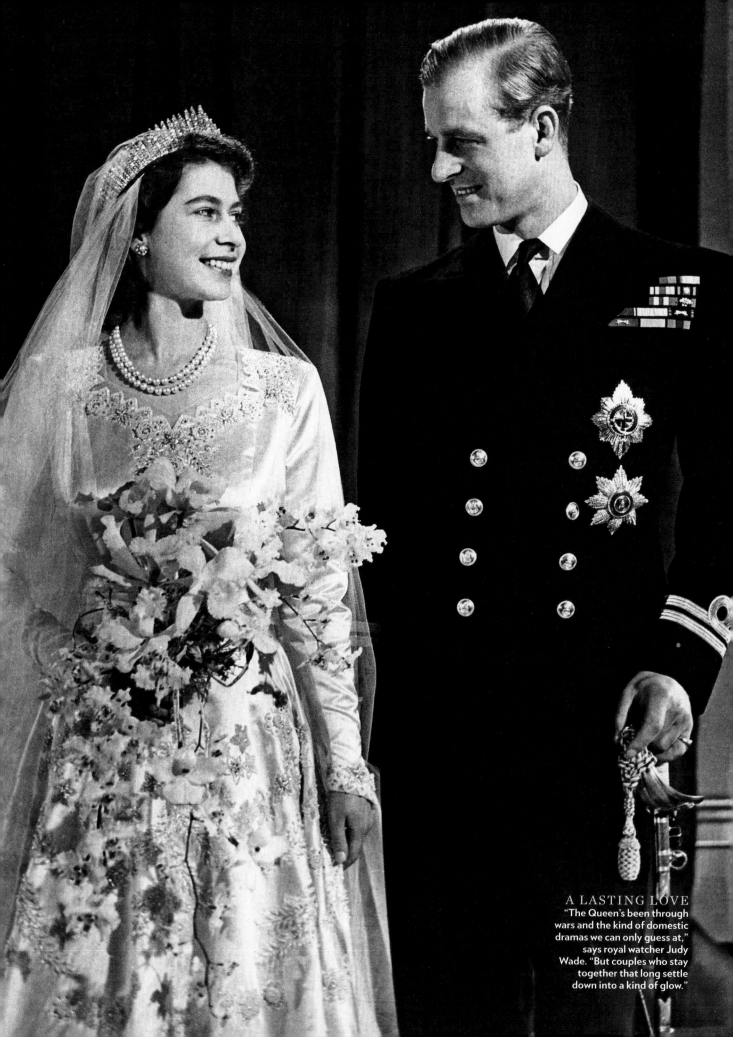

A LASTING LOVE
"The Queen's been through
wars and the kind of domestic
dramas we can only guess at,"
says royal watcher Judy
Wade. "But couples who stay
together that long settle
down into a kind of glow."

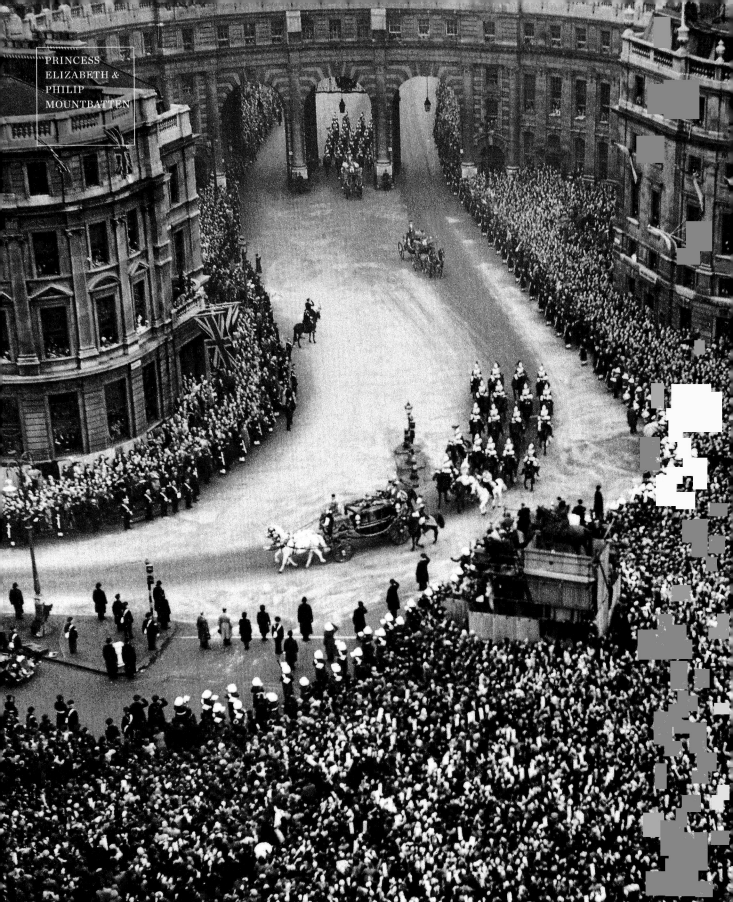

A WEDDING
TO REMEMBER
The white horses of the
Household Cavalry escorted
the bride's carriage through
Trafalgar Square

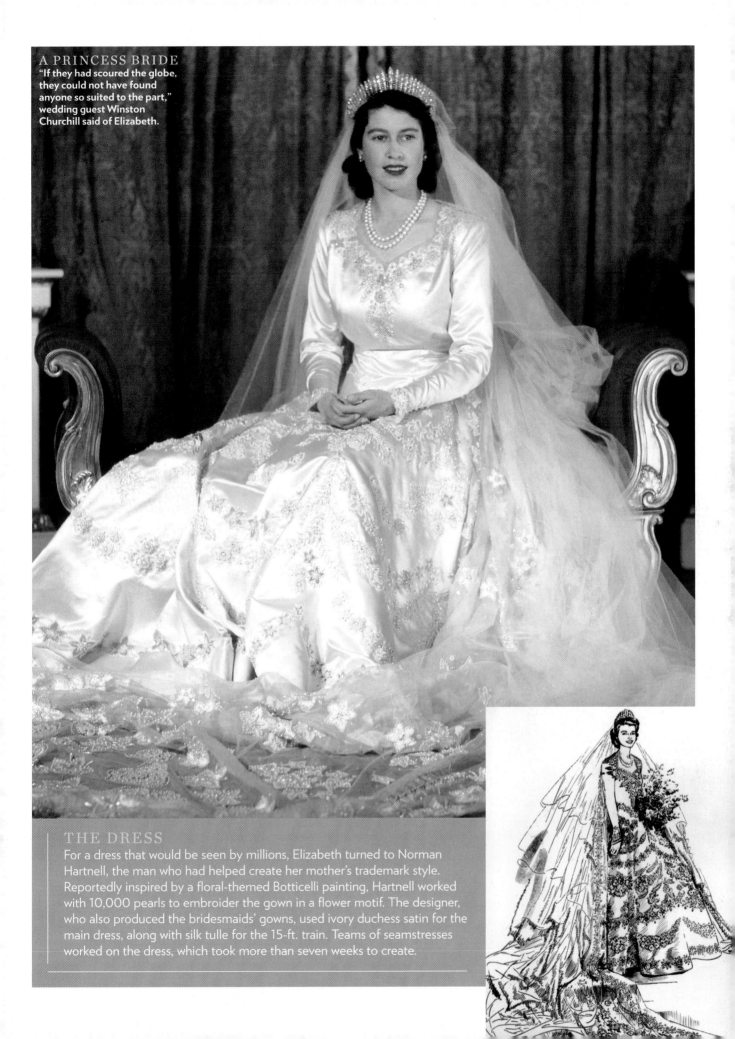

THE DRESS

For a dress that would be seen by millions, Elizabeth turned to Norman Hartnell, the man who had helped create her mother's trademark style. Reportedly inspired by a floral-themed Botticelli painting, Hartnell worked with 10,000 pearls to embroider the gown in a flower motif. The designer, who also produced the bridesmaids' gowns, used ivory duchess satin for the main dress, along with silk tulle for the 15-ft. train. Teams of seamstresses worked on the dress, which took more than seven weeks to create.

A WORLD *of* ROYAL WEDDINGS

Combining centuries of tradition with modern-day opulence, these royal nuptials captured global attention

GOLDEN COUPLE
The crown prince and Salleh (holding a bouquet of gold and diamonds) exchanged vows atop their thrones during a five-minute traditional Malay ceremony.

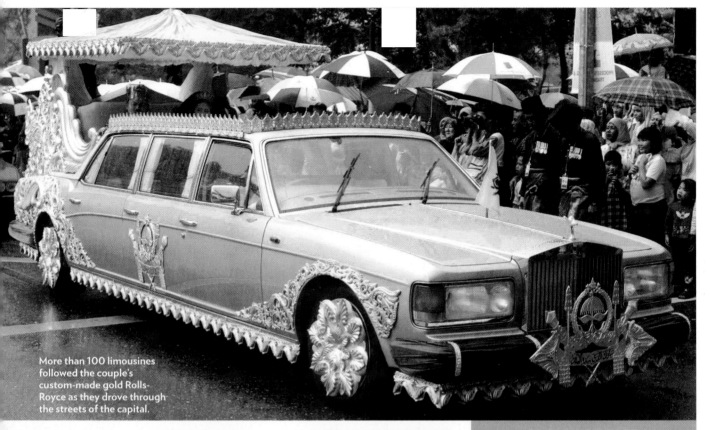

More than 100 limousines followed the couple's custom-made gold Rolls-Royce as they drove through the streets of the capital.

In keeping with protocol, more than 2,000 international guests donned white attire to attend the festivities in the royal palace's cavernous Throne Chamber.

When it came to the wedding of his oldest son, the Sultan of Brunei spared no expense. Thousands of dignitaries filled a banquet hall in the Sultan's 1,788-room palace in the tiny nation's capital, Bandar Seri Begawan, as Prince al-Muhtadee Billah Bolkiah, 30, the Oxford-educated heir to the throne—and a $4.3 billion fortune—wed 17-year-old student Sarah Salleh in a $5 million celebration. Salleh, the daughter of a Swiss nurse and a Bruneian civil servant who met the prince through a friend, arrived an hour late. But the radiant bride did not disappoint her guests. Wearing a diamond tiara and diamond-studded shoes, she was serene as the crown prince gently laid a hand on his wife's head, the only public display of affection between the two. Then the newlyweds kissed the hands of the Sultan and Queen Saleha (Muhtadee's mother and one of the Sultan's two wives) before greeting a throng waiting outside the palace gates.

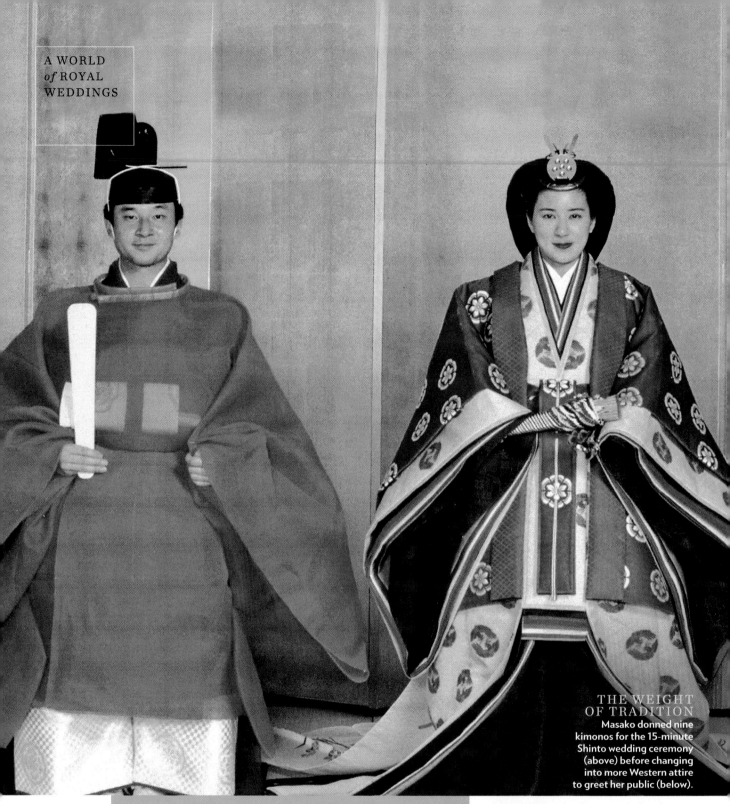

THE WEIGHT
OF TRADITION
Masako donned nine
kimonos for the 15-minute
Shinto wedding ceremony
(above) before changing
into more Western attire
to greet her public (below).

CROWN PRINCE NARUHITO OF JAPAN & MASAKO OWADA

JUNE 9, 1993

After catching the eye of Prince Naruhito at a 1986 palace
reception, 29-year-old Masako Owada, a Harvard-educated
diplomat, gave up her career to marry into the world's oldest
royal family. The thoroughly modern bride rode through
Tokyo with her husband after the ceremony—nearly 200,000
cheering spectators lined the streets.

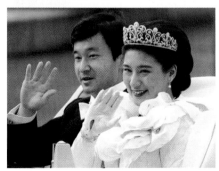

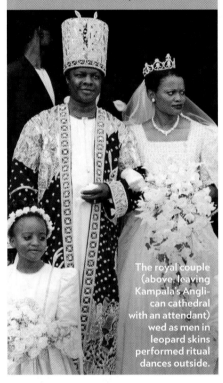

The royal couple (above, leaving Kampala's Anglican cathedral with an attendant) wed as men in leopard skins performed ritual dances outside.

Citizens of the East African nation of Uganda longed to witness the splendor of a royal wedding, not to mention seeing their 43-year-old bachelor Kabaka (king) finally married off. Mutebi II, who reigns over the largest of five kingdoms in a country the size of Oregon, granted both these wishes when he wed British public relations executive Sylvia Luswata, 35. The couple, introduced by friends, hosted a lavish palace reception where thousands of guests feasted on 100 roasted cows and gourds of banana beer.

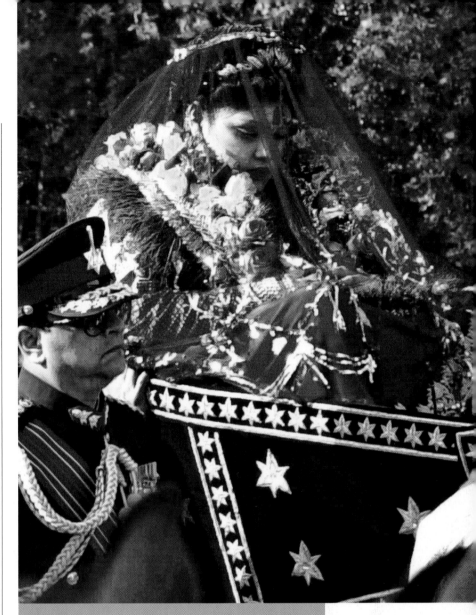

PRINCESS PRERNA OF NEPAL & RAJ BAHADUR SINGH

JANUARY 21-22, 2003

When the only daughter of Nepal's King Gyanendra and Queen Komal wed Raj Singh, a 29-year-old computer programmer, there was more than the usual reason to rejoice. About 20 months earlier, the family had suffered tragedy when Princess Prerna's troubled cousin gunned down nine members of the royal family and then committed suicide. The arranged marriage of Prerna, 24, and Singh, a University of California grad, was a festive occasion but a humble affair: The pair wed before just a small group of family and friends. Per Hindu custom, Singh arrived at his bride's home for a ceremony in which the King and Queen showered the couple's hands with water poured from a golden jug and priests chanted and prayed to the elephant god Ganesh. Alas, despite such an auspicious start, the couple's life took a dramatic turn: In 2008 Nepal abolished its monarchy, and the pair now live in exile in Singapore.

LADY IN RED
Guards carry Princess Prerna (above, in a gold-embroidered sari) to a horse-drawn carriage where her husband awaits. To the strains of pipers playing alongside, the newlyweds were whisked away from the palace to their new home.

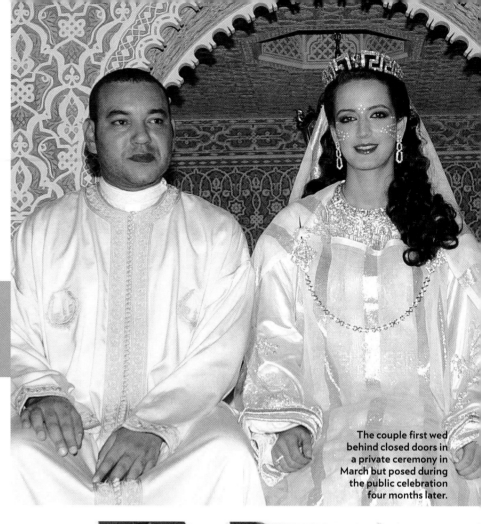

KING MOHAMMED VI OF MOROCCO & SALMA BENNANI

JULY 12-14, 2002

The couple first wed behind closed doors in a private ceremony in March but posed during the public celebration four months later.

When Morocco's King Mohammed VI wed computer engineer Salma Bennani, he didn't merely break with tradition, he pulverized it. Not only did the monarch forgo an arranged marriage, but for the first time in the history of the kingdom, the royals publicly celebrated a wedding. (The King's own mother's picture had never been officially released, and her marriage wasn't even acknowledged until she had produced a male heir.) In contrast, Mohammed made sure Moroccans feted his 24-year-old bride in a never-before-seen bash, complete with a parade of white-robed servants bearing gifts, dozens of singers and dancers, and international guests including President Clinton, his daughter Chelsea and Jordan's Queen Rania.

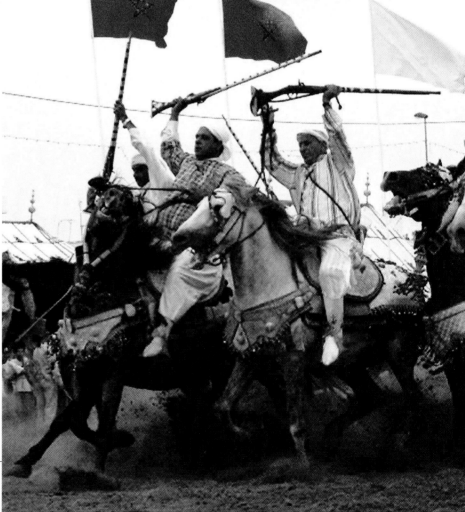

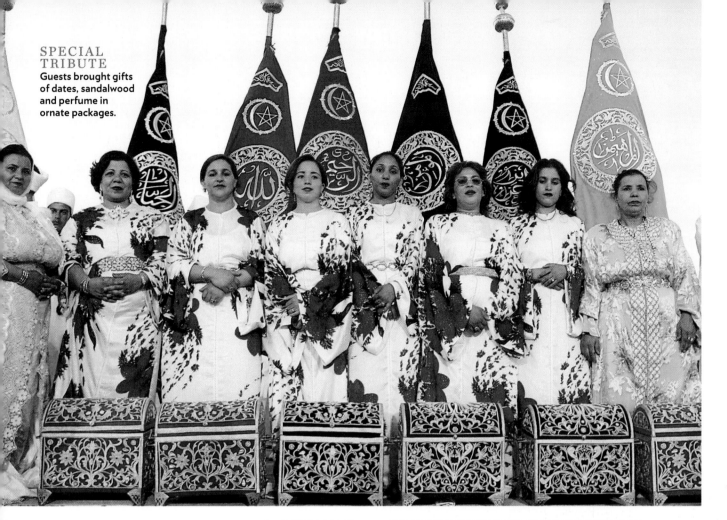

SPECIAL
TRIBUTE
Guests brought gifts
of dates, sandalwood
and perfume in
ornate packages.

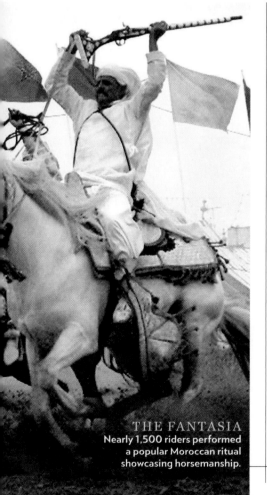

THE FANTASIA
Nearly 1,500 riders performed
a popular Moroccan ritual
showcasing horsemanship.

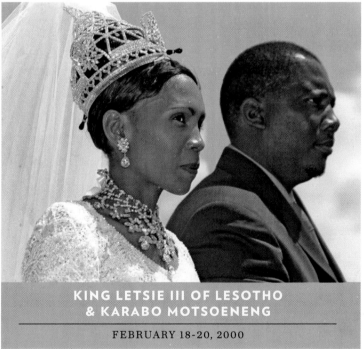

KING LETSIE III OF LESOTHO & KARABO MOTSOENENG

FEBRUARY 18-20, 2000

By tradition, King Letsie, 38, who rules over a landlocked kingdom the size of Maryland, needed only 40 cows in dowry to gain the hand of his South African sweetheart, Karabo Motsoeneng, 23. Nonetheless, for his wedding the King pulled out all the stops. Choirs sang, silver-helmeted royal horsemen rode by, and hundreds of guests, including Nelson Mandela, joined the couple for three days of feasting and dancing.

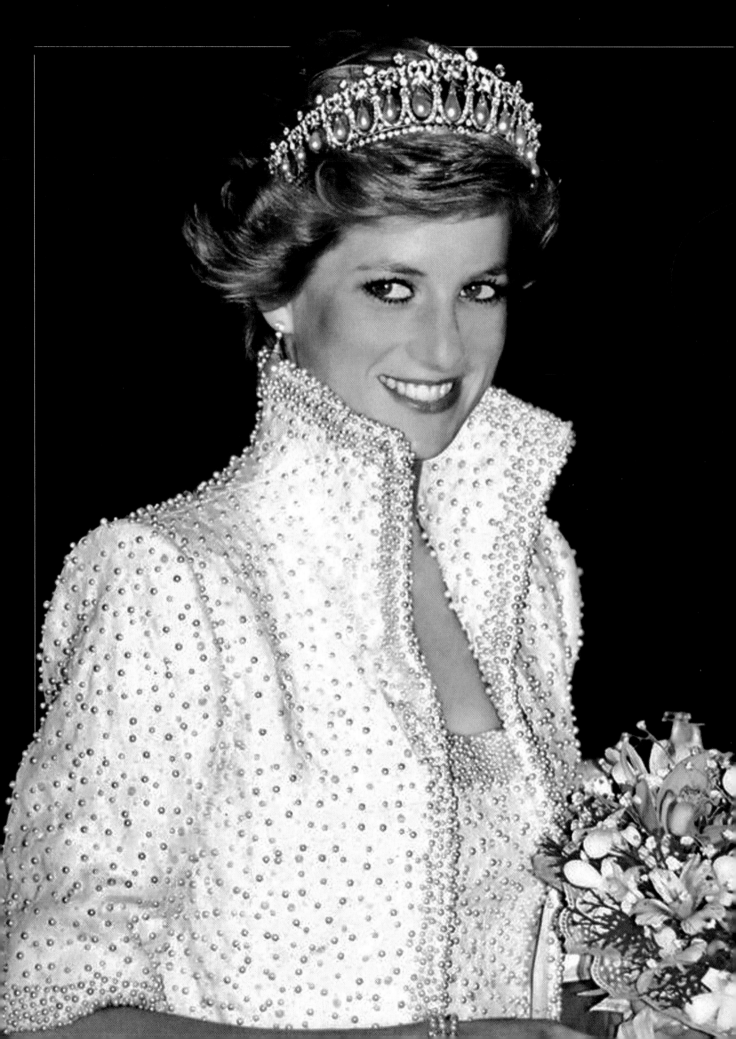

A CENTURY *of* STYLE

Transcending the stodgy looks dictated by tradition and protocol, a handful of royals have reigned over that most difficult of conquests: the world of fashion. From the Duke of Windsor and his knot to the effortless elegance of Monaco's Grace to the glamour of Diana, these aristocrats of chic have kept royalty the object of fascination long after they have faded into history

THE POWER OF LOOKING GOOD Diana's "Elvis Dress," a stunning beaded sheath by Catherine Walker worn during an official visit to Hong Kong in 1989. The actual inspiration wasn't the King of Rock and Roll but Queen Elizabeth I.

A LIFE *in* STYLE

DIANA

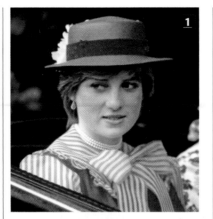

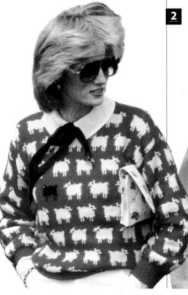

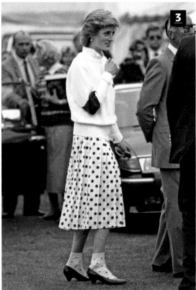

PRINCESS STYLE: THE EARLY YEARS
Initially Di embraced the Windsors' millinery madness (**1**); after she appeared in Warm and Wonderful's "black sheep" sweater, the company sold $1 million worth (**2**); Di in a whole lotta dots, even on her socks (**3**); in princess formal wear for an official portrait, 1985 (**4**).

Long legs emerging from a limousine, body buffed by near-daily visits to the gym, Princess Diana, by the end of her life, was a fashion force to be reckoned with. A thoroughly modern royal, she brought a new sensuality to the palace—and to the image of Englishwomen everywhere. "There's nobody," said royal milliner Philip Somverville, "who you could compare her with."

It hadn't always been that way. Diana came into her marriage like a lamb and left a lioness. Her sense of style followed right along. In the beginning she was a modest English rose in pleats and bows, dressed, it seemed, as if a tea party might break out at any moment. Then, one by one, she threw off the must and fust of tradition. "She broke the barriers of the accepted form of royal dressing," said David Sassoon, who designed clothes for Diana in the early 1980s. She gave up hats and gloves, dared to wear pants to semiformal events, substituted tanned legs for panty hose. (Her adventurousness could lead to etiquette problems for dance partners and escorts. "When I wear a backless dress," she noted at one point, "I find that most people just don't know where to put their hands.") Her clothes reflected her state of mind, from the frilly frocks of a newlywed (sometimes

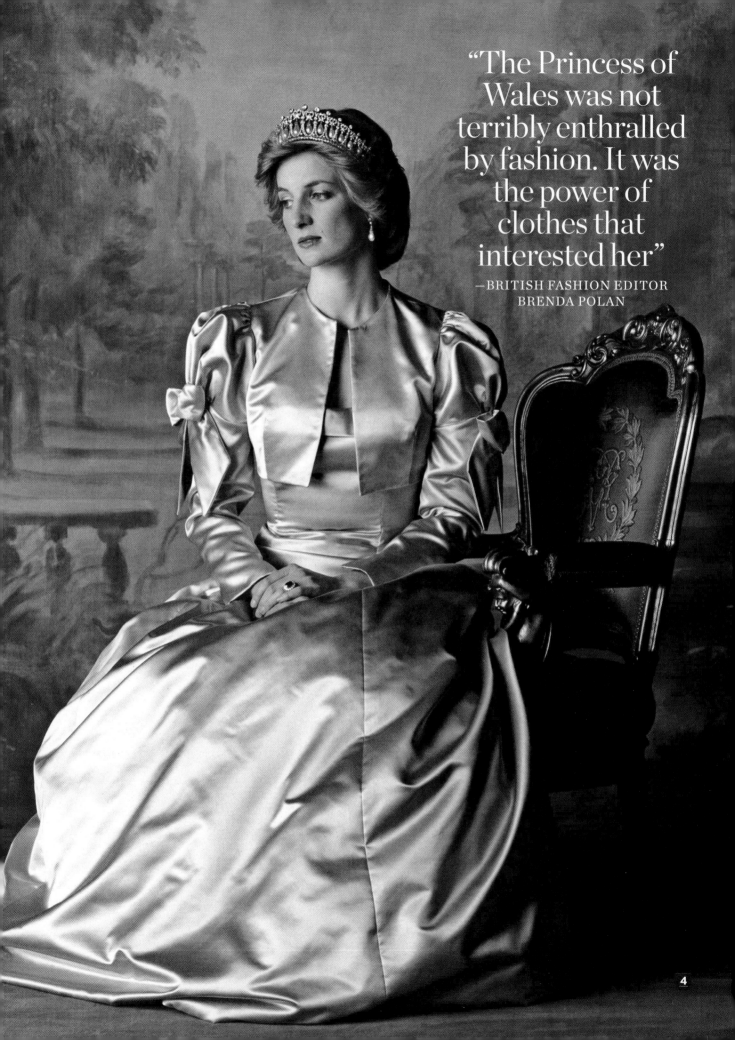

"The Princess of Wales was not terribly enthralled by fashion. It was the power of clothes that interested her"

—BRITISH FASHION EDITOR
BRENDA POLAN

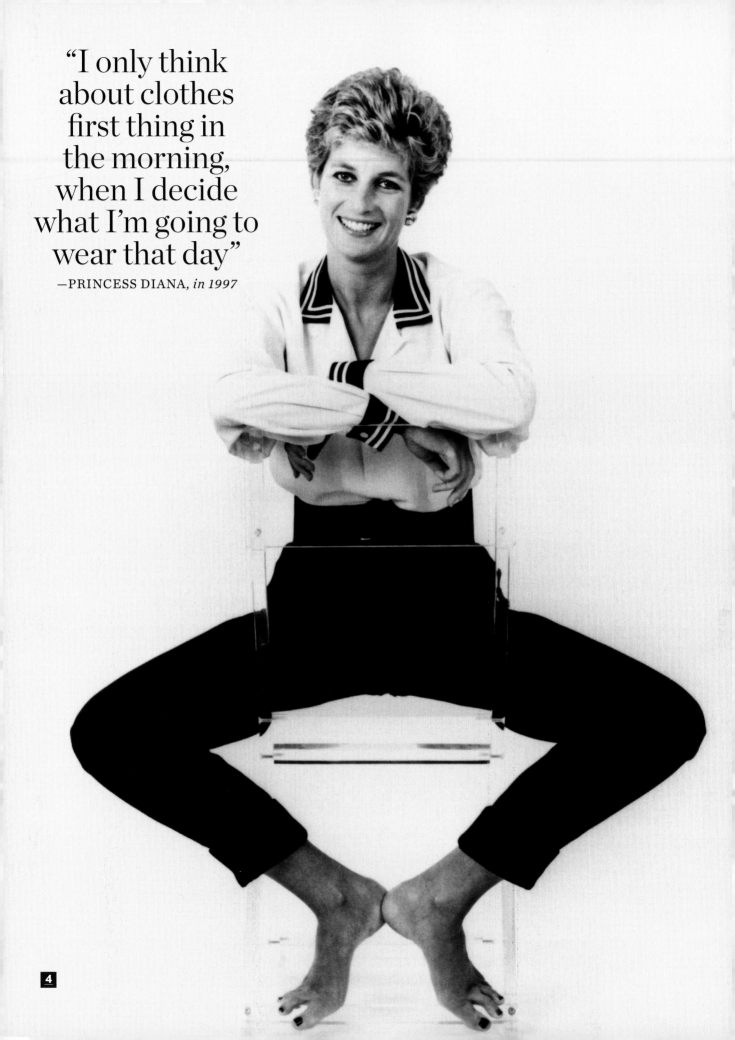

"I only think about clothes first thing in the morning, when I decide what I'm going to wear that day"

—PRINCESS DIANA, *in 1997*

4

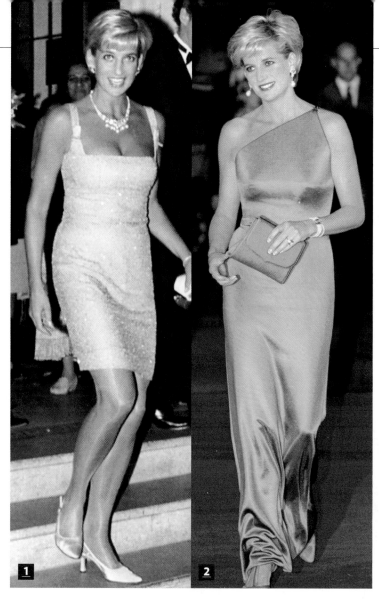

1

2

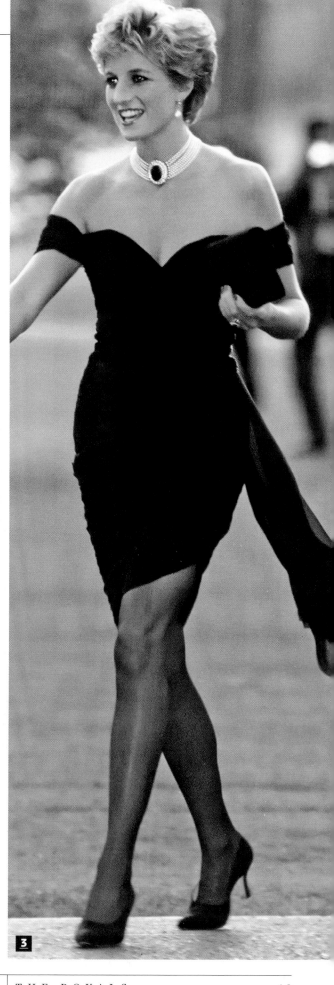

3

sewn by her mother's dressmaker) to the low-cut Valentinos and Versaces she embraced after her divorce, when she was allowed to stop flying the flag for British designers. Along the way, she made few missteps. Said Sassoon: "She understood the art of wearing the right clothes for the occasion."

Diana sometimes bemoaned her image—"Clothes are not my priority," she once protested—but clearly she loved fashion: Her annual clothing bills ran into six figures. And the public's fascination with her style, she knew, helped draw attention, and support, to her causes. In one of her last significant public acts— a sort of casting off life as Her Royal Highness—she auctioned off 79 gowns through Christie's in Manhattan and raised nearly $6 million for charity.

HOW DO YOU LIKE ME NOW?
Over the years, Diana found a modern look—elegant, healthy, at ease—that suited her and enchanted the world. By the numbers: (1) sky blue at the ballet in London (1997); (2) draped in Versace during a trip to Australia (1996); (3) a little black dress for an art gallery fund-raiser (1994); and, far left (4), comfortable in slacks and a pose that is unlikely ever to be duplicated by the Queen (1995).

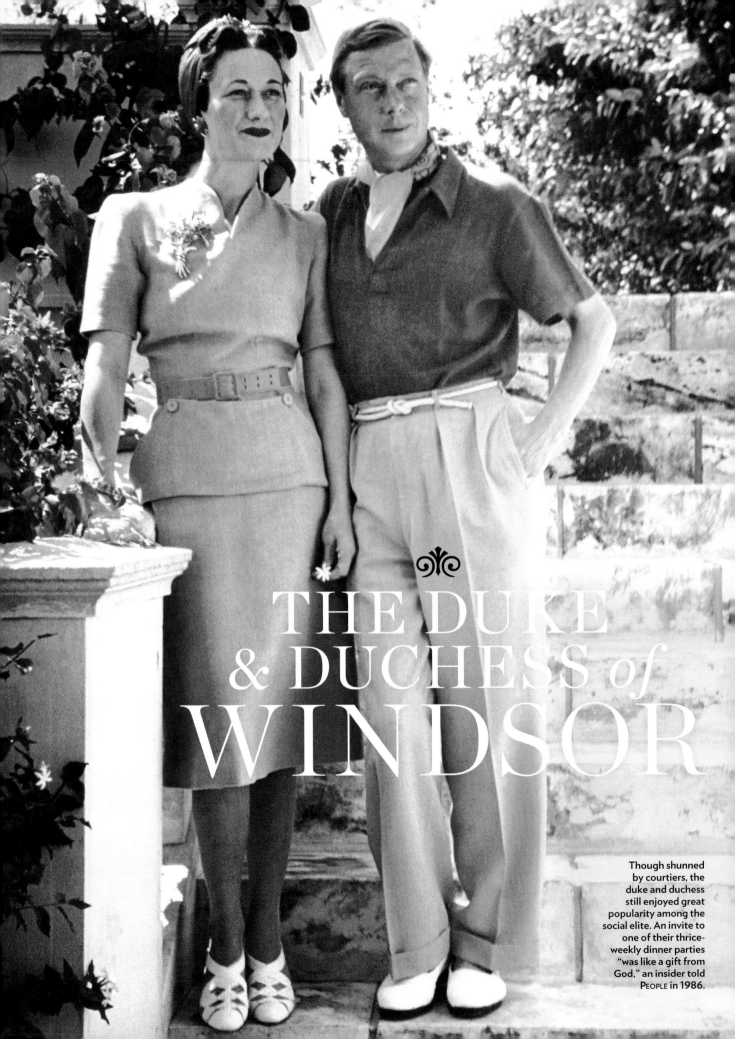

THE DUKE & DUCHESS *of* WINDSOR

Though shunned by courtiers, the duke and duchess still enjoyed great popularity among the social elite. An invite to one of their thrice-weekly dinner parties "was like a gift from God," an insider told PEOPLE in 1986.

They were a scandalous couple whose love affair cost him the British crown. But when it came to fashion, at least, Edward VIII and Wallis Simpson—the American divorcée he refused to give up—never put a foot wrong. Named Duke and Duchess of Windsor after he abdicated and they wed in 1937, the pair spent most of the next four decades as royal outcasts in a mansion in Neuilly, outside Paris. But these exiles lived in sublime style. The Baltimore-bred duchess, who famously said, "A woman can't be too rich or too thin," accentuated her narrow frame with sharply tailored suits from Mainbocher, Dior, Chanel and Givenchy. Among her trademarks: high-necked evening gowns, knee-length skirts and dazzling gems. Little wonder she made international Best Dressed lists for more than 40 years. For his part, Edward, a consummate English dandy, cut a dapper figure in made-to-measure suits and popularized a foppish look for golf: baggy plus-fours and a riot of plaids, checks and stripes. Their 35-year union was marked by extravagant parties and a seemingly limitless clothing budget. "It was a fairy-tale life," Jean-Pierre Auge, the couple's former chef, told PEOPLE. "But they lived it very well."

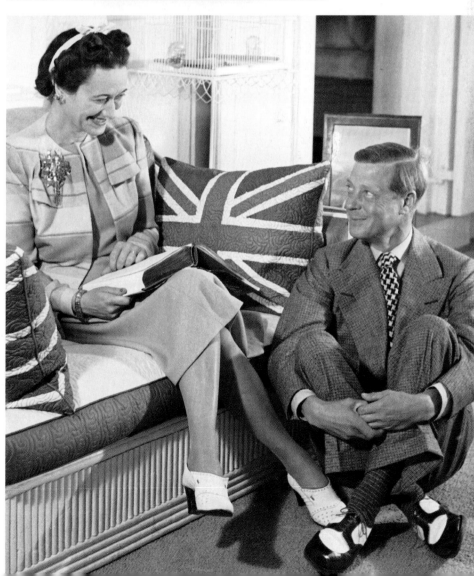

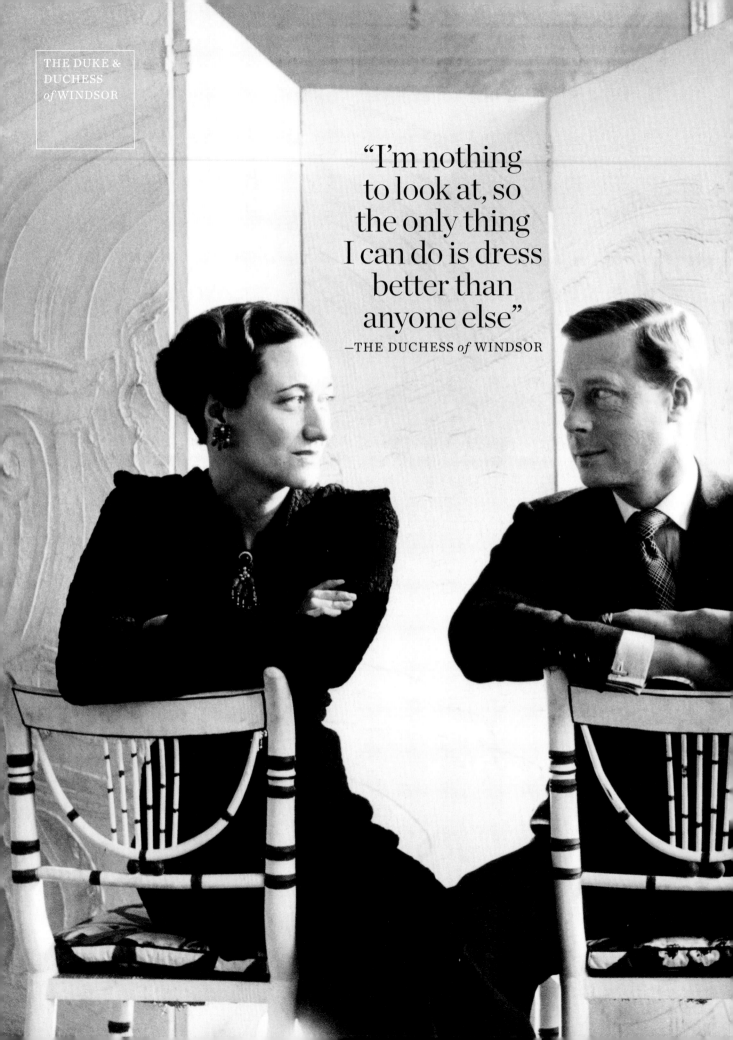

"I'm nothing
to look at, so
the only thing
I can do is dress
better than
anyone else"
—THE DUCHESS *of* WINDSOR

THE JEWELS OF A DUCHESS

Wallis Simpson would never become queen, but she accessorized herself like one. Her jewelry collection is still considered legendary. After her death, Sotheby's auctioned off many of the prized gems for charity, including the insignia Prince of Wales brooch the duke had made for her around 1935. Rumor has it that a bidding war ensued between Prince Charles, intent on giving it to his wife, Diana, and Elizabeth Taylor, who called into the auction while poolside at her L.A. home. A longtime friend of the Windsors', Taylor had admired the plume of pavé-set diamond feathers for decades and won the pin with a $623,000 bid. "I knew the duchess wanted me to have it," she wrote in her book *My Love Affair with Jewelry*. "It's a royal piece that I save for very special occasions."

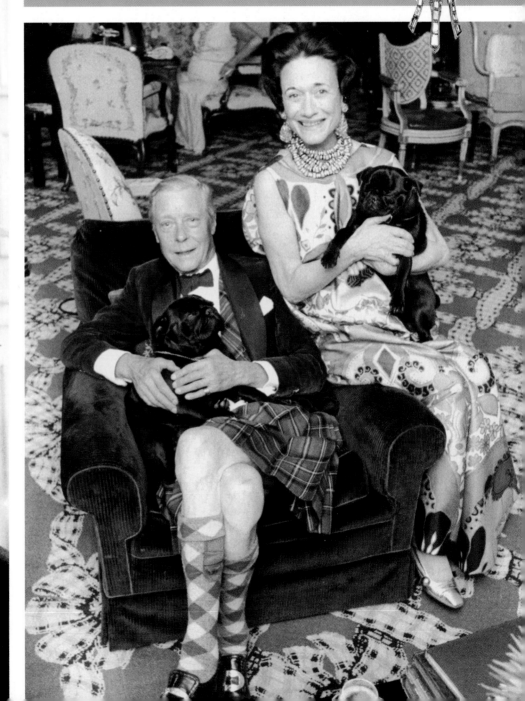

Always well turned out, the couple even adorned their four pugs with mink collars and gold Cartier leashes and spritzed them with Christian Dior perfume. "They had nothing else really to do except worry about how they looked," fashion writer Kathleen Craughwell-Varda later told People.

the JET-SET PRINCESS

Long before Prince Harry made tabloid headlines, his great-aunt Margaret (1930-2002) was the wild Windsor. With a tortoiseshell cigarette holder in one hand and a tumbler of Famous Grouse whisky in the other, Queen Elizabeth's kid sister became an It Girl for dreary 1950s Britain and conquered London nightlife with pals who included Elizabeth Taylor, Peter Sellers and Noël Coward. A fan of Dior's, Margaret disdained the buttoned-down look favored by the Queen and other royals, and by the swinging '60s was turning heads in miniskirts and psychedelic prints. But a flair for fashion couldn't mask a life plagued by unhappiness and confusion about her royal role. Still, Princess Margaret remains a fashion influence today, inspiring a recent Burberry Prorsum collection with rich brocade coats, elegant silk shirts and sophisticated dresses.

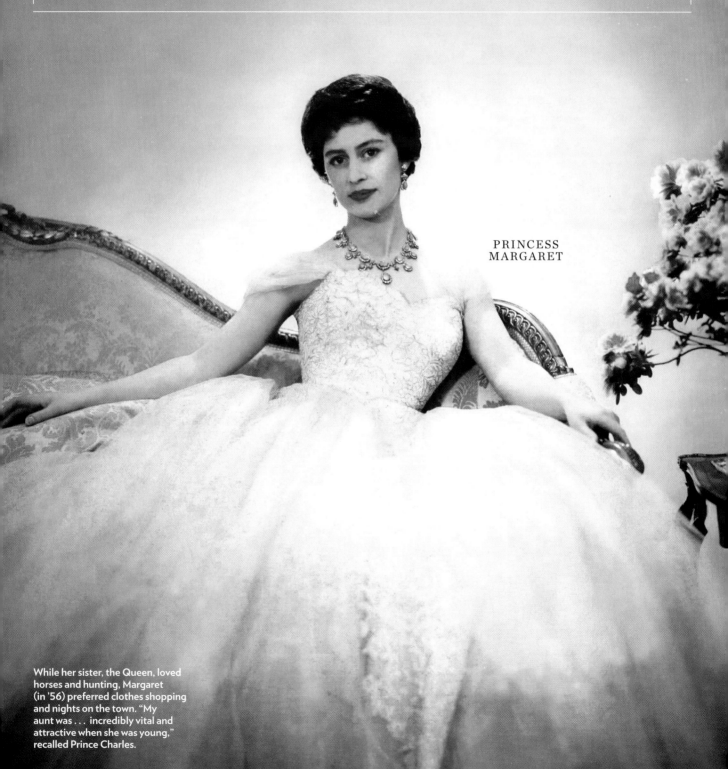

PRINCESS
MARGARET

While her sister, the Queen, loved horses and hunting, Margaret (in '56) preferred clothes shopping and nights on the town. "My aunt was . . . incredibly vital and attractive when she was young," recalled Prince Charles.

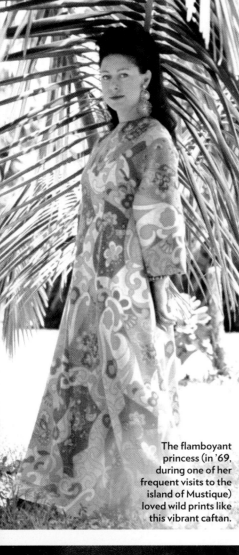

The flamboyant princess (in '69, during one of her frequent visits to the island of Mustique) loved wild prints like this vibrant caftan.

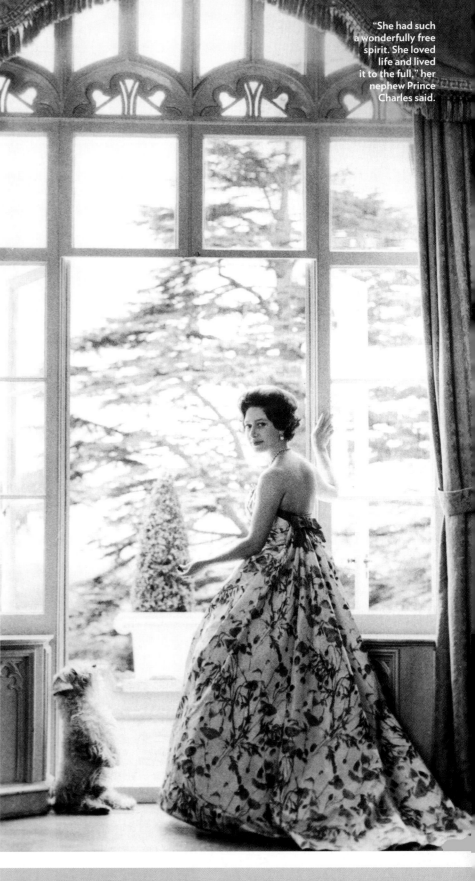

"She had such a wonderfully free spirit. She loved life and lived it to the full," her nephew Prince Charles said.

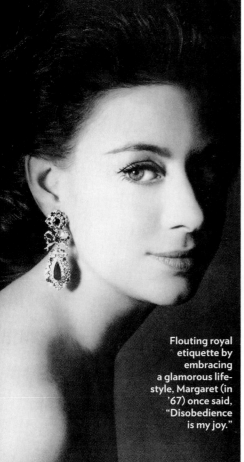

Flouting royal etiquette by embracing a glamorous life-style, Margaret (in '67) once said, "Disobedience is my joy."

"I can't imagine anything more wonderful than being who I am"

—PRINCESS MARGARET

O nscreen and off, she was grace itself. Born to a rich Philadelphia family, Grace Patricia Kelly gained fame as an actress and the embodiment of American style: pearls, white gloves, cashmere twinsets, cinched waists and long full skirts that fashion editors quickly dubbed the Grace Kelly look. A devotee of Christian Dior, Oleg Cassini and Hollywood costume designers Edith Head and Helen Rose (who would later create her wedding dress), she exuded a cool sophistication that became the essence of '50s chic.

Nonetheless, after a meteoric Hollywood rise (the former model made her first picture in 1951, at 22, and four years later collected a Best Actress Oscar for *The Country Girl*), she tired of films. "I don't want to dress up a picture with just my face," Kelly once said of a career that often called for her to play little more than a decorative high-society blonde. Instead, she went on to conquer the heart of Prince Rainier III of Monaco, ruler of a tiny principality and among the world's most eligible bachelors. After a whirlwind courtship, the pair starred in a lavish April 1956 wedding not unlike a Hollywood blockbuster.

The movie star bride put Monaco on the map, and she soon mastered a new role: Her Serene Highness. As Princess Grace, she fused new-world ease to old-world haute couture, adding lavish ball gowns, crisp suits and even turbans to her wardrobe. To her fans' dismay, Grace never returned to acting—but she never left the headlines. At 51, the princess was turning heads in a straw hat and purple gown at the 1981 wedding of Prince Charles and Diana Spencer.

A year later she was dead—the victim of a car accident near the same twisting Riviera corniches she and Cary Grant drove in Hitchcock's *To Catch a Thief.* By then she'd earned fashion immortality. In 1990 she was chosen one of the most stylish people in history by the International Best Dressed Poll. The secret to her unsurpassed elegance, according to Cassini, a former beau: "She dressed like a lady."

PRINCESS GRACE

From Hollywood glamour girl to beloved matriarch of Monaco, she created a look that remains both regal and romantic

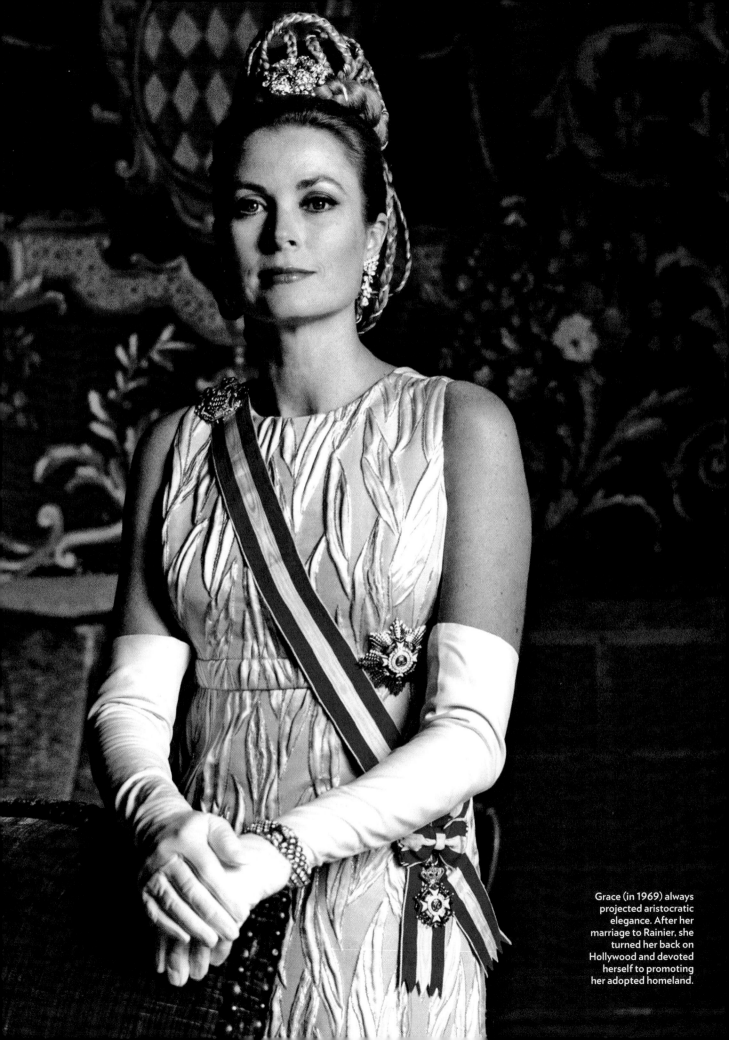

Grace (in 1969) always projected aristocratic elegance. After her marriage to Rainier, she turned her back on Hollywood and devoted herself to promoting her adopted homeland.

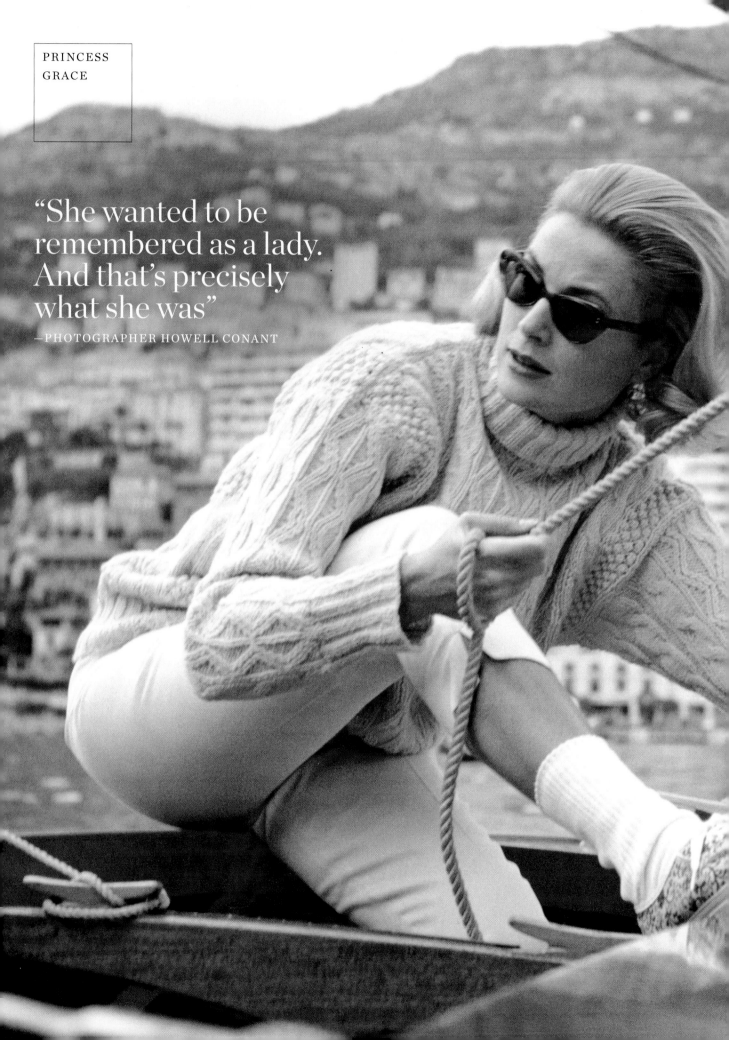

"She wanted to be
remembered as a lady.
And that's precisely
what she was"
—PHOTOGRAPHER HOWELL CONANT

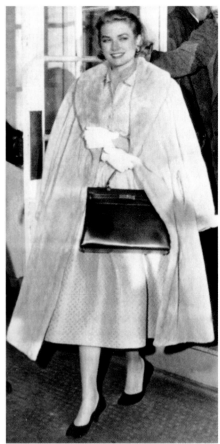

THE PRINCESS AND THE BAG

So adored was Princess Grace that when she used her oversize crocodile-skin Hermès bag to demurely conceal her pregnancy during a 1956 U.S. visit, the accessory became an immediate must-have. The company was so grateful to the princess, who also toted the boxy purse during a LIFE magazine cover shoot, they called it the Kelly bag. It remains a perennial bestseller: The waiting list for some models can be up to three years. According to legend, even Princess Diana had to wait six months for a powder-blue ostrich-skin version of the coveted Hermès classic.

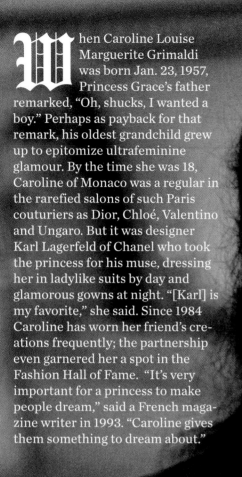

When Caroline Louise Marguerite Grimaldi was born Jan. 23, 1957, Princess Grace's father remarked, "Oh, shucks, I wanted a boy." Perhaps as payback for that remark, his oldest grandchild grew up to epitomize ultrafeminine glamour. By the time she was 18, Caroline of Monaco was a regular in the rarefied salons of such Paris couturiers as Dior, Chloé, Valentino and Ungaro. But it was designer Karl Lagerfeld of Chanel who took the princess for his muse, dressing her in ladylike suits by day and glamorous gowns at night. "[Karl] is my favorite," she said. Since 1984 Caroline has worn her friend's creations frequently; the partnership even garnered her a spot in the Fashion Hall of Fame. "It's very important for a princess to make people dream," said a French magazine writer in 1993. "Caroline gives them something to dream about."

CHIC CAROLINE

The older daughter of Monaco's prince and his glamorous movie-star bride grew into an elegant Continental beauty

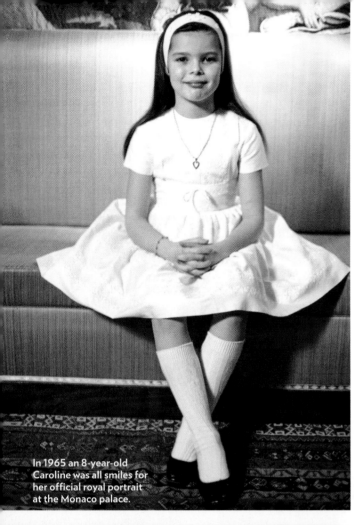

In 1965 an 8-year-old Caroline was all smiles for her official royal portrait at the Monaco palace.

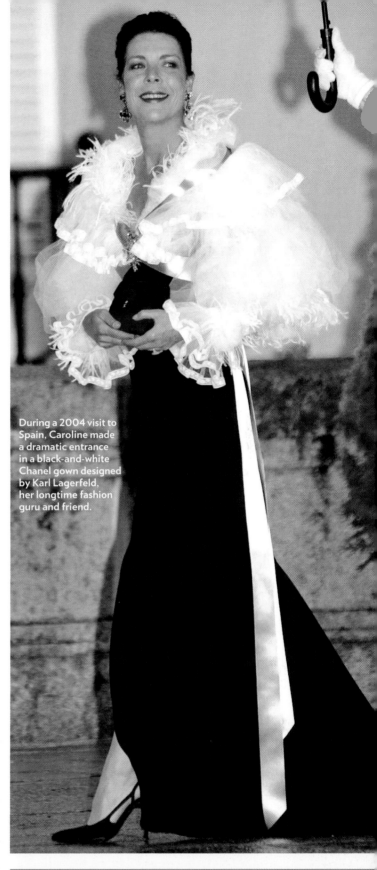

During a 2004 visit to Spain, Caroline made a dramatic entrance in a black-and-white Chanel gown designed by Karl Lagerfeld, her longtime fashion guru and friend.

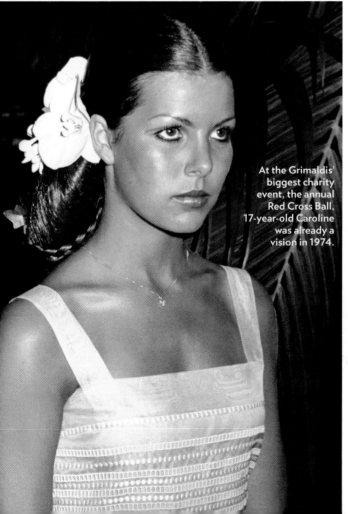

At the Grimaldis' biggest charity event, the annual Red Cross Ball, 17-year-old Caroline was already a vision in 1974.

"Her elegance is something she was born with"

—KARL LAGERFELD

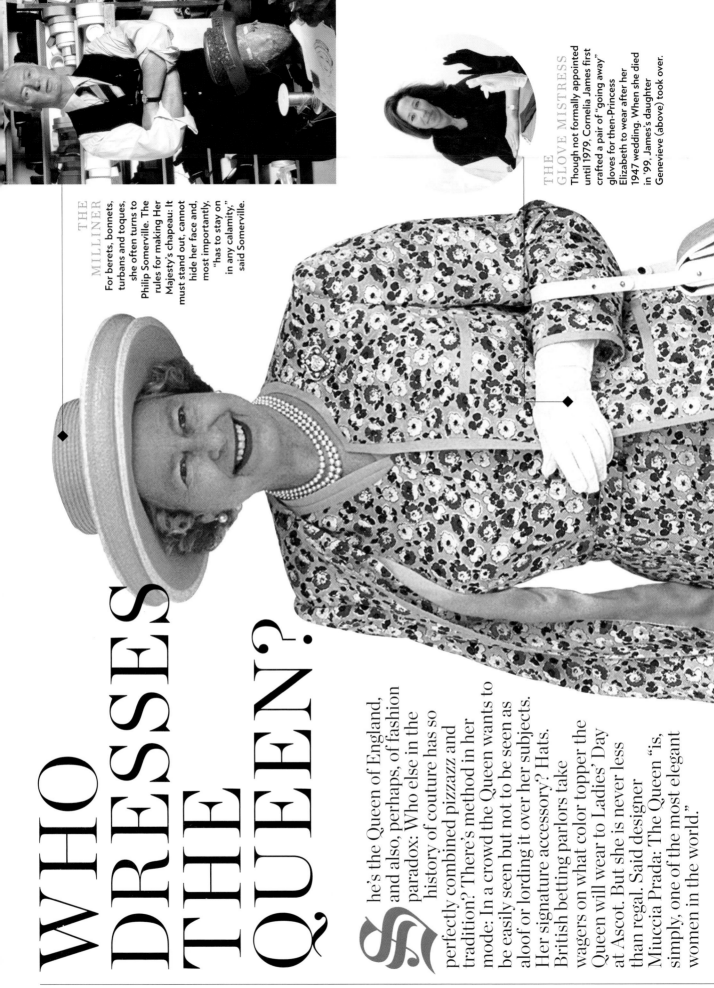

WHO DRESSES THE QUEEN?

THE
MILLINER

For berets, bonnets, turbans and toques, she often turns to Philip Somerville. The rules for making Her Majesty's chapeau: It must stand out, cannot hide her face and, most importantly, "has to stay on in any calamity," said Somerville.

THE
GLOVE MISTRESS

Though not formally appointed until 1979, Cornelia James first crafted a pair of "going away" gloves for then-Princess Elizabeth to wear after her 1947 wedding. When she died in '99, James's daughter Genevieve (above) took over.

She's the Queen of England, and also, perhaps, of fashion paradox: Who else in the history of couture has so perfectly combined pizzazz and tradition? There's method in her mode: In a crowd the Queen wants to be easily seen but not to be seen as aloof or lording it over her subjects. Her signature accessory? Hats. British betting parlors take wagers on what color topper the Queen will wear to Ladies' Day at Ascot. But she is never less than regal. Said designer Miuccia Prada: The Queen "is, simply, one of the most elegant women in the world."

THE PURSE PURVEYOR

The London-based Launer has supplied the Queen's handbags for the past 40 years. The ubiquitous bags reportedly are used to send coded messages to staff. According to Palace lore, if a purse dangles loosely from her left arm, all is well. But if the Queen switches her handbag to the right, it means she's bored with the person talking to her and needs a rescue.

THE COBBLER

Anello & Davide, the firm that created Dorothy's red slippers for *The Wizard of Oz*, became Elizabeth's shoemaker in 2001 on recommendation of the late Queen Mother, who wore their creations for years.

THE DRESSMAKER

The Queen's official couturier for almost 50 years, Sir Hardy Amies, who died in 2003, crafted hundreds of pastel- and candy-colored dresses for her. Though he was proud of the restrained styles he created, "I sometimes wish she had been a bit more of a clothes person," Amies once recalled. As to why Elizabeth never embraced high fashion, he said, "The Queen's attitude is that she must always dress for the occasion, usually for a large mob of middle-class people, towards whom she wishes to seem friendly. There's always something cold and cruel about chic clothes, which she wants to avoid." These days designers such as Karl Ludwig Rehse carry on the tradition.

HARDY AMIES

Dress and jacket in yellow printed silk faille.

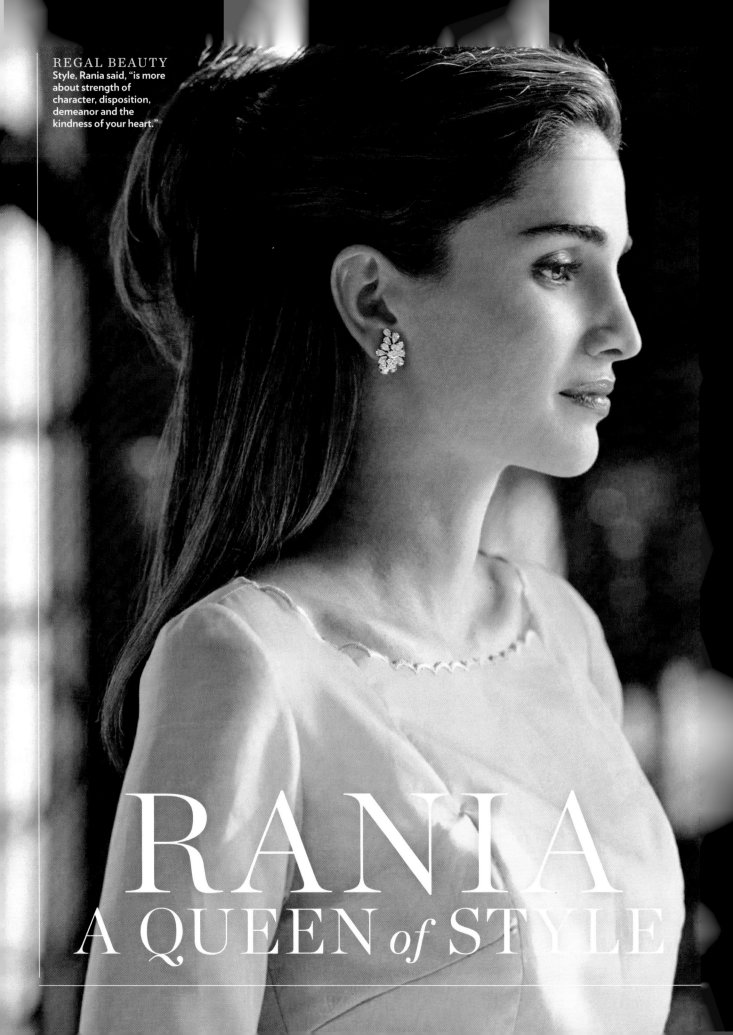

RANIA
A QUEEN *of* STYLE

Thoroughly modern and yet proudly Muslim and Palestinian, Rania of Jordan has helped redefine how the world sees the women of the Middle East. Westerners may debate the role of the veil, but for Rania, 39, the answer is simple: Women should be judged "according to what is going on in their heads rather than what is on top of their heads." The queen's own look is both daring and respectful of Jordanian values: an alluring array of elegant suits and dramatic gowns from favored designers like Givenchy and Roland Mouret. The wife of King Abdullah and mother of four, says Giorgio Armani, "has the body of a model and holds herself like the queen she is. What more could you want?"

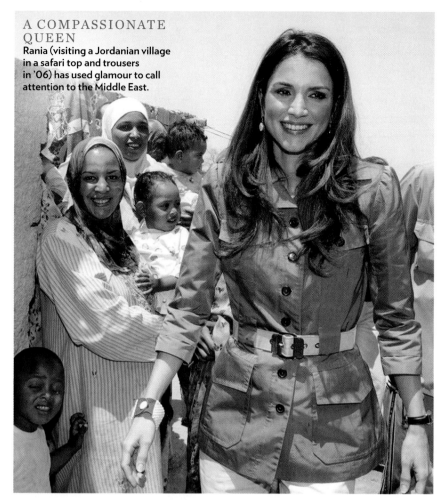

A COMPASSIONATE QUEEN
Rania (visiting a Jordanian village in a safari top and trousers in '06) has used glamour to call attention to the Middle East.

REDEFINING TRADITION

Rania's flair for dressing has been compared to that of Jacqueline Kennedy Onassis and Princess Diana, but the former Apple marketing executive also juggles several demanding roles: hands-on mother, advocate for the developing world and role model for Arab women. "The young relate to her," Maha Khatib of the Jordan River Foundation said of Rania (below, at public appearances in '03, '04 and '05). "She has this ability to maintain her Arabic style with a modern approach."

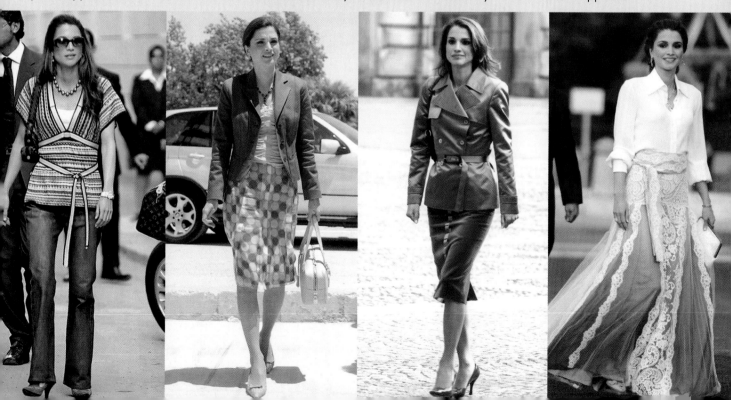

WHO DRESSES THE PRINCE?

Impeccable tailoring has helped make Prince Charles the king of London's menswear mecca, Savile Row, where high-end shops sometimes bear his royal warrant (a tri-feathered heraldic badge of approval). His look is timeless: sharply cut double-breasted suits, shirts with spread collars, bold rep ties and pocket squares. The prince has single-handedly kept the double-breasted look in fashion since the '80s, but he's not afraid to take a risk, pressing on with linen suits after the press bashed his rumpled appearance. "He couldn't care less," says his former personal tailor Thomas Mahon. "He even ordered another." And the dapper royal's fans aren't just at the palace. In '04 American hip-hop star André 3000 declared, "Prince Charles is my No. 1 British style icon."

THE ROYAL SHIRTMAKER

Since 1980 Turnbull & Asser has supplied Charles with handmade cotton shirts and is widely known to now be making his suits—an unexpected choice since the store is owned by Ali Al-Fayed, uncle of Diana's late boyfriend Dodi. The shop's customer service may have won the prince over: After one of his polo injuries, they made him one-armed shirts with matching slings.

As colonel of the Welsh Guards, Prince Charles wears this regalia and bearskin hat on ceremonial occasions.

THE ROYAL SUITMAKERS

After two decades of shopping at 104-year-old Anderson & Sheppard, Charles caused a stir when he pulled his warrant in 2006. No reason was given ("The prince's shopping is a matter of personal taste," said a Palace spokesman). But former A&S tailor Mahon suspects Charles's lack of time for the two or three fittings required for their $6,000 bespoke creations led to dissatisfaction: "You only get one fitting with Prince Charles." Charles now wears Turnbull & Asser ready-made suits constructed from a template. "You can tell by the lapels," sniffs Mahon. "A good handmade suit has an understated class."

THE ROYAL COBBLER

Taking a cue from his parents, Prince Charles awarded a royal warrant to the shoe store John Lobb, which measures and outlines customers' feet before making a wooden replica to design perfectly fitting footwear. Style icon Jacqueline Kennedy Onassis bought Lobb's traditional riding boots, some of whose styles are 140 years old. Men's leather shoes start at $3,900. Order them in the spring and they'll be ready by fall.

The Royal Valets

"It's a very intimate relationship," says a royal source of Prince Charles and his team of valets. One or the other wakes the prince every morning, draws his bath and enters his color-coded mahogany closet to choose the first of up to five outfits for the day. He then lays out suit, shirt, tie (usually striped) and silk handkerchief on Charles's bed, with buttons undone and cuff links in place. Shoes are placed on a bedside chair with laces loosened, and socks are folded so Charles can easily slip in his foot. Valets wash the princely underwear. "No one could be closer [to Charles]," says the source. "The job is completely unique."

Former valet Ken Stronach (in '86) arranges medals on Charles's naval wear in the Uniform Room at Kensington Palace.

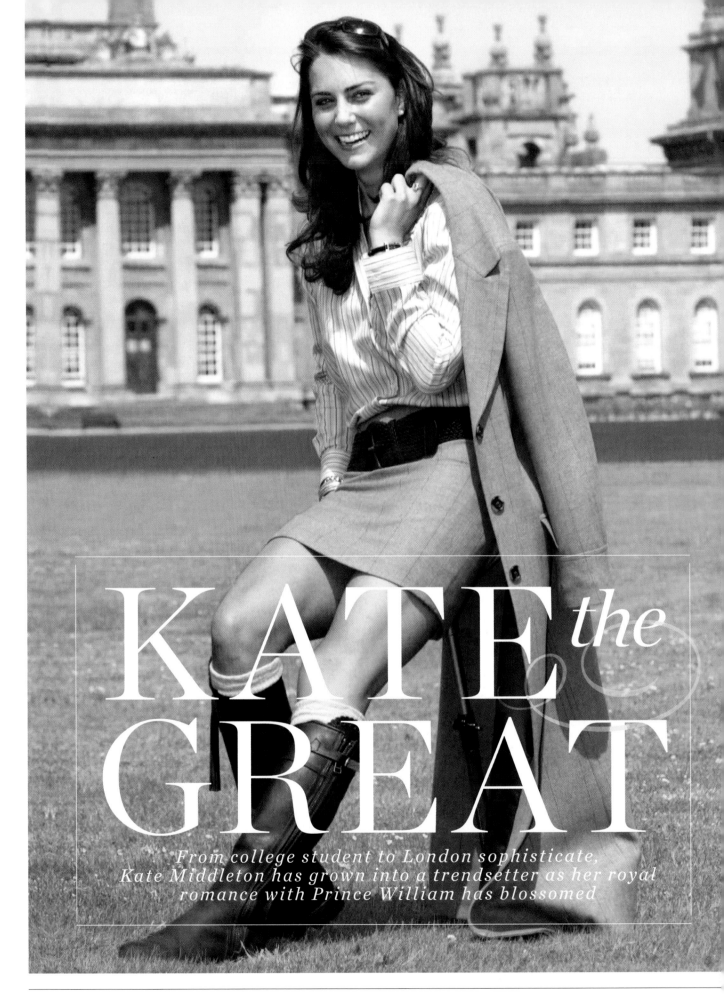

KATE *the* GREAT

From college student to London sophisticate, Kate Middleton has grown into a trendsetter as her royal romance with Prince William has blossomed

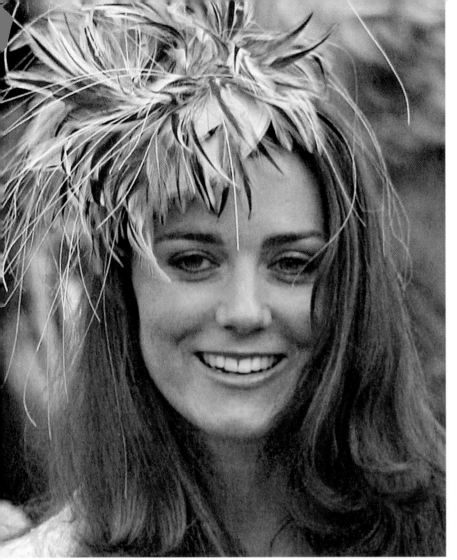

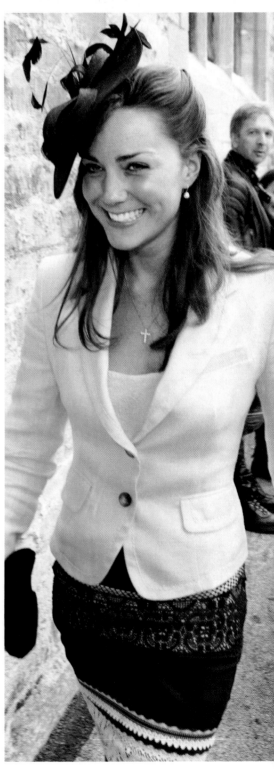

hen Kate Middleton first caught the public eye in March 2002, her outfit caused a stir. Walking the runway for a charity fashion show at Scotland's University of St. Andrews, the amateur model wore a sheer black sheath over a bandeau top and bikini bottom. Seated in the front row? A captivated Prince William, whom she had met when they entered college the same year.

Since then Kate's relationship with the prince has grown from friendship (the pair moved off-campus with two pals sophomore year) to very serious romance, marked by Middleton's increasing frequent appearances at Windsor family events. As her role in the prince's life has changed, so has her style. In her teens, high school friend Gemma Williamson says, Kate—whose parents own a mail-order party-goods store—"looked good by wearing standard stuff." By university she was casual but posh in Miss Sixty jeans. After she entered royal circles, Kate, 28, adopted a sophisticated look with Longchamp bags, miniskirts that showed off legs toned by years of field hockey and tennis and locks highlighted at Richard Ward's

"She is a natural"

—A PALACE INSIDER

London salon with "chocolate chunks and caramel slices," says an acquaintance. At heart Kate remained an unfussy product of England's Home Counties, her ever-present knee-high riding boots symbolizing her love of horses, hounds and shooting parties—a plus for William, an avid hunter who has said, "I am a country boy at heart."

Mixing edgy trends with a classic British look, Kate radiates the air of a modern princess. At the June 4, 2005, wedding of William's longtime pal, management consultant Hugh van Cutsem, she wore a conservative white jacket and knee-length skirt. But her Philip Treacy hat gave "a funky edge to an otherwise simple ensemble," noted celebrity stylist Jill Wanless. She impressed observers by composing herself to smile in the face of the paparazzi—a test, declares royals writer Judy Wade, that "she passed."

The following March, Kate seemed to clear another bar: She was invited to sit with Charles and Camilla in their box at the Cheltenham horse races and turned heads in a beige herringbone and brown velvet Katherine Hooker jacket, topped with a brown fur hat that evoked Julie Christie's Lara in *Dr. Zhivago*. Two months later her position in the inner circle was sealed: At the wedding of William's stepsister Laura Parker Bowles, Kate wore a chic cream-and-gold embroidered coat.

Now the world waits to see if Kate's wardrobe will include a tiara or two. Although the couple broke up briefly in 2007, since reuniting they seem to be stronger than ever. Will they become engaged? Says one friend of the couple, echoing, it seems, both the belief and hopes of a nation: "It's a question of when, not if."

PART OF THE FAMILY?

Kate (with Prince Harry and the Duchess of Cornwall) dressed with the right mix of elegance and fun at a 2008 service for the Most Noble Order of the Garter. Increasingly welcomed into royal circles, she has also appeared in the royal box at the Cheltenham Gold Cup and the Defence Helicopter Flying School at Royal Air Force Shawbury, where William received his wings.

Kate and William flirted at a June '05 polo match in Gloucestershire, where the prince bought his gal an ice-cream cone.

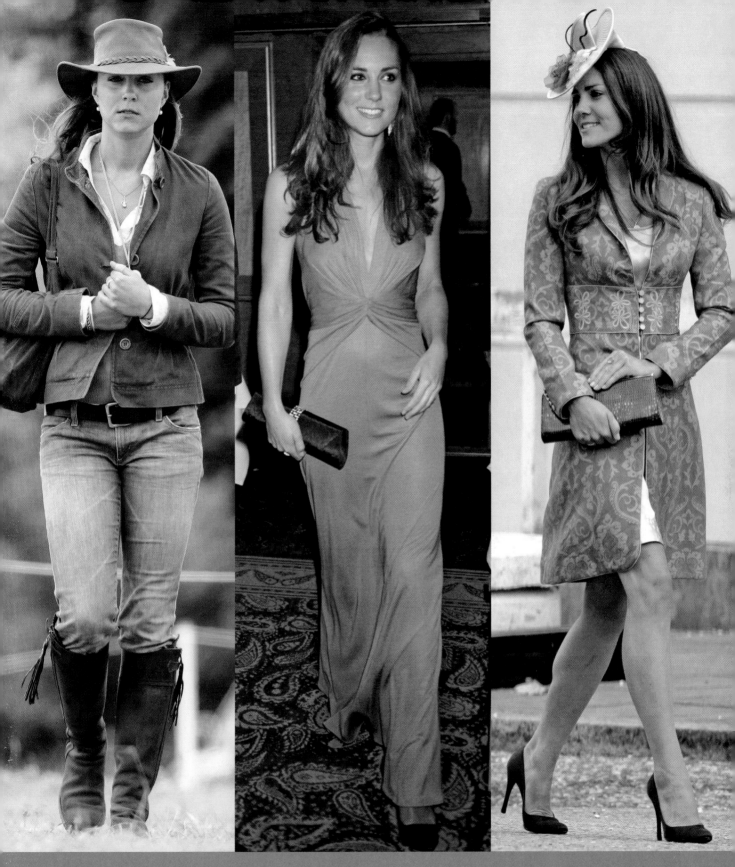

A MODERN GIRL ENTERS THE ROYAL WORLD

Global casual: For a horse show at Princess Anne's estate, Gatcombe Park, in 2005, Middleton jazzed up Seven for All Mankind jeans and her trademark Spanish leather Really Wild Clothing Company boots with a vintage cowboy hat from Manhattan's Screaming Mimi's (left). By night Kate went sleek and fuchsia for a charity ball in 2008 (middle). Tidily put together in lilac and *petit chapeau*, she attended the August 2009 wedding of Prince William's good friend Nicholas van Cutsem and Alice Hadden-Paton at the Guards Chapel at Wellington Barracks in London (right).

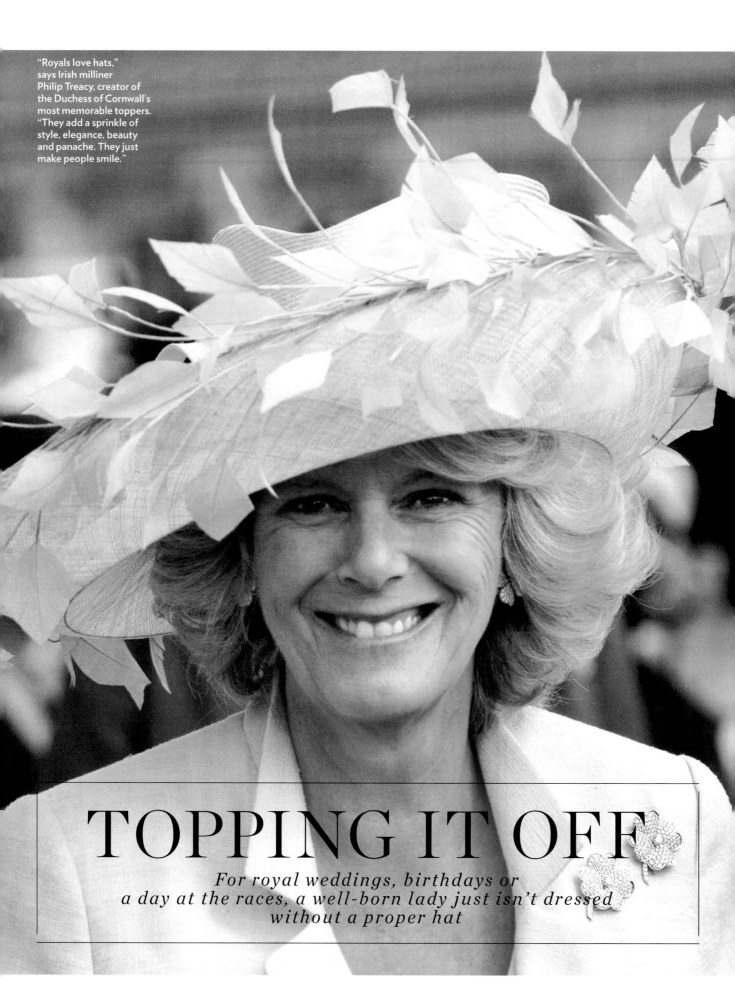

"Royals love hats," says Irish milliner Philip Treacy, creator of the Duchess of Cornwall's most memorable toppers. "They add a sprinkle of style, elegance, beauty and panache. They just make people smile."

TOPPING IT OFF

For royal weddings, birthdays or a day at the races, a well-born lady just isn't dressed without a proper hat

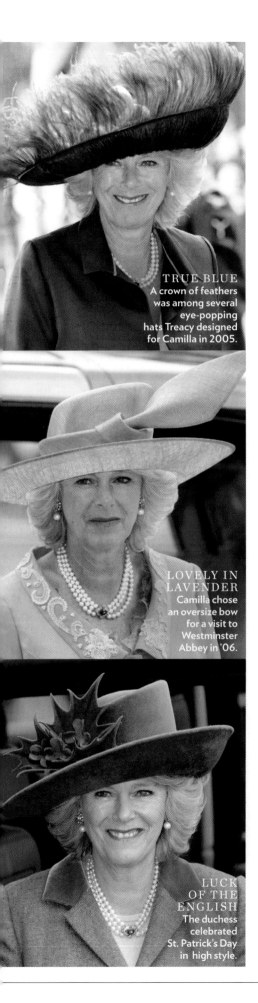

TRUE BLUE
A crown of feathers was among several eye-popping hats Treacy designed for Camilla in 2005.

LOVELY IN LAVENDER
Camilla chose an oversize bow for a visit to Westminster Abbey in '06.

LUCK OF THE ENGLISH
The duchess celebrated St. Patrick's Day in high style.

HEAD CASES

1. Princess Anne's daughter Zara Phillips wore a fedora-inspired number to Ladies' Day at Royal Ascot in 2002.

2. Princess Beatrice wore a vivid blue topper to church in 2003.

3. Sophie Countess of Wessex wore an Easter top hat in 2000.

4. For the wedding of her mother and Prince Charles, Laura Parker Bowles wore a gilded design.

5. Princess Máxima of the Netherlands chose a broad-brimmed hat for a 2004 royal wedding in Spain.

6. Fergie's daughter Princess Eugenie went green for Ladies' Day at Royal Ascot in 2009.

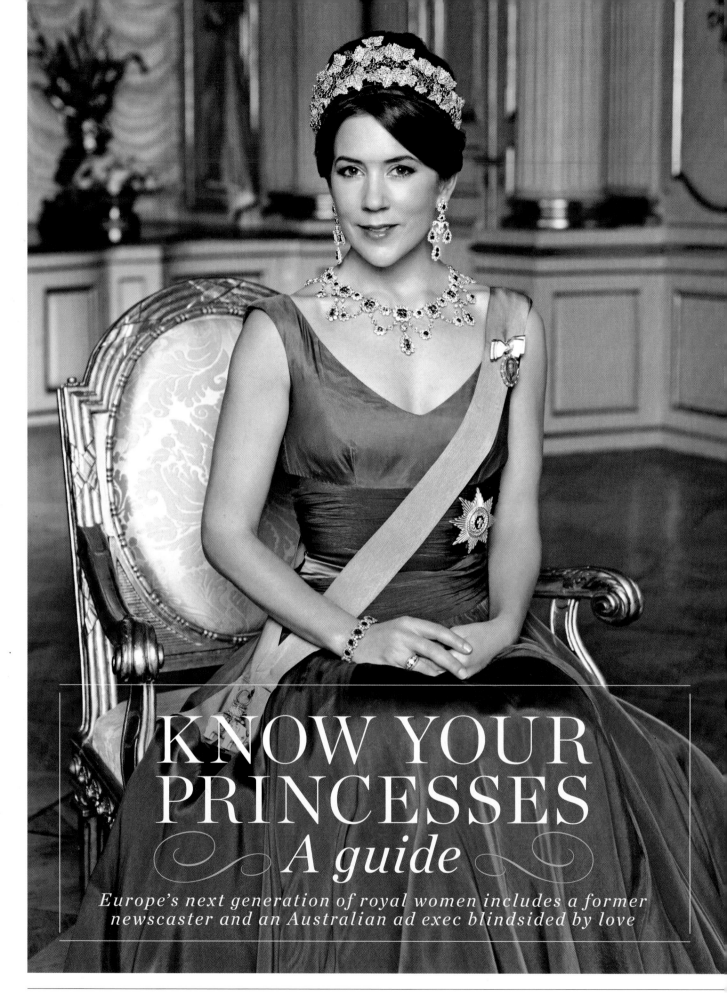

KNOW YOUR PRINCESSES
A guide

Europe's next generation of royal women includes a former
newscaster and an Australian ad exec blindsided by love

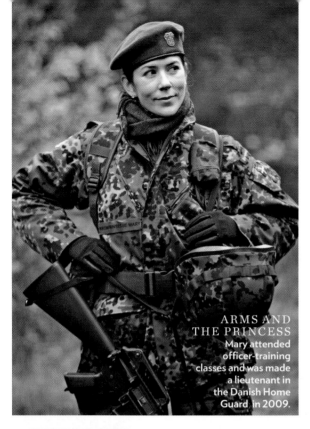

ARMS AND
THE PRINCESS
Mary attended
officer-training
classes and was made
a lieutenant in
the Danish Home
Guard in 2009.

STAMP OF APPROVAL
Shortly after the birth of Prince
Christian, Greenland—part of
the Kingdom of Denmark—put
the royal family on its postage.

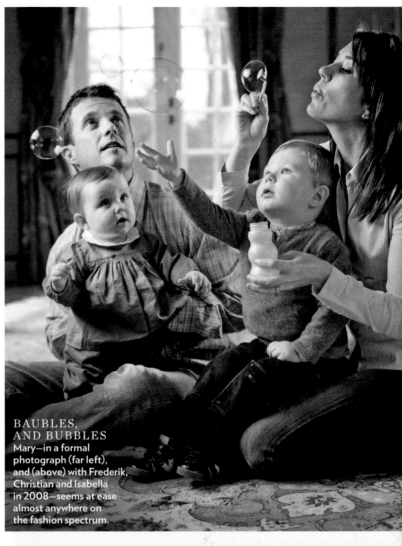

BAUBLES,
AND BUBBLES
Mary—in a formal
photograph (far left),
and (above) with Frederik,
Christian and Isabella
in 2008—seems at ease
almost anywhere on
the fashion spectrum.

CROWN PRINCESS
MARY
DENMARK

Growing up in Hobart, Tasmania, Mary Donaldson probably did not dream of becoming the Crown Princess of Denmark. Instead she focused on a career in advertising and followed a rapid but straightforward trajectory—until the summer of 2000. At the Sydney Olympics, Donaldson, then 28, met a visiting dignitary, Crown Prince Frederik of Denmark, 32. Long-distance phone calls and surreptitious international visits ensued; a year later Donaldson moved to Paris. The next year she moved to Denmark; the next year the couple were engaged; the next year they married. A year later their first child, Prince Christian, arrived; their second, Princess Isabella, was born in 2007.

HONEY, YOU LOOK
TERRIFIC
Putting on the royal ritz, Mary
and Frederik attended the
annual New Year's reception at
his family's winter residence,
Amalienborg palace, in 2010.

CROWN PRINCESS
MAXIMA
THE NETHERLANDS

Buenos Aires–born Máxima Zorreguieta was an investment banker when she met Prince Willem-Alexander at a Spanish festival in 1999. They quickly fell in love, but there was an impediment to marriage: Her father, Jorge, had been a high government official in Argentina during its oppressive military regime, and many Dutch were uncomfortable with the possible connection with the royal family. Eventually the Dutch parliament granted permission for the marriage (and Jorge voluntarily did not attend the wedding).

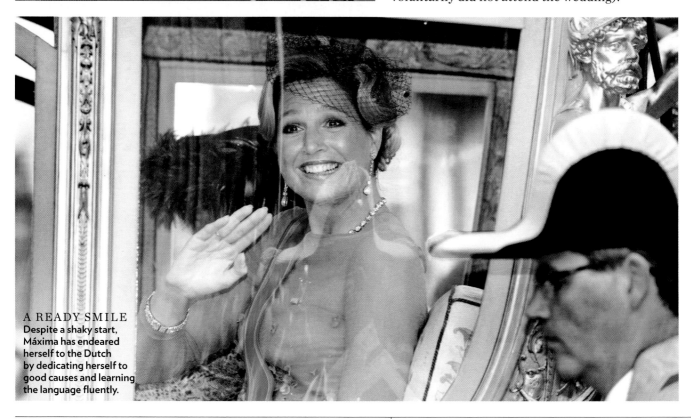

A READY SMILE
Despite a shaky start, Máxima has endeared herself to the Dutch by dedicating herself to good causes and learning the language fluently.

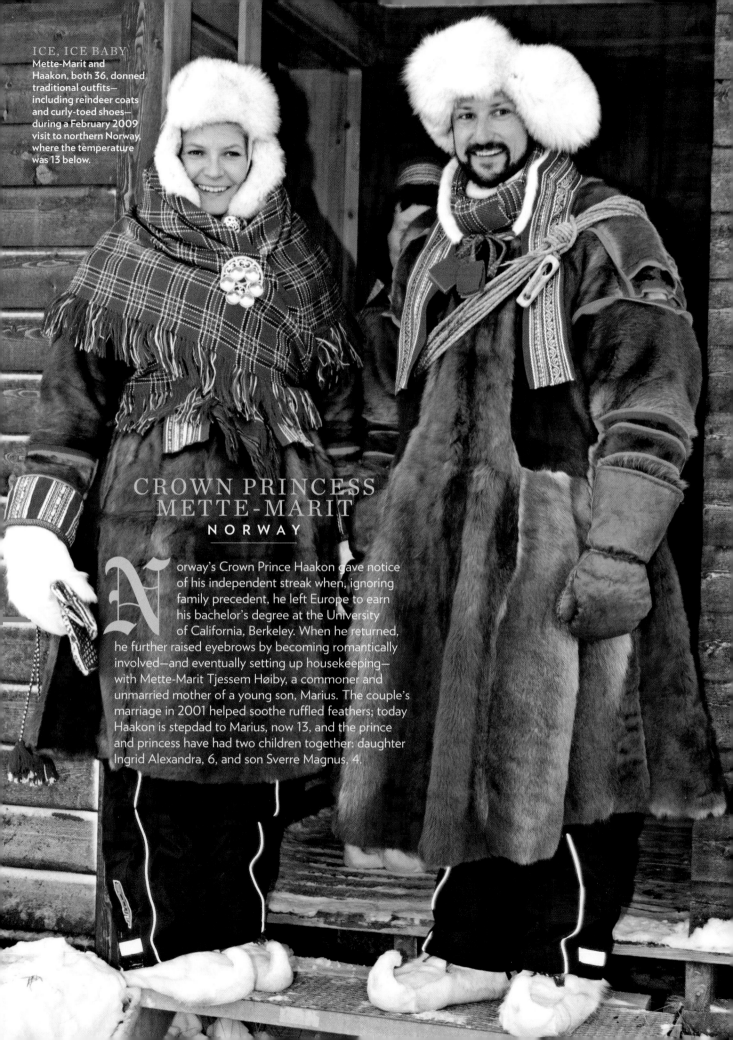

CROWN PRINCESS
METTE-MARIT
NORWAY

Norway's Crown Prince Haakon gave notice of his independent streak when, ignoring family precedent, he left Europe to earn his bachelor's degree at the University of California, Berkeley. When he returned, he further raised eyebrows by becoming romantically involved—and eventually setting up housekeeping—with Mette-Marit Tjessem Høiby, a commoner and unmarried mother of a young son, Marius. The couple's marriage in 2001 helped soothe ruffled feathers; today Haakon is stepdad to Marius, now 13, and the prince and princess have had two children together: daughter Ingrid Alexandra, 6, and son Sverre Magnus, 4.

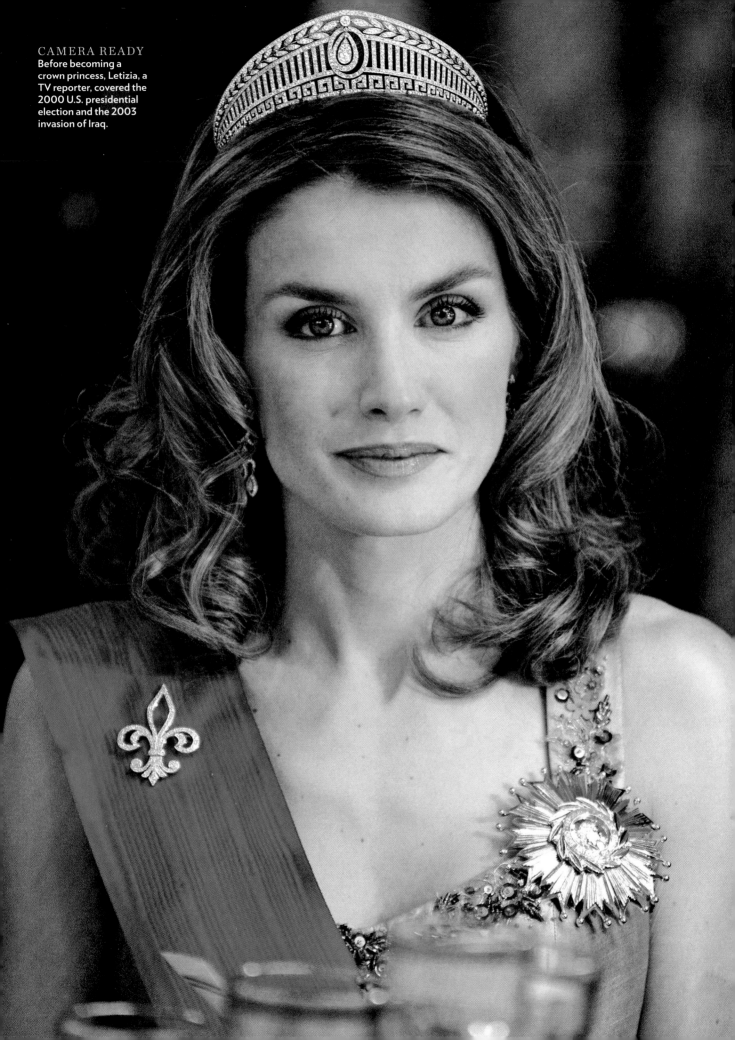

CROWN PRINCESS
LETIZIA
SPAIN

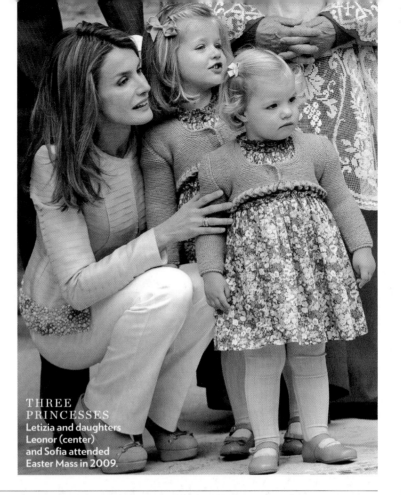

He was a playboy whose globe-trotting past included romances with a German baroness and a Norwegian model; she was a TV journalist, the daughter of a newspaperman and a nurse. She was also divorced. But when Spain's Crown Prince Felipe, now 42, met Letizia Ortiz, 37, in 2002, modern romance trumped tradition. "How in love I am with Letizia!" he told PEOPLE before their 2004 wedding; she called him "an exceptional human being." The elegant, elaborate ceremony captivated Spain. "It's like a fairy tale," said a fellow journalist. "Not because she is marrying a prince, but because she is marrying a man she loves."

THREE PRINCESSES
Letizia and daughters Leonor (center) and Sofia attended Easter Mass in 2009.

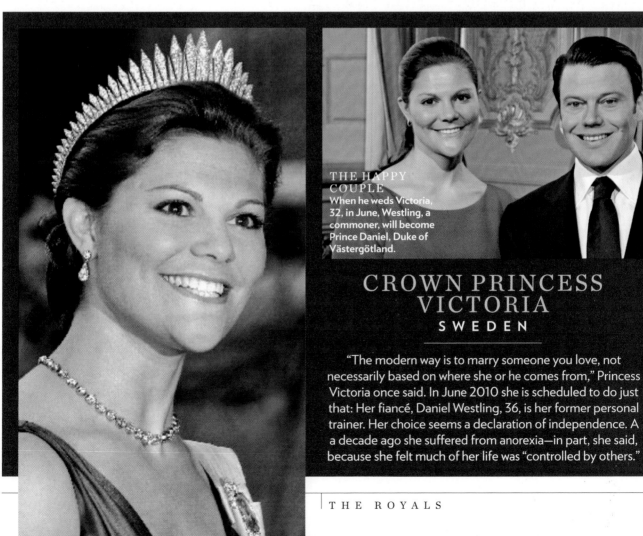

THE HAPPY COUPLE
When he weds Victoria, 32, in June, Westling, a commoner, will become Prince Daniel, Duke of Västergötland.

CROWN PRINCESS
VICTORIA
SWEDEN

"The modern way is to marry someone you love, not necessarily based on where she or he comes from," Princess Victoria once said. In June 2010 she is scheduled to do just that: Her fiancé, Daniel Westling, 36, is her former personal trainer. Her choice seems a declaration of independence. A a decade ago she suffered from anorexia—in part, she said, because she felt much of her life was "controlled by others."

JEWELS

Shimmering tiaras, medieval crowns, dazzling gems hundreds of years old: The priceless treasures of the world's monarchies are as fabled as the dynasties that have possessed them. This unique store, passed down through generations, reveals an extraordinary history told by a sparkling array of precious stones

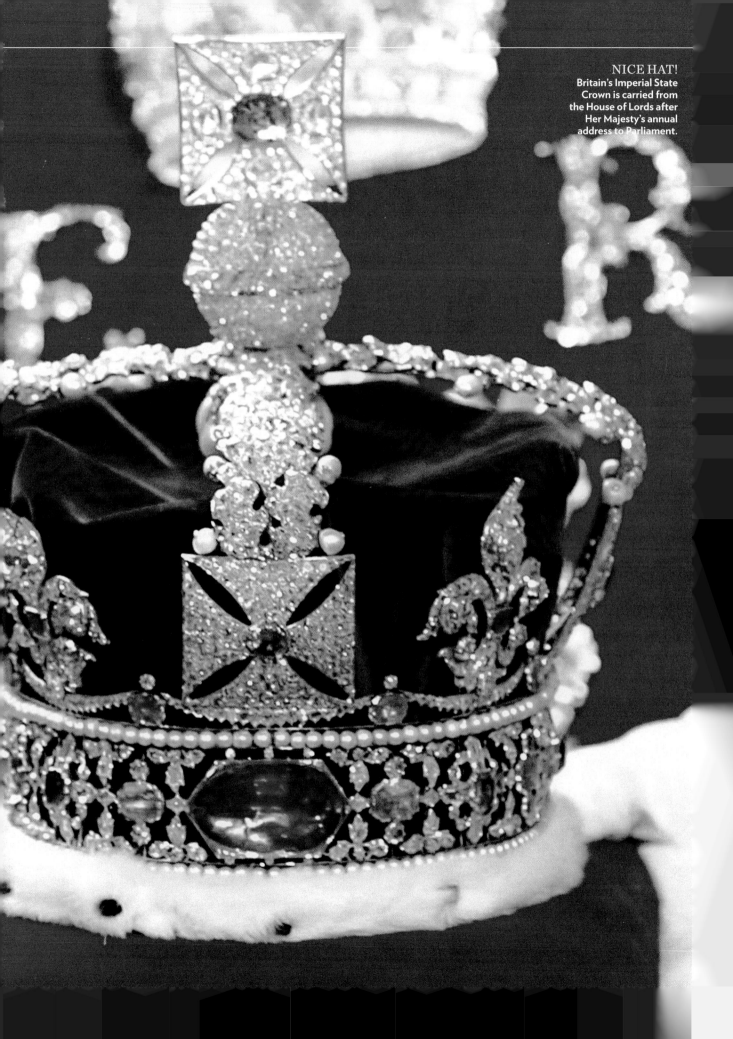

All the QUEEN'S CROWNS

What becomes Her Majesty most? The gleaming collection of royal diadems that have adorned the head of Elizabeth II since childhood

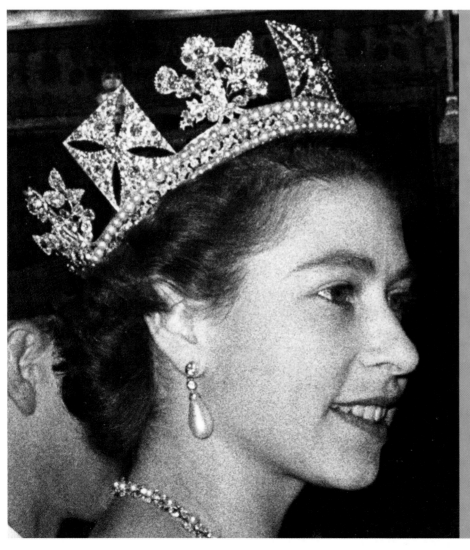

THE GEORGE IV DIADEM

Pictured on British postage stamps, the delicate crown is a royal symbol commoners can literally get their hands on. More than 169 pearls and 1,333 diamonds in the shape of crosses and the national floral emblems of roses, thistles and shamrocks make it a national treasure. Dating back to 1820, a time when critics deemed it too effeminate for George IV, the crown was first worn by Queen Victoria, who attended almost every formal occasion in the diamond headpiece. The present Queen (left, in 1952) is not as attached to the bauble, though she does wear the diadem to the House of Lords for the opening of Parliament each November. That appearance—plus the daily mail—ensure more people see the George IV diadem than any other item of royal jewelry.

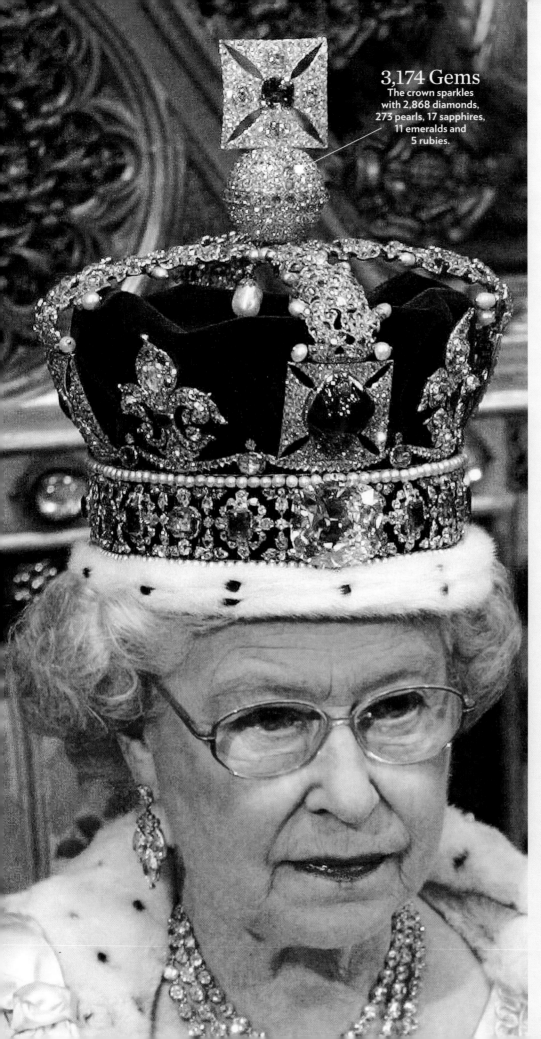

3,174 Gems
The crown sparkles with 2,868 diamonds, 273 pearls, 17 sapphires, 11 emeralds and 5 rubies.

THE IMPERIAL STATE CROWN

In a collection of jewels full of superlatives, Britain's Imperial State Crown may outdo them all. The gold frame holds some 3,000 gems set in silver. Front and center lies the 317.4-carat Cullinan II diamond, second in size only to the Cullinan I diamond, another stunner, found in the royal scepter. Named for the African mine in which they were discovered in 1905, the 11 major Cullinan stones and hundreds of fragments were cut from the largest gem-quality diamond ever found. Just above the spectacular Cullinan II sits the Black Prince's Ruby, which has belonged to the monarchy since it was given to its namesake Edward of Woodstock in 1367. But the most storied of all the stones, the St. Edward's Sapphire, takes its place atop the cross. Historians believe the shimmering gem once adorned the 1043 coronation ring of Edward the Confessor. In spite of their splendor, these awe-inspiring jewels appear just once a year, when Her Majesty opens Parliament (left).

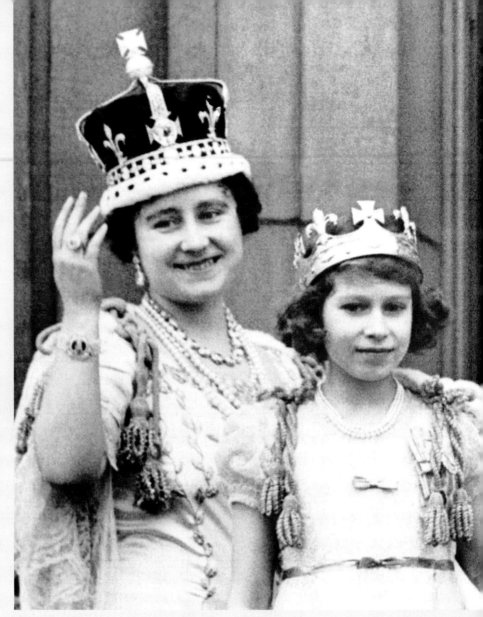

THE MOTHER & DAUGHTER CROWNS

An 11-year-old Princess Elizabeth would have to wait more than a decade to officially take her place on the throne, but the gilded trappings of the monarchy came her way as soon as her father, King George VI, and his wife, Queen Elizabeth, were crowned. Just like her parents, Lilibet received a gleaming headpiece of her own for their May 1937 coronation. At the moment her mother was made Queen, she and her sister Margaret donned miniature medieval-looking circlets. Though the girls' grandmother Queen Mary would later write in her journal that the two "looked too sweet . . . especially when they put on their coronets," the silk-lined, silver-gilt trinket (below left), fashioned by the royal family's jeweler Garrard & Co., accentuated Elizabeth's already regal air. The youngster greeted the British public from the balcony of Buckingham Palace alongside her mother, who wore a spectacular platinum crown specially made for the ceremony. The Queen Mum would have many occasions to wear her coronet through the years, though none more special than when she again watched her daughter Elizabeth become Queen 16 years later.

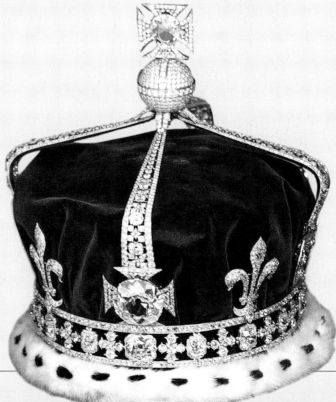

The crown of Queen Elizabeth, the Queen Mother, shimmers with precious stones and contains the Koh-i-Noor, once the world's largest cut diamond. Set in the center of the headpiece, the 105.6-carat gem, whose name means Mountain of Light in Persian, was thought to bring bad luck to men who possessed it. Not so for women like the hearty Queen Mum, who died at age 101. The gem shone brightly in the crown atop her casket after her death in 2002 (left).

THE ST. EDWARD'S CROWN

On June 2, 1953, before 8,251 guests and dignitaries from 129 nations seated in Westminster Abbey, the Archbishop of Canterbury uttered words first spoken in 973: "God crown you with a crown of glory and righteousness . . ." With that, he placed a diadem first used in 1661 by Charles II on the head of 27-year-old Elizabeth, formally installing her as head of the British Commonwealth 16 months after the death of her father. Though certainly not the most valuable of crown jewels (which include the George IV Diadem and the Imperial State Crown), the St. Edward's, as the coronation crown, eclipses all others in importance. Named for a famed Anglo-Saxon monarch and dotted with 444 precious stones, the nearly 5-lb. behemoth is so unwieldy that Queen Elizabeth practiced wearing it around Buckingham Palace for several weeks before the day of the ceremony. Officially, however, Her Majesty wore the crown for just three hours, the length of her investiture, and exchanged the heavy headpiece for the Imperial Crown to return to Buckingham Palace. The St. Edward's, meanwhile, retook its place in the Tower of London, where it lies in wait until the next sovereign is crowned.

Coronation Classic

Made of gold and ringed by two rows of gold beads, the St. Edward's Crown boasts 16 diamond rosettes, amethysts, pink and green tourmalines, white and yellow topazes and aquamarines.

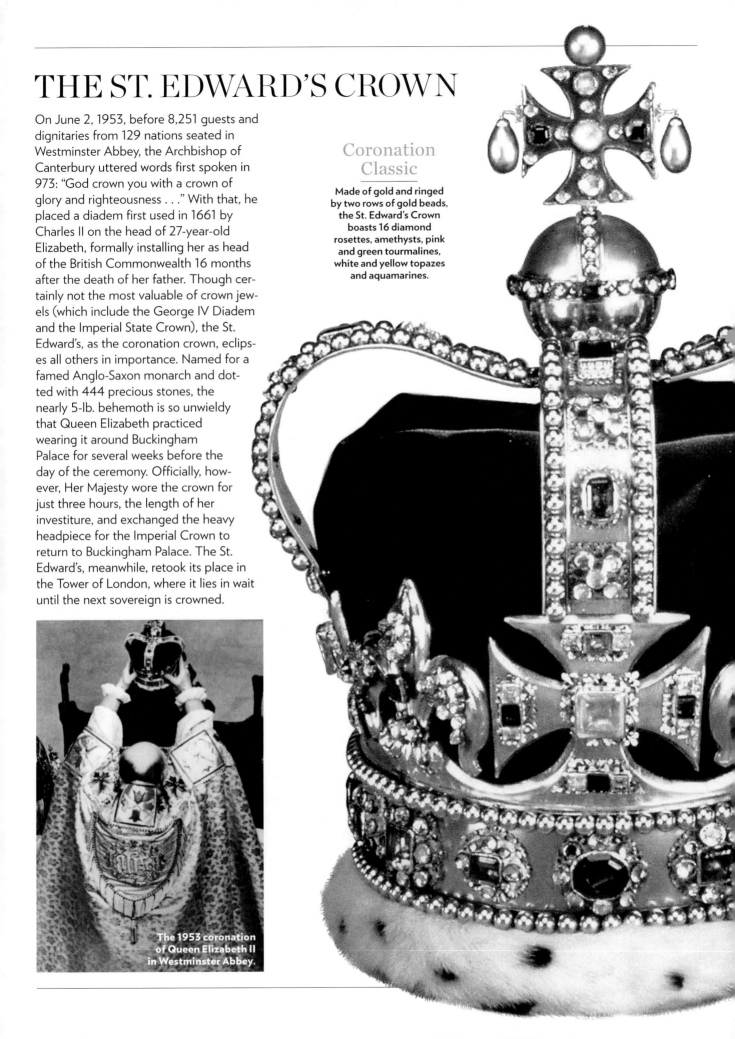

The 1953 coronation of Queen Elizabeth II in Westminster Abbey.

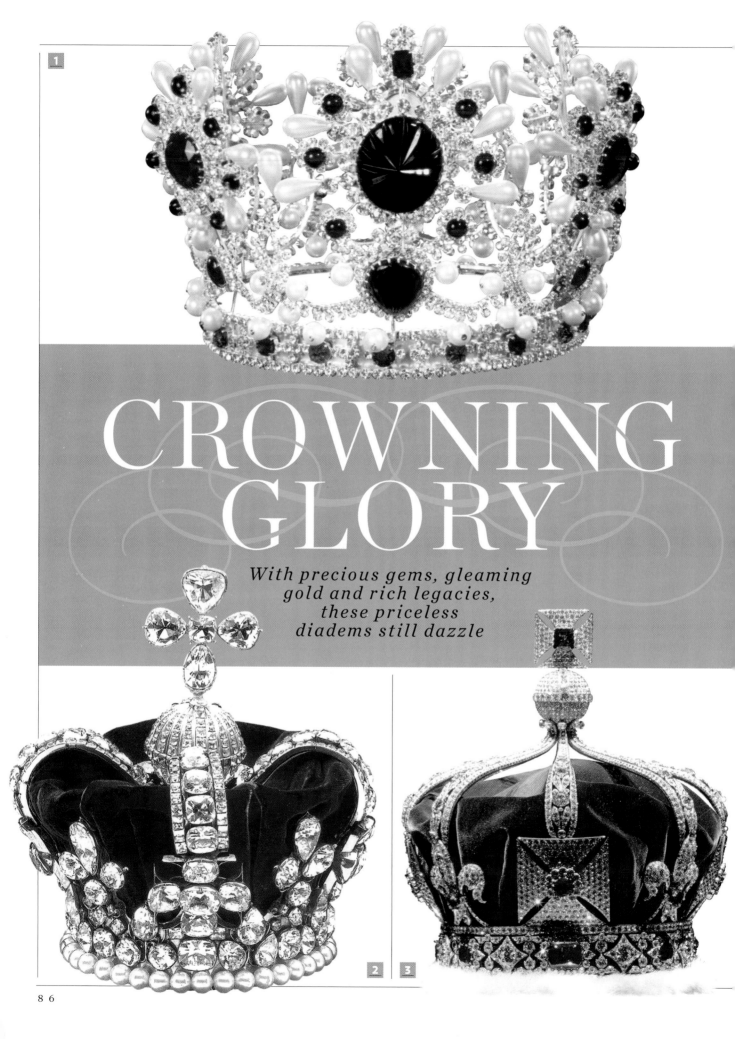

CROWNING GLORY

With precious gems, gleaming gold and rich legacies, these priceless diadems still dazzle

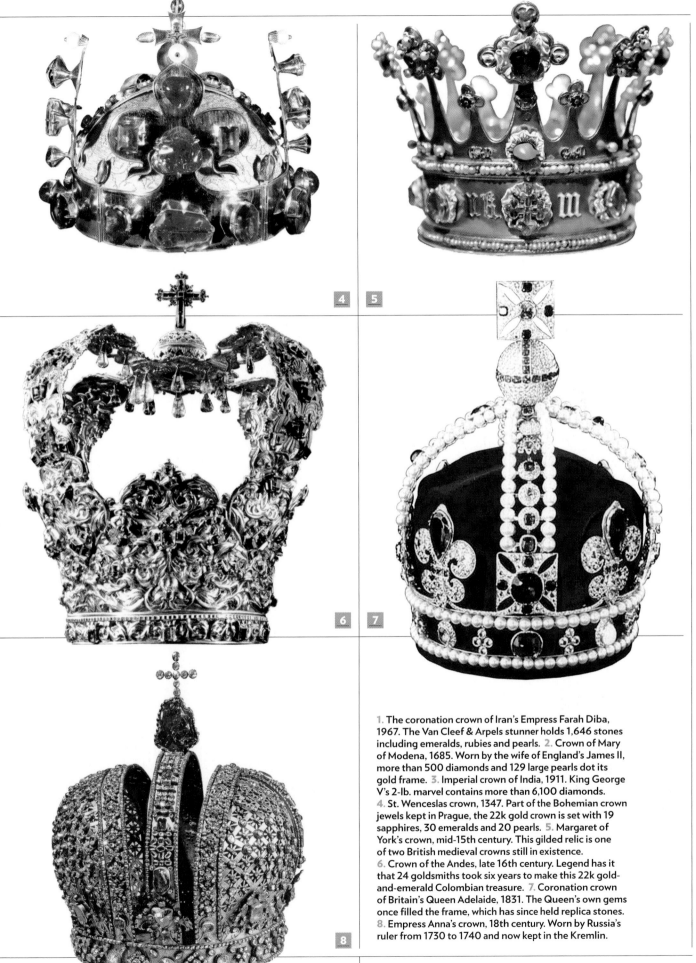

1. The coronation crown of Iran's Empress Farah Diba, 1967. The Van Cleef & Arpels stunner holds 1,646 stones including emeralds, rubies and pearls. 2. Crown of Mary of Modena, 1685. Worn by the wife of England's James II, more than 500 diamonds and 129 large pearls dot its gold frame. 3. Imperial crown of India, 1911. King George V's 2-lb. marvel contains more than 6,100 diamonds. 4. St. Wenceslas crown, 1347. Part of the Bohemian crown jewels kept in Prague, the 22k gold crown is set with 19 sapphires, 30 emeralds and 20 pearls. 5. Margaret of York's crown, mid-15th century. This gilded relic is one of two British medieval crowns still in existence. 6. Crown of the Andes, late 16th century. Legend has it that 24 goldsmiths took six years to make this 22k gold-and-emerald Colombian treasure. 7. Coronation crown of Britain's Queen Adelaide, 1831. The Queen's own gems once filled the frame, which has since held replica stones. 8. Empress Anna's crown, 18th century. Worn by Russia's ruler from 1730 to 1740 and now kept in the Kremlin.

A *Timeless* TREASURE

Forever linked to Princess Diana, the Cambridge Lover's Knot tiara carries the legacy of royal women from ages past

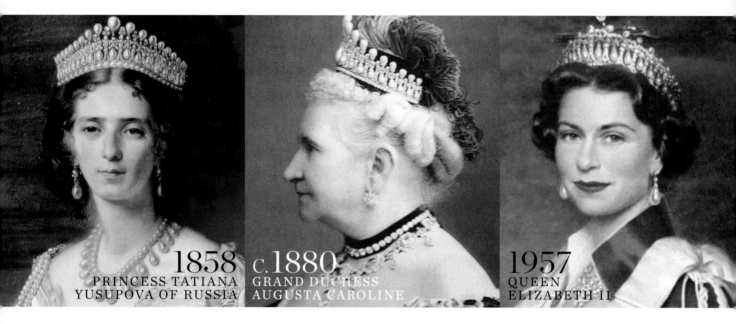

1858
PRINCESS TATIANA
YUSUPOVA OF RUSSIA

c.1880
GRAND DUCHESS
AUGUSTA CAROLINE

1957
QUEEN
ELIZABETH II

hen Britain's Queen Mary wanted to design a new tiara in 1914, she found inspiration close to home. Modeling her jewels after tiaras worn by the Romanov Princess Tatiana and Mary's aunt the Grand Duchess Augusta, Mary had 19 diamond arches with drop pearls set on a diamond band. Her creation, called the Lover's Knot—made with gems she'd received as wedding gifts—was a standout in her collection, now owned by Queen Elizabeth II. But only when it rested on the head of Princess Diana, who received the diadem as a wedding present, was the tiara's power to enchant truly felt.

1983
PRINCESS DIANA

The day before Diana married Prince Charles, her future mother-in-law handed her a red leather box. Inside lay the storied Lover's Knot tiara, once worn by the Queen's grandmother Mary and passed down through three royal generations. But that morning Diana's mind wasn't on the jewelry's legacy. Using a nickname given to the Queen by the British press, she was said to have shouted with glee, "I have Brenda's rocks!"

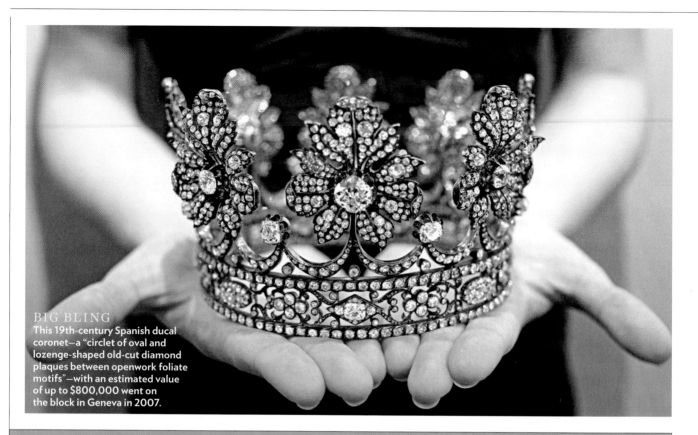

BIG BLING
This 19th-century Spanish ducal coronet—a "circlet of oval and lozenge-shaped old-cut diamond plaques between openwork foliate motifs"—with an estimated value of up to $800,000 went on the block in Geneva in 2007.

Royal
BIDDING

You'll probably never have Queen Victoria's title, but, at auction, you could have bought her socks

ROXBURGHE ROCKS
The Roxburghe Rubies—eye-catching ruby-and-diamond earrings and a necklace that once belonged to Britain's Mary Duchess of Roxburghe—could have been yours for a mere shake of the paddle (and $5,769,309) in 2009.

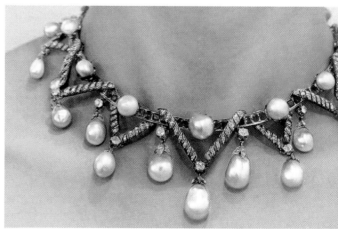

A "MAD" KING'S TIMEPIECE

Offered for sale in Geneva in 2007. Bavarian monarch Ludwig II's eccentric passions—for the most part, he dedicated his life to Wagnerian opera and building fairy-tale castles—caused his ministers to have him declared insane. He drowned in mysterious circumstances while in custody.

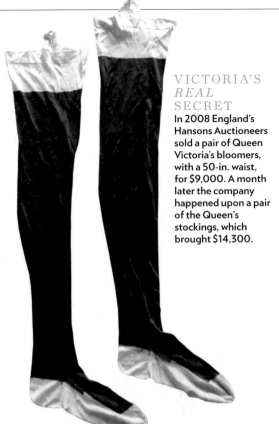

VICTORIA'S *REAL* SECRET

In 2008 England's Hansons Auctioneers sold a pair of Queen Victoria's bloomers, with a 50-in. waist, for $9,000. A month later the company happened upon a pair of the Queen's stockings, which brought $14,300.

LET'S GET MEDIEVAL

In what amounted to a royal tag sale, Sotheby's sold off 20,000 items—from delicate porcelain vases to a pair of 18th-century silver kettledrums decorated with ivory—belonging to Germany's royal house of Hanover in 2005. You could have found your knight in shining armor—or at least the suit—for $332,000.

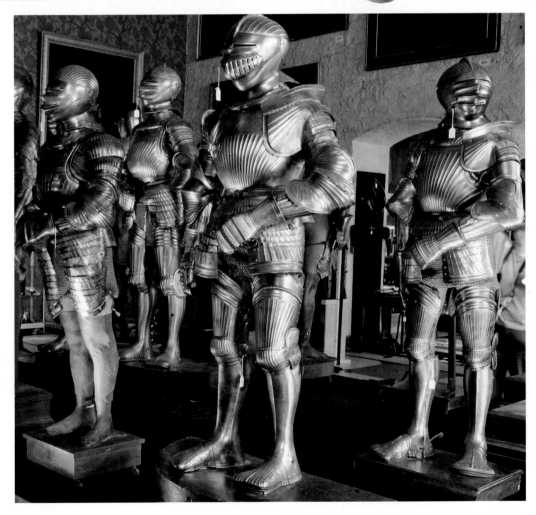

PEARLS WITH A PAST

Identified only as the the "property of a nobleman" at a London auction in 2007, this necklace was expected to fetch up to $800,000, but it failed to sell. The pearls once belonged to Marie Antoinette and thus may have adorned one of the most famous necks in history.

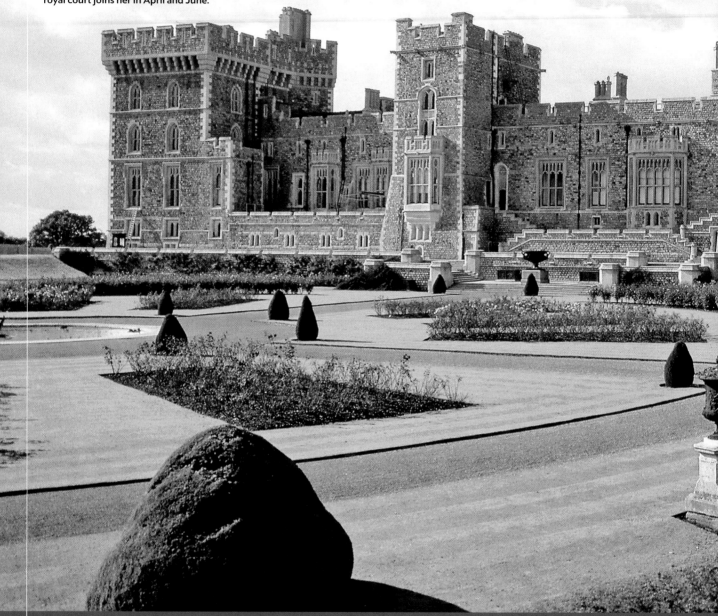

Begun in the 1070s on a rise overlooking the Thames, Windsor sprawls over nearly 13 acres and is the world's largest castle still serving as a royal residence. Queen Elizabeth often weekends there, and the entire royal court joins her in April and June.

BEHIND PALACE WALLS

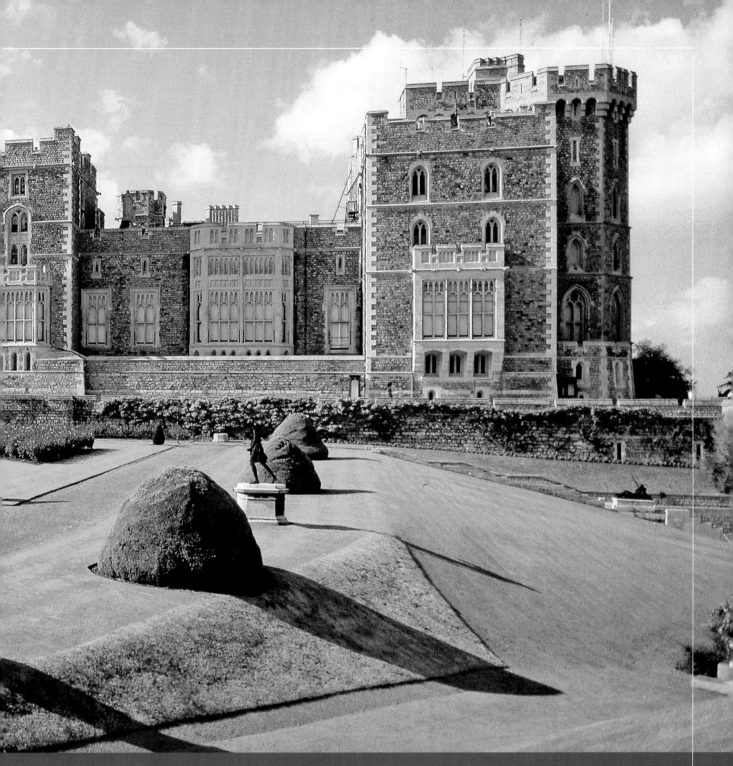

Every king needs a castle, but it's the Queen of England's three royal residences—Windsor, Balmoral and Buckingham Palace—that set the romantic standard for old-world, crenellated majesty

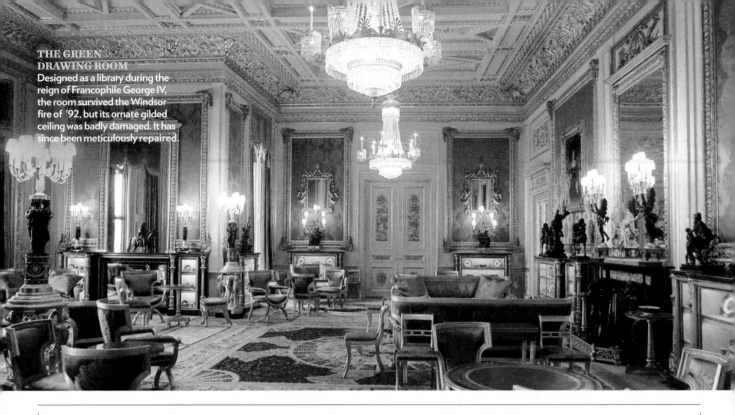

Inside WINDSOR

The Queen's weekend place has all mod cons, plus 650 rooms, eight thrones and a kitchen that's been cooking since the 11th century

At 900 years and counting, Queen Elizabeth's castle in the Berkshire countryside has seen royal wedding receptions (Prince Charles and Camilla Parker Bowles), burials (the Queen Mum) and parties of note: When Prince William turned 21, an intruder crashed his Africa-themed bash wearing a peach ball gown and a fake beard. Built by William the Conqueror and frequently renovated, the 650-room residence boasts a dungeon *and* an indoor swimming pool. Seized by Oliver Cromwell during the British Civil War, Windsor suffered another blow in 1992 when a spotlight ignited a curtain in the private chapel, sparking a blaze that caused $53 million in damage. Now immaculately restored, the refuge where Princesses Elizabeth and Margaret were sent for safety during World War II remains Her Majesty's favorite retreat.

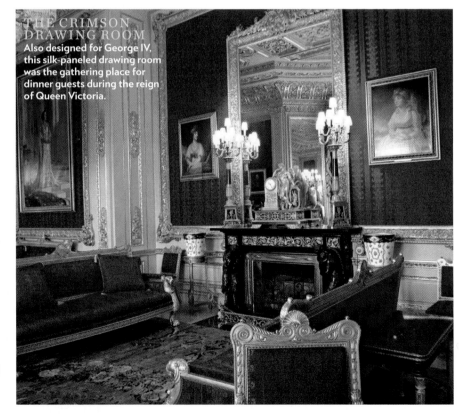

THE CRIMSON DRAWING ROOM
Also designed for George IV, this silk-paneled drawing room was the gathering place for dinner guests during the reign of Queen Victoria.

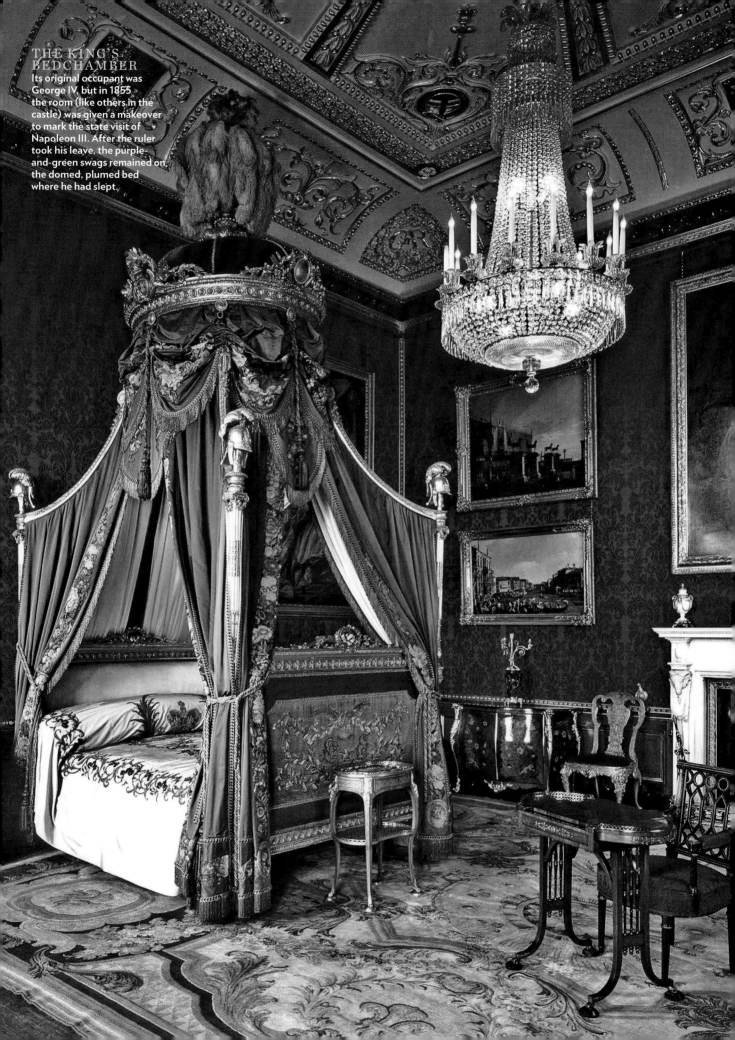

THE KING'S BEDCHAMBER

Its original occupant was George IV, but in 1855 the room (like others in the castle) was given a makeover to mark the state visit of Napoleon III. After the ruler took his leave, the purple-and-green swags remained on the domed, plumed bed where he had slept.

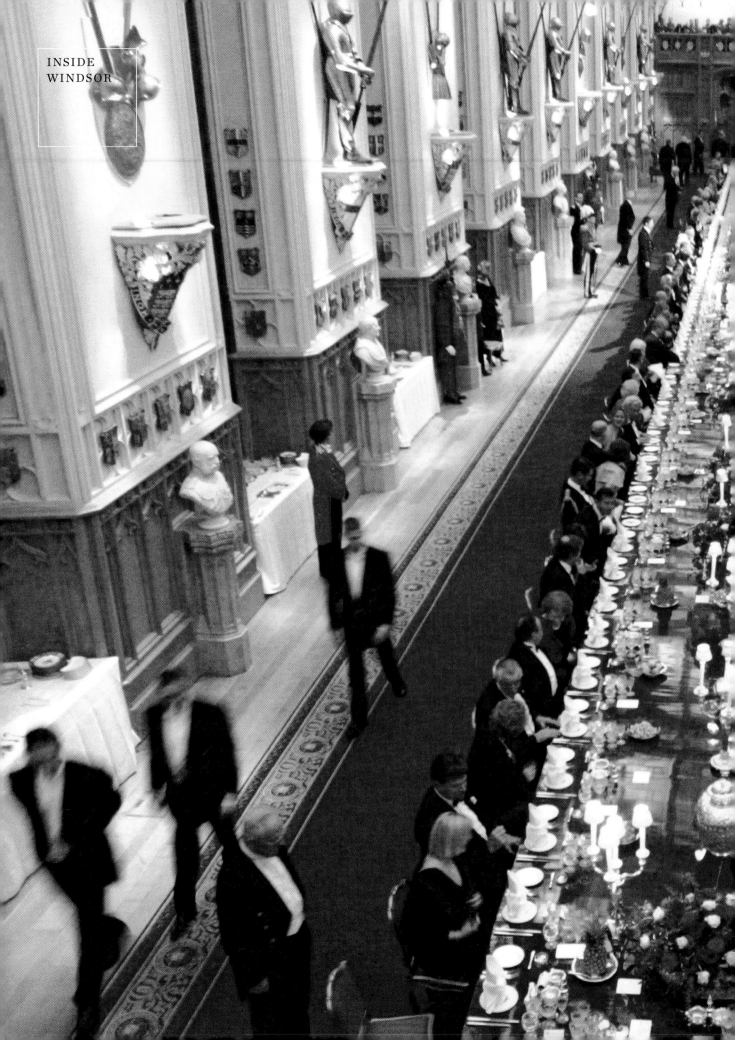

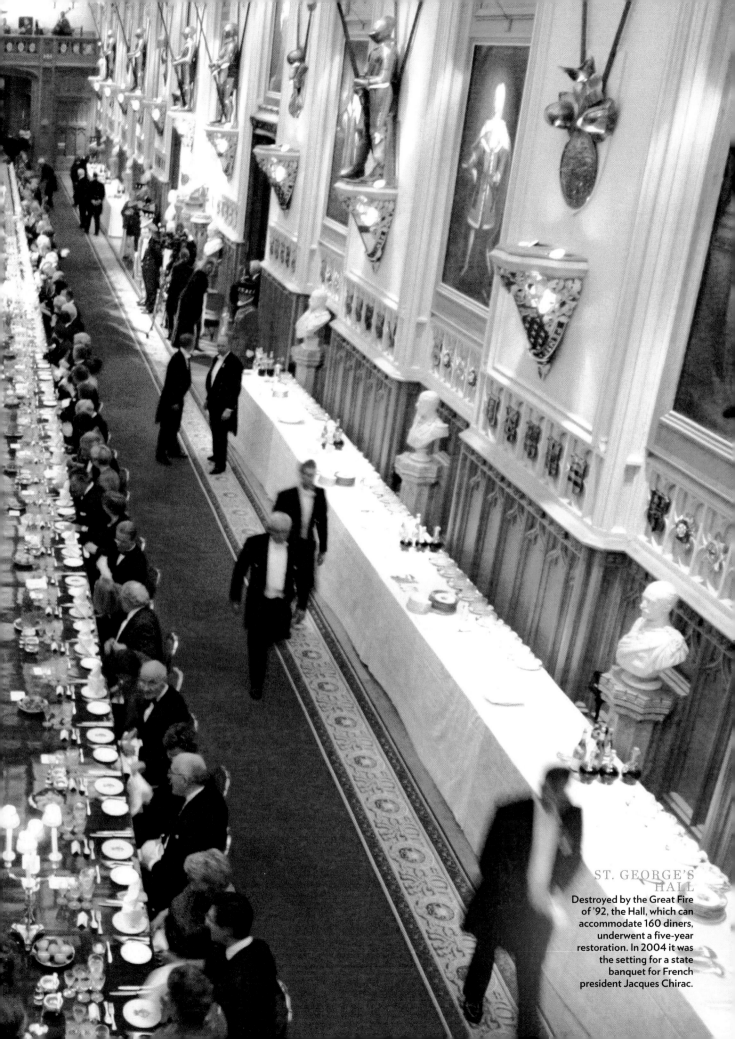

ST. GEORGE'S
HALL
Destroyed by the Great Fire
of '92, the Hall, which can
accommodate 160 diners,
underwent a five-year
restoration. In 2004 it was
the setting for a state
banquet for French
president Jacques Chirac.

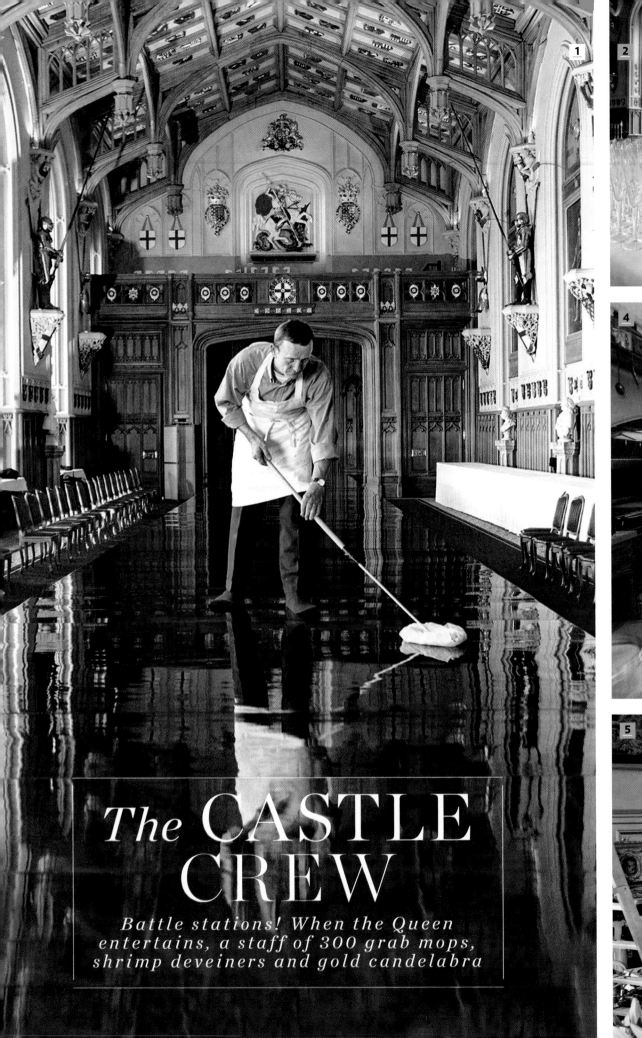

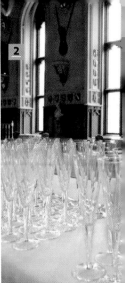

The CASTLE CREW

Battle stations! When the Queen entertains, a staff of 300 grab mops, shrimp deveiners and gold candelabra

THE ROYAL TREATMENT

Six months of planning goes into state occasions at Windsor, and household staff are tasked with pulling it off just right. Footmen and underbutlers greet and serve guests, housekeepers unpack and repack their suitcases, and castle "fendersmiths" stoke glowing fireplaces. Who oversees it all? The Queen, who signs off on everything, down to hand soap in the guest rooms. When Her Majesty entertains, spit and polish is all.

1. Castle craftsmen use vinegar and water to clean the Grand Table, used for banquets in St. George's Hall. How to get that gleam? Slide over every inch of the wood in socks.

2. To prepare for 140-guest banquets—which often include champagne, two different dinner wines and a dessert wine—kitchen servants must clean 816 glasses.

3. Flowers are arranged in the gilded Waterloo Chamber, built during George IV's reign.

4. Chefs begin to prep food for banquets 12 hours in advance. The menu, typically three courses, must be approved by the Queen.

5. In the Grand Reception Room, staff assembled some of the thousands of spring blossoms used for Charles and Camilla's '05 wedding.

6. Chief French polisher Eddie Mills arranges a centerpiece among shoulder-high candelabra on the Waterloo Chamber's 50-ft. table. It sits on a carpet reputed to be the largest piece of woven material in the world.

7. Setting the Grand Table requires a ruler to ensure plates, glasses and cutlery (large parties can require more than 900 pieces) are equidistant from each other and the table's edge. Servers are cued by red and green lights flashing from behind a balcony.

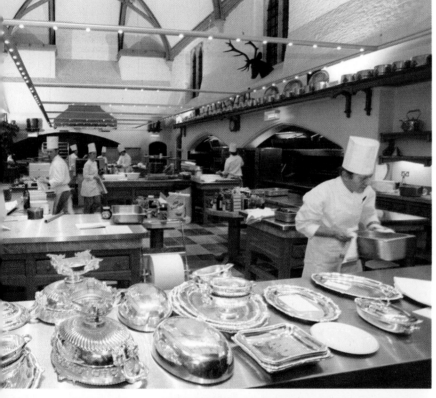

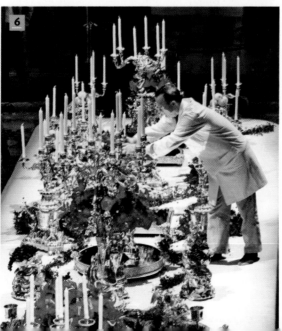

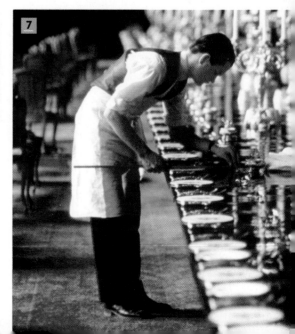

BUCKINGHAM: THE

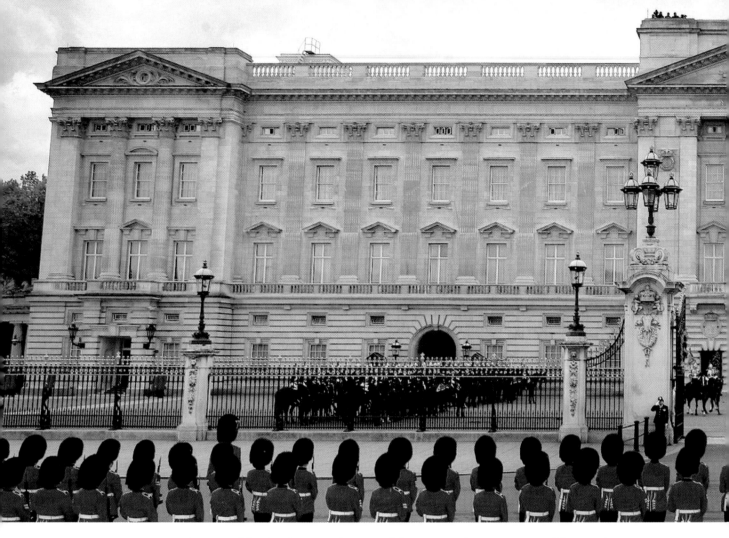

At her official London address, the Queen lives it up and gets down to business

The Duke of Edinburgh joked about "living above the shop" in Buckingham Palace. But the royal residence—furnished with paintings by Rembrandt and Vermeer, gilded ceilings and grand staircases—is a step above the typical home office.

Like every British sovereign since Queen Victoria, the Queen carries out most state duties at the 600-room royal mansion nestled between St. James's Park and Green Park. Once a townhouse built by the Duke of Buckingham in 1702, the palace was expanded to include 240 bedrooms, 78 bathrooms and 92 offices. It now hosts more than 50,000 guests a year at a battery of official receptions. The Queen typically conducts at least 20 royal investitures (the bestowing of knighthoods and other honors) annually in the Ballroom, an expansive space with a 45-ft. ceiling. Other dignitaries are received in the ornate blue-and-gold Music Room, one of 19 state rooms. More mundane tasks, such as answering the mail, are confined to the Queen's quarters in the North Wing. But life in the palace isn't all work. "I remember rollerblading in the state apartments when they used to take the carpets up, and we used to race round," recalled Prince Andrew, who, along with his siblings Prince Edward and Princess Anne, lives at the palace when he is in London. With a staff of more than 400 attending to the royal family's every need, it's no wonder the Duchess of York, Sarah Ferguson, once called Buckingham Palace "the best hotel in London."

WORKING PALACE

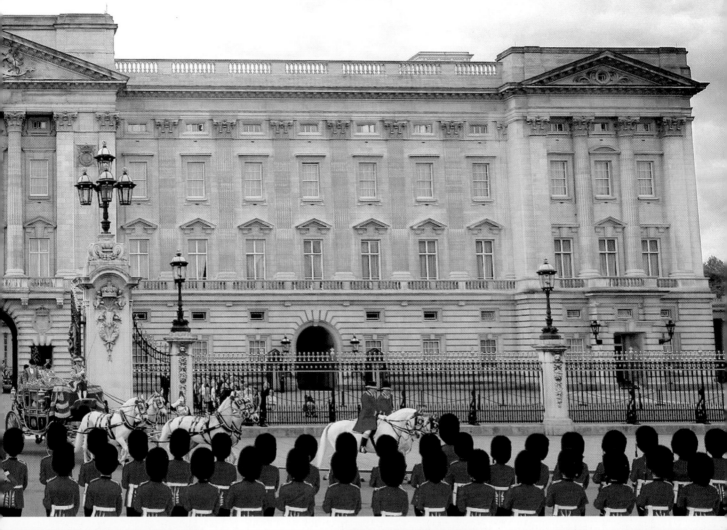

Though her son Prince Andrew admits trying to get his type-A mum to slow down, telling TIME, "There's no need to do six engagements a day," that hasn't kept Her Majesty from duties that begin at 9:30 each morning and often include meeting with world leaders and their representatives. From left: The Queen with First Lady Michelle Obama, and greeting the ambassadors of Lesotho (center) and the Kyrgyz Republic.

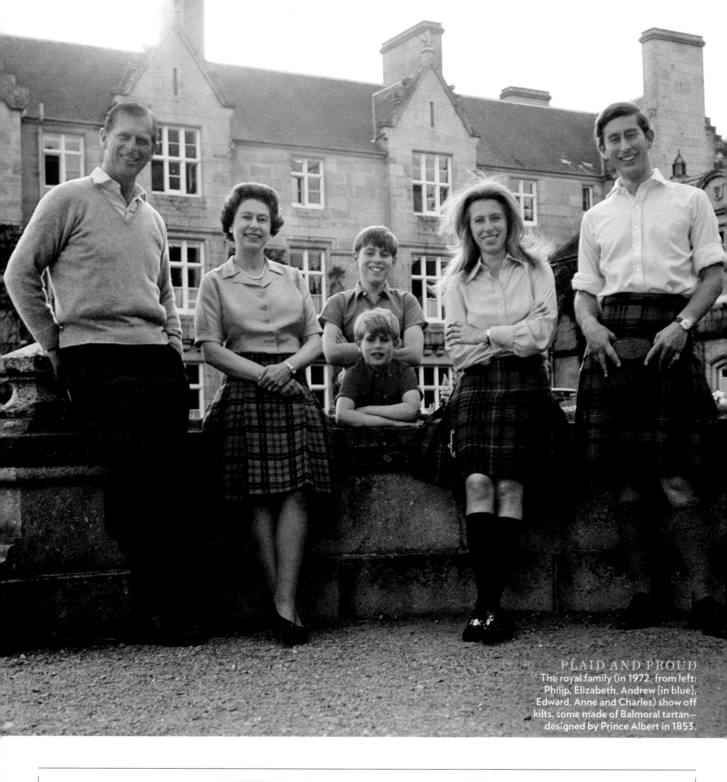

BALMORAL *A Windsor Retreat*

t was a gift from her husband, Prince Albert—though he neglected to wrap it—in 1852, and soon Queen Victoria had dubbed Balmoral, a 50,000-acre Scottish estate, "my dear paradise in the Highlands." Ever since, usually in summer, the royals have immersed themselves in local culture: donning kilts, downing kippers and waking each morning to a piper playing outside the Queen's window. Free of daily duties and the paparazzi, the royals sometimes mix with the locals: e.g., playing in cricket matches organized by Prince Edward and showing off their folk-dancing skills at an annual ball for the estate's workers. Sound like fun? You can do it too. The Queen rents out several cottages on the grounds for up to $2,250 a week.

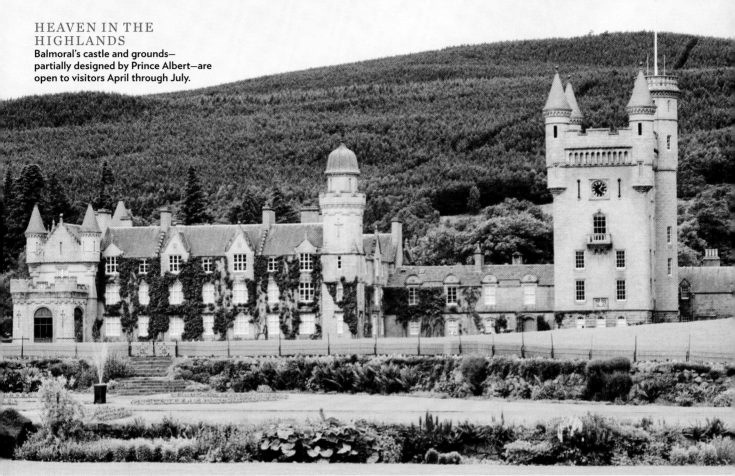

HEAVEN IN THE HIGHLANDS

Balmoral's castle and grounds—partially designed by Prince Albert—are open to visitors April through July.

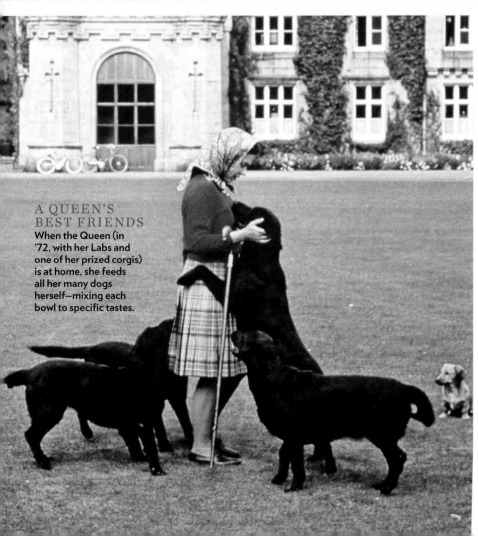

A QUEEN'S BEST FRIENDS

When the Queen (in '72, with her Labs and one of her prized corgis) is at home, she feeds all her many dogs herself—mixing each bowl to specific tastes.

HOME OF THE HIGHLAND FLING

Prince William has often spirited Kate Middleton away to Tom-na-Gaidh—a remote cozy cottage on the grounds. He's hardly the only Windsor to use Balmoral for a romantic getaway. Prince Philip proposed to the Queen at the estate in 1946, and the couple spent part of their honeymoon at Birkhall, a 12-bedroom hunting lodge on the grounds. So did Prince Charles—who called the lodge a "unique haven of coziness and character"—when he wed Camilla Duchess of Cornwall in 2005.

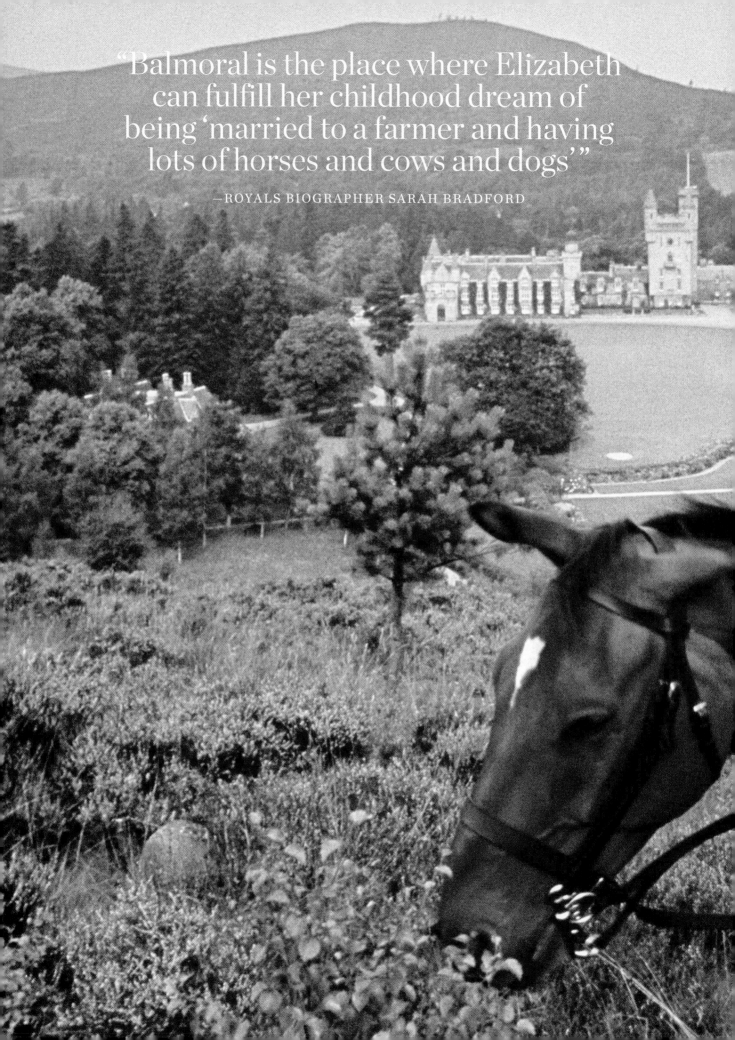

"Balmoral is the place where Elizabeth can fulfill her childhood dream of being 'married to a farmer and having lots of horses and cows and dogs'"

—ROYALS BIOGRAPHER SARAH BRADFORD

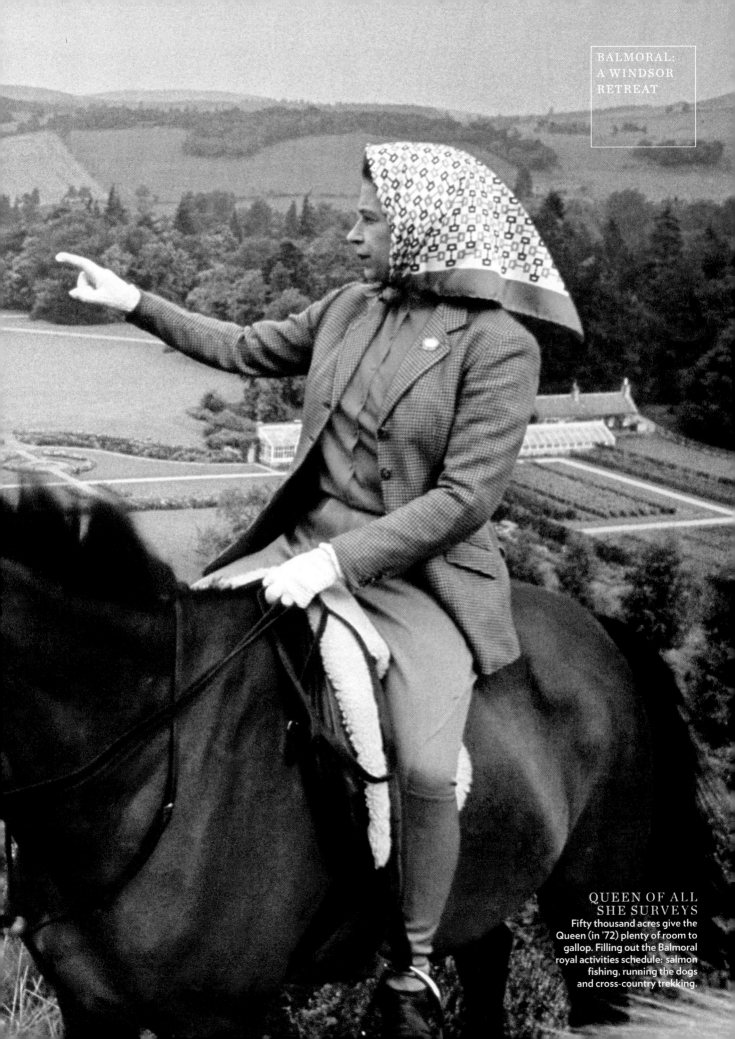

QUEEN OF ALL
SHE SURVEYS
Fifty thousand acres give the
Queen (in '72) plenty of room to
gallop. Filling out the Balmoral
royal activities schedule: salmon
fishing, running the dogs
and cross-country trekking.

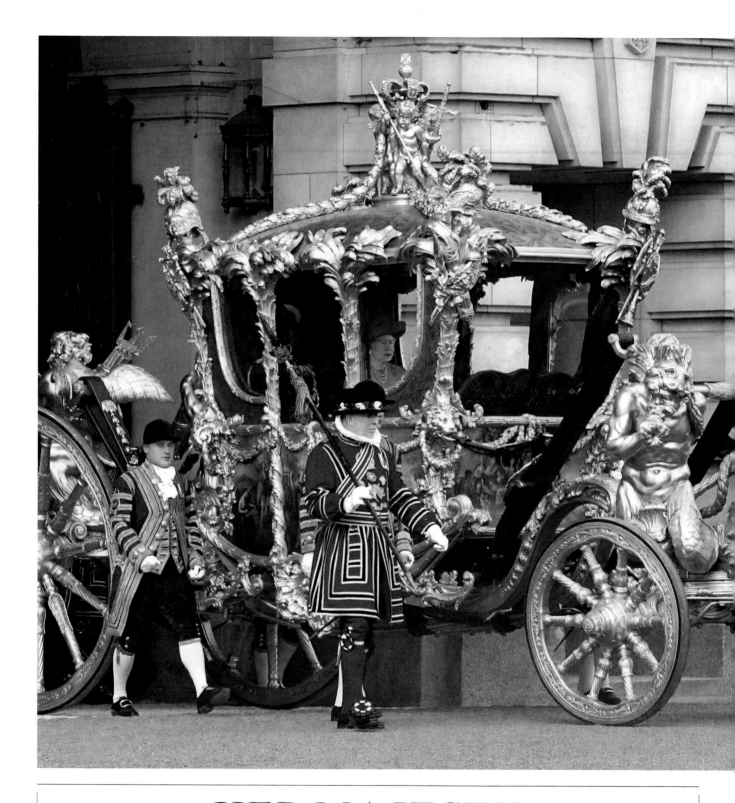

HER MAJESTY
TRAVELS
Carriages survive, but royal yachts and trains are mainly on the wane

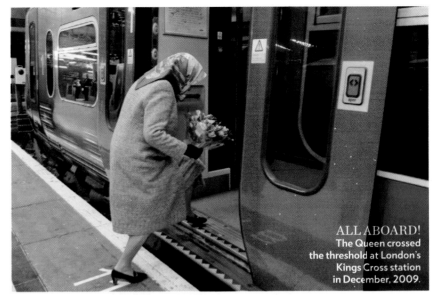

ALL ABOARD!
The Queen crossed the threshold at London's Kings Cross station in December, 2009.

BACKTRACKING
Historically, for long journeys within the U.K., the Queen has used the royal train, her palace on wheels. But the train costs more than $1.3 million a year to run, and sometimes even a Queen has to cut back. Which is why, last December, bystanders at Kings Cross Station were startled to see a familiar figure, dressed in a sensible coat and holding a bouquet, walk up the platform and board the scheduled train to King's Lynn, Norfolk. In first class, of course.

STATE CRAFT, TEMPORARILY
For her 80th birthday in 2006, the Queen chartered the *Hebridean Princess* for a Scottish cruise.

CRUISE CONTROL
For decades, when the Windsors wanted to get away from it all, they boarded *Britannia*, a 412-ft. yacht steeped in luxury and tradition (Charles and Di borrowed it for their honeymoon, though he did need to ask that a double bed—a first—be installed). But *Britannia* was retired in 1997, so nowadays, when royals want to rule the waves, they, like lesser mortals, charter.

GILT TRIP
The most elaborate of all royal coaches, the Gold State Coach, originally built for King George III in 1762, stands 12 feet tall, 24 feet long and weighs 4 tons. Covered with gold leaf and adorned with cherubs, crowns, palm trees and lion heads, the carriage is used when Queen Elizabeth requires a means of transportation unmatched in pomp and pageantry. So far, there have been only three worthy occasions: her 1953 coronation, the Silver Jubilee celebration in 1977 and, most recently, the 2002 Golden Jubilee.

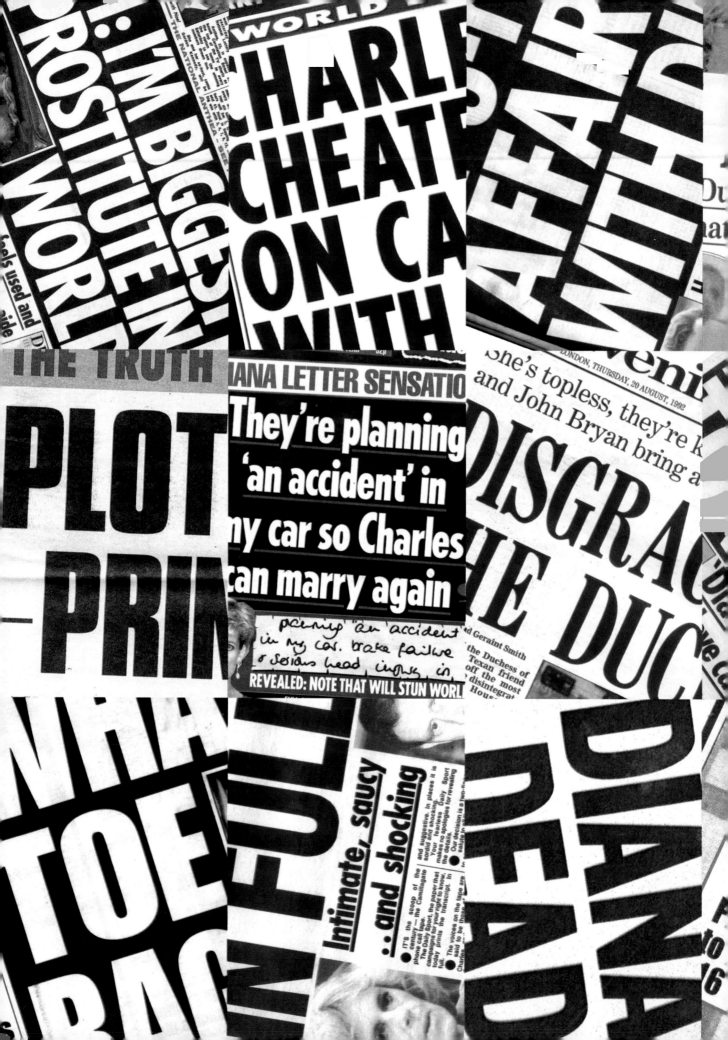

SCANDALS

Heavy lies the head that's hunted by the paparazzi: From the sordid (Fergie's toe-sucking exploits) to the tragic (Princess Grace's car crash) to nearly everything about Diana's long-running tabloid woes and shocking death, the royals have a history of falling hard and fast. And we can't look away

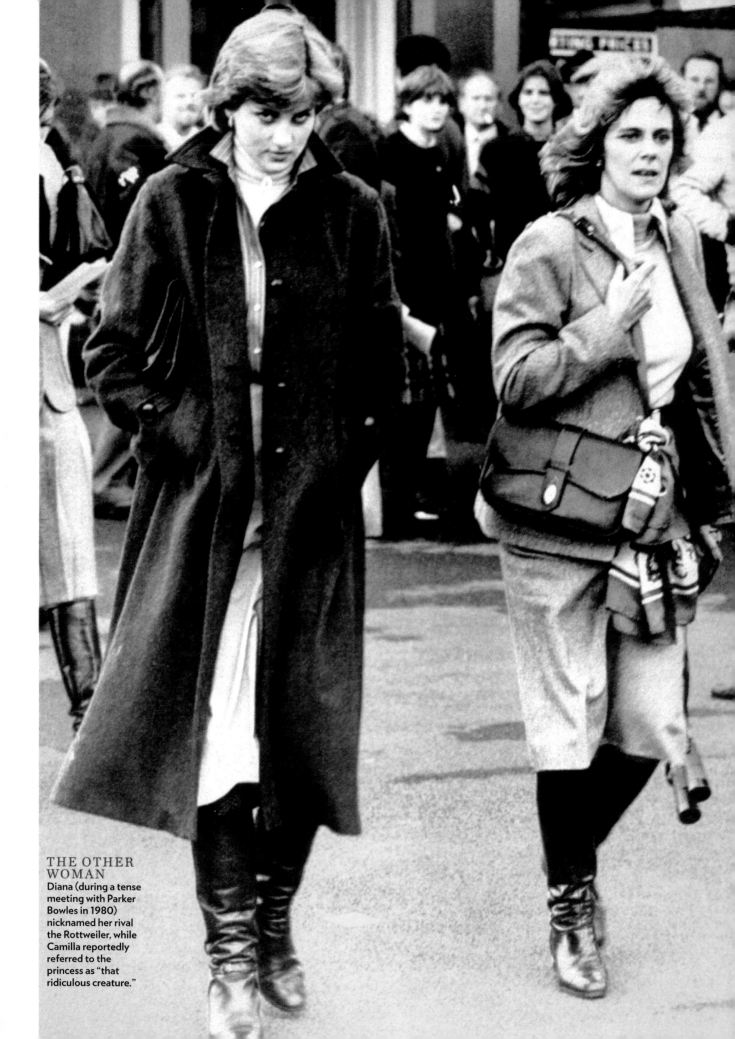

THE OTHER WOMAN
Diana (during a tense meeting with Parker Bowles in 1980) nicknamed her rival the Rottweiler, while Camilla reportedly referred to the princess as "that ridiculous creature."

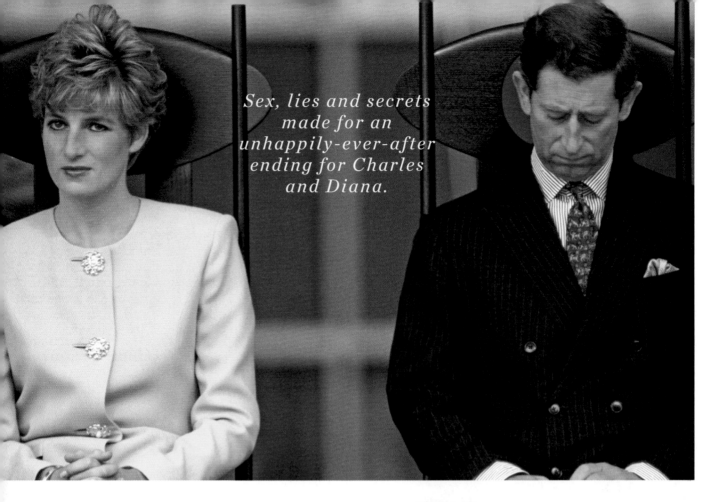

Sex, lies and secrets made for an unhappily-ever-after ending for Charles and Diana.

The WAR of the WALESES

THE MAJOR
James Hewitt (with Di and Prince William in '91) went on to write a tell-all about their affair.

By October 1991 the Prince and Princess of Wales were deeply unhappy, gazing at the world from a prison of a marriage that had begun, in the words of Diana, with "tremendous hopes in my heart." During a visit to Toronto that month, even strangers could tell that hope was gone: The Waleses' 10-year union had dissolved under the weight of betrayal. So plain was their misery, and so scandalous were the revelations of the following year—Andrew Morton's as-told-to biography about the princess, *Diana: Her True Story*, and transcripts of the pair's adulterous phone conversations among them—that Prime Minister John Major's December 1992 announcement of a royal separation was anticlimactic. But unlike celebrity couples with publicists to curb their worst impulses, Diana and Charles floated damning stories about each other even after they parted. Only Diana's death in Paris with divorced playboy Dodi Fayed brought a lasting truce.

By then the world knew the Waleses' happily-ever-after marriage had actually been an unmitigated disaster. The Windsors quickly discovered that Charles's bride was impossible to control. Diana, in turn, found she had married into a kind of Stepford kingdom. When Diana confronted Charles on their honeymoon about his relation-

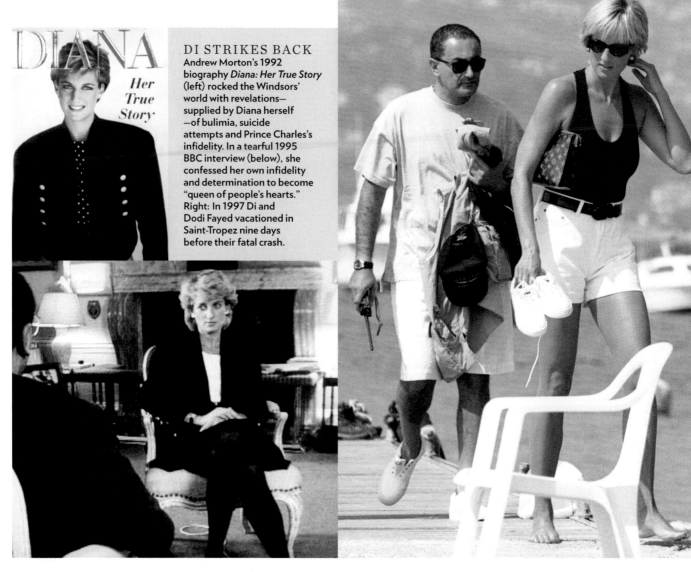

DI STRIKES BACK
Andrew Morton's 1992 biography *Diana: Her True Story* (left) rocked the Windsors' world with revelations— supplied by Diana herself —of bulimia, suicide attempts and Prince Charles's infidelity. In a tearful 1995 BBC interview (below), she confessed her own infidelity and determination to become "queen of people's hearts." Right: In 1997 Di and Dodi Fayed vacationed in Saint-Tropez nine days before their fatal crash.

ship with longtime love Camilla Parker Bowles, she was stonewalled. Distraught, the 20-year-old battled an eating disorder, losing so much weight after the 1982 birth of Prince William that courtiers questioned her sanity. Depending on whom you believe, Charles and Camilla resumed their affair right after his wedding or waited until his marriage was "irretrievably broken," as the prince said in a 1994 BBC interview. That broadcast contained another revelation: that he had never loved Diana. She fired back with a TV tell-all of her own a year later, confiding to journalist Martin Bashir, "There were three of us in this marriage, so it was a bit crowded."

The Waleses' troubles first came to light in October 1987, after the couple had spent 37 consecutive days apart. "Palace flaks can put forth as many excuses as they want," an insider told PEOPLE. "The prince and princess are leading separate lives." By then, Diana was seeking comfort outside her marriage, eventually being linked to bodyguard Barry Manakee, banker Philip Dunne, car salesman James Gilbey, army major James Hewitt, art dealer Oliver Hoare, rugby player Will Carling and surgeon Hasnat Khan. Hewitt, a riding instructor, later traded on his notoriety with a tell-all book that earned him the nickname Major Rat; a recorded cell phone chat between Diana and Gilbey revealed his nickname for the princess—"Squidgy"—to the world. Charles and Camilla were likewise embarrassed by a salacious cell phone transcript, but "the drip, drip effect of embarrassing revelations about [Diana's] private life had a corrosive effect on her public image," said Patrick Jephson, her chief of staff.

When the Waleses divorced in 1996, Diana was at last free to forge her own path, devoting herself to charity and outshining her former in-laws in the process. By 1997 it seemed she and Charles were ready to bury the hatchet. Finally able to acknowledge Camilla, he was magnanimous when pictures of Diana embracing Fayed, heir to the owner of Harrods, hit the tabs. "I'm happy if she's happy," he said. But Di's happiness was cut brutally short. And the Prince of Wales, his second wife and the monarchy itself began a long struggle—for the most part, successful—to refurbish the image of the British royal family.

THE DEATH OF A PRINCESS

On Aug. 31, 1997, a vacationing Diana and Dodi Fayed left the Paris Ritz in a Mercedes S280 at 12:20 a.m. with bodyguard Trevor Rees-Jones and driver Henri Paul. The group was pursued by paparazzi in a 90-mph car chase; at 12:23 a.m., the car crashed into a support in the Place de l'Alma tunnel, fatally injuring Diana, Dodi and driver Paul. Despite never-ending conspiracy theories, an exhaustive, $20 million British investigation, which included testimony from 250 people, concluded in 2008 that the deaths resulted from the grossly negligent driving of Henri Paul.

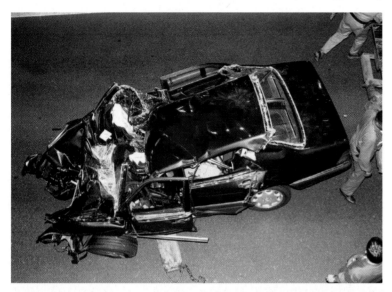

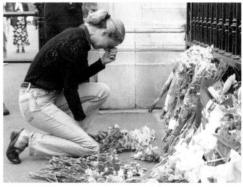

MOURNING THE QUEEN OF HEARTS

After Diana's Paris car crash (left), thousands flocked to Buckingham Palace to mourn her death. The Queen, on vacation at Balmoral, drew sharp criticism for remaining in Scotland rather than joining the throngs paying their respects in London.

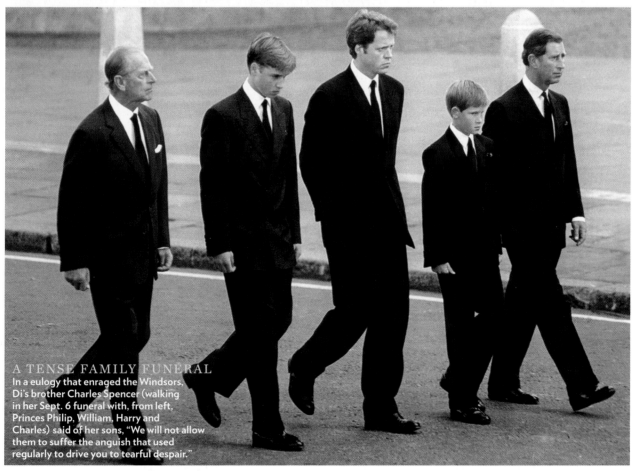

A TENSE FAMILY FUNERAL

In a eulogy that enraged the Windsors, Di's brother Charles Spencer (walking in her Sept. 6 funeral with, from left, Princes Philip, William, Harry and Charles) said of her sons, "We will not allow them to suffer the anguish that used regularly to drive you to tearful despair."

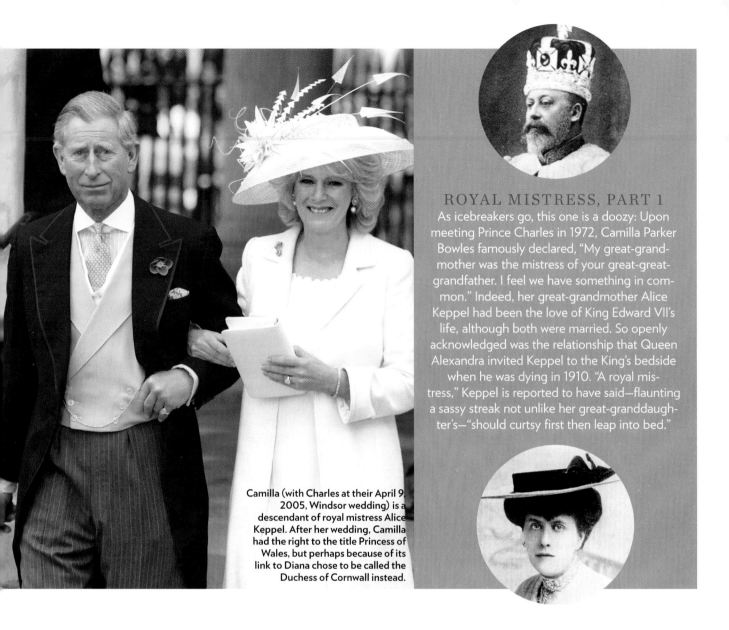

ROYAL MISTRESS, PART 1

ROYAL MISTRESS, PART 1

As icebreakers go, this one is a doozy: Upon meeting Prince Charles in 1972, Camilla Parker Bowles famously declared, "My great-grandmother was the mistress of your great-great-grandfather. I feel we have something in common." Indeed, her great-grandmother Alice Keppel had been the love of King Edward VII's life, although both were married. So openly acknowledged was the relationship that Queen Alexandra invited Keppel to the King's bedside when he was dying in 1910. "A royal mistress," Keppel is reported to have said—flaunting a sassy streak not unlike her great-granddaughter's—"should curtsy first then leap into bed."

Camilla (with Charles at their April 9, 2005, Windsor wedding) is a descendant of royal mistress Alice Keppel. After her wedding, Camilla had the right to the title Princess of Wales, but perhaps because of its link to Diana chose to be called the Duchess of Cornwall instead.

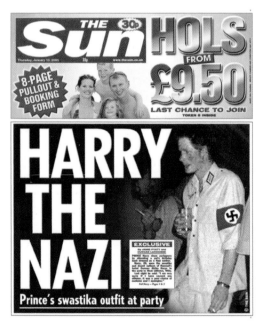

THE TROUBLE WITH HARRY

His big brother is cautious, deliberate and ever-responsible. Prince Harry? He's working on it. At 16, the party prince made news for pot smoking and underage drinking, prompting his father to send Harry for a day visit to a London drug-rehab clinic for a dose of reality. Among his favorite places to party at the time: Club H, the young princes' basement rec room, outfitted with a fully stocked bar, at the family's Highgrove estate. Then, in 2005, the prince—whom Princess Diana once playfully called "the naughty one"—managed to offend just about everyone when he turned up at a friend's costume party dressed as a Nazi soldier, complete with a swastika armband. "I am very sorry if I caused any offense," he said in a statement. "It was a poor choice of costume."

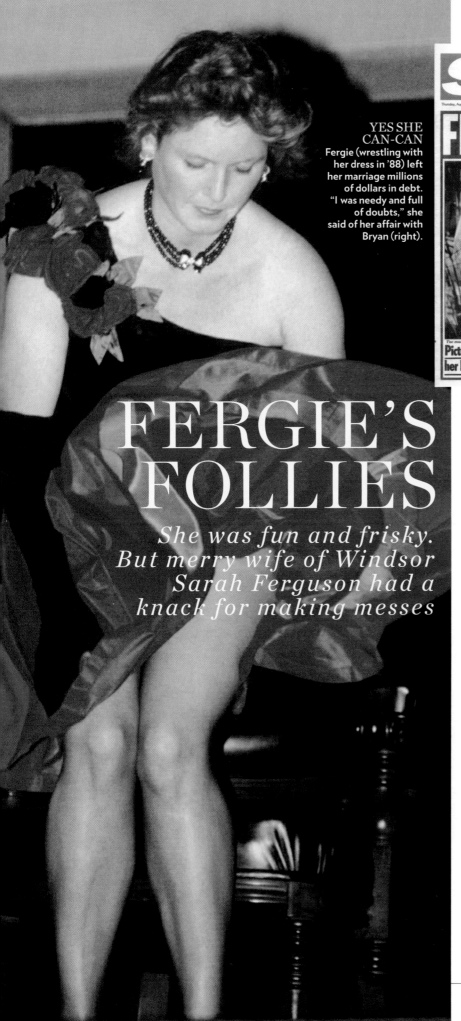

YES SHE
CAN-CAN
Fergie (wrestling with
her dress in '88) left
her marriage millions
of dollars in debt.
"I was needy and full
of doubts," she
said of her affair with
Bryan (right).

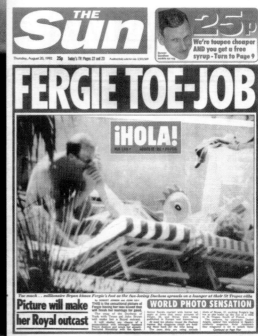

FERGIE'S FOLLIES

*She was fun and frisky.
But merry wife of Windsor
Sarah Ferguson had a
knack for making messes*

Gullible and naive" by her own description, Sarah Ferguson wrote in her 1996 autobiography that she "was never cut out for the job" of being royal. The feisty 26-year-old redhead was hailed as a breath of fresh air when she wed Prince Andrew in 1986, but she soon drew criticism for everything from her weight ("Duchess of Pork," sneered Fleet Street) to her clothes to her mothering skills, which came under fire when she left 6-week-old daughter Beatrice to join Andrew in Australia. Then came rumors of strife in the royal marriage, beginning with Fergie's alleged affair with Texas businessman Steve Wyatt in 1989. Her troubles reached a low in 1992, when the duchess—then separated from her husband—was photographed topless on the Côte d'Azur while American financial adviser John Bryan (a distant cousin of Wyatt's) sucked her toes. The photos made headlines, and "the Queen was furious," wrote Fergie. In 1996 she and Andrew divorced. Still close to her ex, she found a second act as a pitchwoman for Weight Watchers in the U.S. "The harder I pushed," she said of her Windsor years, "the more things fell apart."

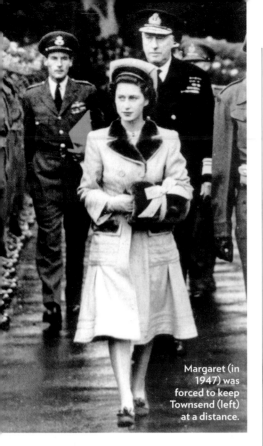

Margaret (in 1947) was forced to keep Townsend (left) at a distance.

MARGARET'S FORBIDDEN LOVE

It was the lint that launched a thousand headlines: At her sister Elizabeth's 1953 coronation, Princess Margaret brushed a bit of fuzz off the uniform of Group Capt. Peter Townsend. The intimate flick exposed a secret: The princess, 22, and Townsend, 38 and a divorced father, were having an affair. His divorce made him unsuitable in the eyes of the Church of England, and Margaret ultimately bowed to intense religious and political pressures and ended the liaison in 1955. Years later, said her friend Lady Glenconner, Margaret sometimes wondered "what her life would have been like if they had married."

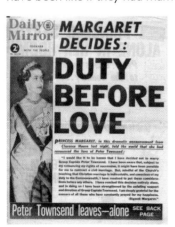

Daily Mirror

MARGARET DECIDES:

DUTY BEFORE LOVE

Peter Townsend leaves—alone SEE BACK PAGE

FOR THE WOMAN HE LOVED

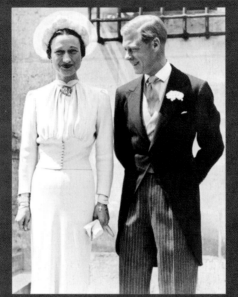

He was the heir to the British throne; she was a twice-divorced American socialite. Who would have guessed that the 1930 meeting of the future King Edward VIII, then 36, and ambitious Wallis Simpson, 34, at a house party would change history? But so besotted was Edward that in 1936, after just 325 days on the throne, he sacrificed a kingdom to marry the woman he couldn't resist. (The King was head of the Church of England, which didn't allow marriage to a divorced person.) After refusing his family's pleas to abandon Wallis, Edward passed the throne to his brother George VI and wed Simpson in 1937. "She promised to bring into my life something that wasn't there," he wrote in his 1951 autobiography. "I was convinced that with her I'd be a more creative and more useful person." The royal family snubbed Simpson as a social climber but eventually received her at Buckingham Palace for her husband's funeral in 1972.

THE NAZI CONNECTION

Living in exile in France, Edward and his bride—then Duke and Duchess of Windsor— embarrassed Britain by visiting Hitler in 1937 (right). With the royal family's German roots already a source of suspicion, many feared the pair were Nazi sympathizers plotting to restore Edward to the throne. Such suspicions were never firmly proved, but Allied intelligence did spy on the couple, and the British government sent them off to the Bahamas during World War II.

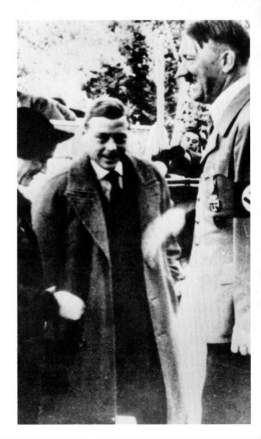

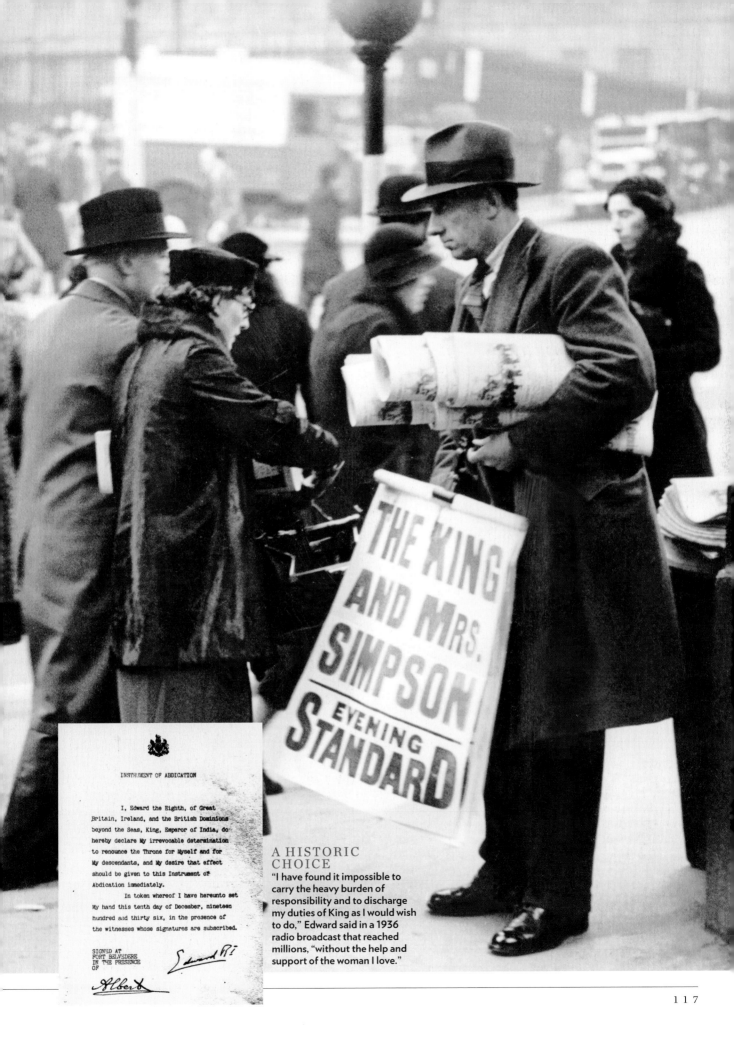

INSTRUMENT OF ABDICATION

I, Edward the Eighth, of Great
Britain, Ireland, and the British Dominions
beyond the Seas, King, Emperor of India, do
hereby declare My irrevocable determination
to renounce the Throne for Myself and for
My descendants, and My desire that effect
should be given to this Instrument of
Abdication immediately.

In token whereof I have hereunto set
My hand this tenth day of December, nineteen
hundred and thirty six, in the presence of
the witnesses whose signatures are subscribed.

SIGNED AT
FORT BELVEDERE
IN THE PRESENCE
OF

A HISTORIC CHOICE

"I have found it impossible to carry the heavy burden of responsibility and to discharge my duties of King as I would wish to do," Edward said in a 1936 radio broadcast that reached millions, "without the help and support of the woman I love."

THE TROUBLED

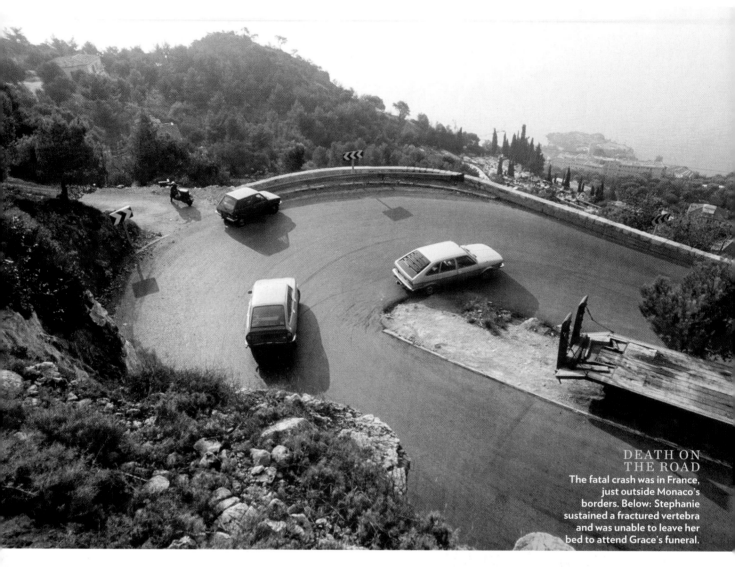

THE DEATH OF PRINCESS GRACE

From Philadelphia debutante to Hollywood star to leading lady of Monaco, Princess Grace lived a life that was nothing less than cinematic. So it's not surprising that her tragic death at 52 seemed like something out of the movies. On Sept. 13, 1982, Grace and her then-17-year-old daughter, Princess Stephanie, were driving on a road near Monaco when their Rover plunged 120 feet down a steep mountainside. Grace died the next day; almost immediately rumors swirled that Stephanie—who was below legal driving age—had been at the wheel and that the Palace had covered up the truth in order to protect her. Doctors later reported that Kelly had suffered two strokes, and in 2002 Stephanie told her side of the story for the first time to *Paris Match*. "I wasn't driving," she said. "I tried everything [to stop it]." She acknowledged that she had climbed out of the driver's side window, which made some think she had been driving: "The passenger's side was crushed." Of the rumors, she said, "I can't stand it anymore. Let my mother rest in peace, and as for me, let me live."

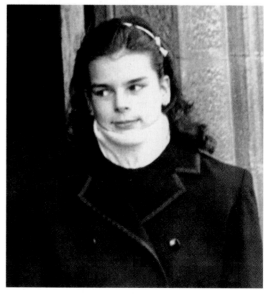

HOUSE *of* GRIMALDI

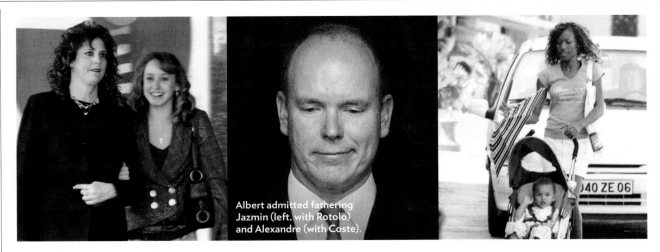

Albert admitted fathering Jazmin (left, with Rotolo) and Alexandre (with Coste).

PRINCE ALBERT: MISADVENTURES IN FATHERHOOD

Monaco's bachelor prince has a playboy reputation. But even jaded Grimaldi watchers were shocked in 2005 when Prince Albert, 53, admitted to fathering a son, Alexandre Eric Stéphane, 6, with flight attendant Nicole Coste. Just 11 months later, he acknowledged paternity of 18-year-old Jazmin Grace Grimaldi, who lives with her mother, ex-waitress Tamara Rotolo, in Palm Desert, Calif. Neither child is qualified to inherit the crown, but both stand to collect a share of Albert's $2 billion fortune.

| Rob Lowe | Mario Jutard | Daniel Ducruet | Raymond Gottlieb | Franco Knie | Adans Lopes Peres | Franck Brasseur |

THE PRINCESS AND HER MEN

Grace and Rainier's youngest has always been a royal wild child. A former swimsuit designer, perfume peddler and pop singer (she released her debut album in '86 and in '91 sang with Michael Jackson on "In the Closet"), she has had a love life that is the stuff of soap operas. Among her exes: Rob Lowe (whom she dated in '86), race-car driver Paul Belmondo, record producer Ron Bloom and businessman Jean-Yves Le Fur. A '95 marriage to bodyguard Daniel Ducruet (father to Louis, 17, and Pauline, 16) ended when he was photographed romping with an ex-Miss Bare Breasts of Belgium. Stephanie then had another child, Camille, in 1998, allegedly with bodyguard Jean-Raymond Gottlieb. (She has never publicly identified the father.) Then it was off to the circus: She toured with elephant tamer Franco Knie (they lived in his trailer), then wed trapeze artist Adans Lopes Peres in 2003. They divorced a year later.

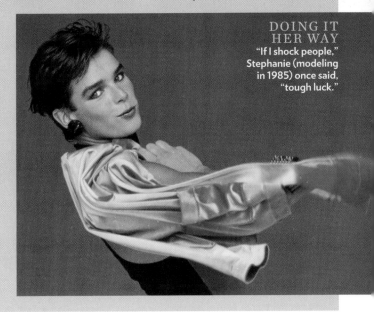

DOING IT HER WAY
"If I shock people," Stephanie (modeling in 1985) once said, "tough luck."

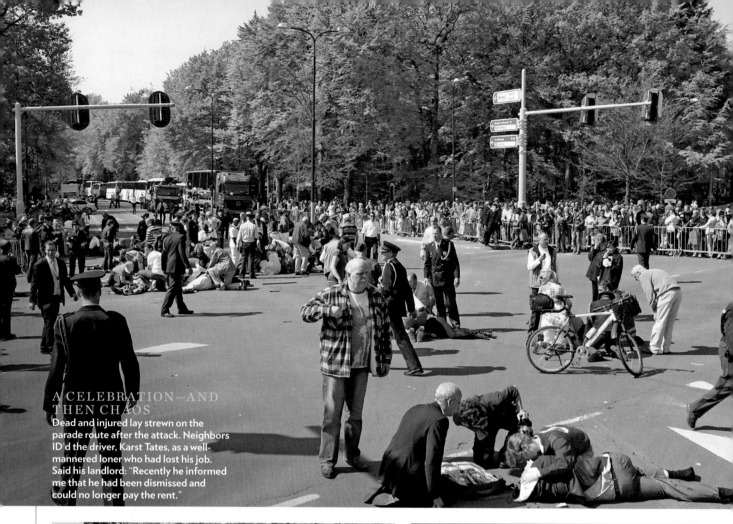

HORROR
in HOLLAND

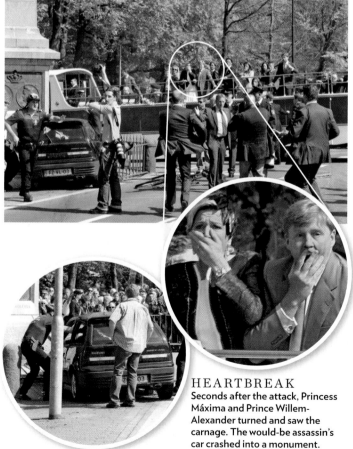

HEARTBREAK
Seconds after the attack, Princess
Máxima and Prince Willem-
Alexander turned and saw the
carnage. The would-be assassin's
car crashed into a monument.

On April 30, 2009, as the Dutch celebrated Queen's Day—an annual holiday on the birthday of Queen Beatrix—Karst Tates, 38, a security guard who had recently lost his job and apartment, stepped on the gas in his small black Suzuki car and rammed, full-speed, into a crowd of spectators at a parade in Apeldoorn, 45 miles east of Amsterdam. Seven bystanders died and a dozen were injured. Tates, who died the next day from injuries, told a police officer that his target had been the royal family, who had been riding in an open-top bus.

The attack stunned Holland. "Queen's Day will never be the same," the *Trouw* newspaper said. "The Netherlands always has been proud of their no-nonsense royal family. With this comes a Queen who not only cycles a bike, but also mixes with people without obvious security measures. Is that still possible now the royal family has been the target of an attack?"

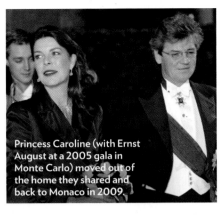
Princess Caroline (with Ernst August at a 2005 gala in Monte Carlo) moved out of the home they shared and back to Monaco in 2009.

THE IMPORTANCE OF BEING ERNST

Prince Ernst August of Hanover—a.k.a. Heaven's Gift to the Tabloids—is at it again. After a decade that included public drunkenness, fist fights, public urination and an appearance in Libya to celebrate the 40th anniversary of Colonel Khaddafi's reign, Ernst August, 56, was photographed frolicking in Thailand in early 2010 with a woman very much not his wife, Princess Caroline of Monaco, 53. Weeks later the prince and his inamorata were spotted in Austria, where, said a local restaurateur, they ate schnitzels and "enjoyed their meal very much." Caroline, meanwhile, should not be surprised: Ernst August was married when they first started dating in the late '90s.

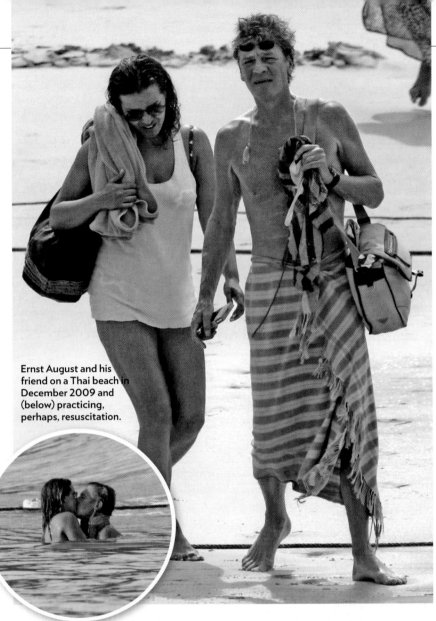
Ernst August and his friend on a Thai beach in December 2009 and (below) practicing, perhaps, resuscitation.

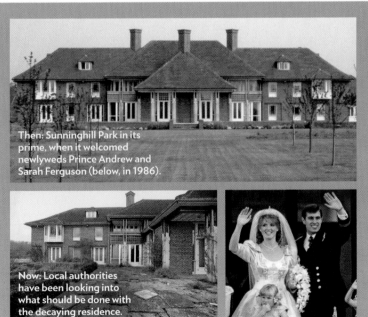
Then: Sunninghill Park in its prime, when it welcomed newlyweds Prince Andrew and Sarah Ferguson (below, in 1986).

Now: Local authorities have been looking into what should be done with the decaying residence.

ROYAL FIXER-UPPER

It's the house that can't seem to stay out of the news. First, Queen Elizabeth gave Sunninghill Park to Prince Andrew and Sarah Ferguson as a wedding gift in 1986. Its mondo-ranch-house style earned it the nickname South York after oil baron J.R. Ewing's Southfork spread on *Dallas*. Andrew and Fergie divorced in 1996, and in 2002 he put the house on the market. In 2007 it sold to billionaire Timur Kulibayev, son-in-law of the President of Kazakhstan, for over $22 million—about $5 million *above* the asking price. (The prince, who acts as a roving ambassador for British trade and has had frequent contact with Kazakhs who control the country's oil wealth, has denied any impropriety.) And then: nothing. No one ever moved in, and the house, plagued by time, weather and vandals, is falling apart.

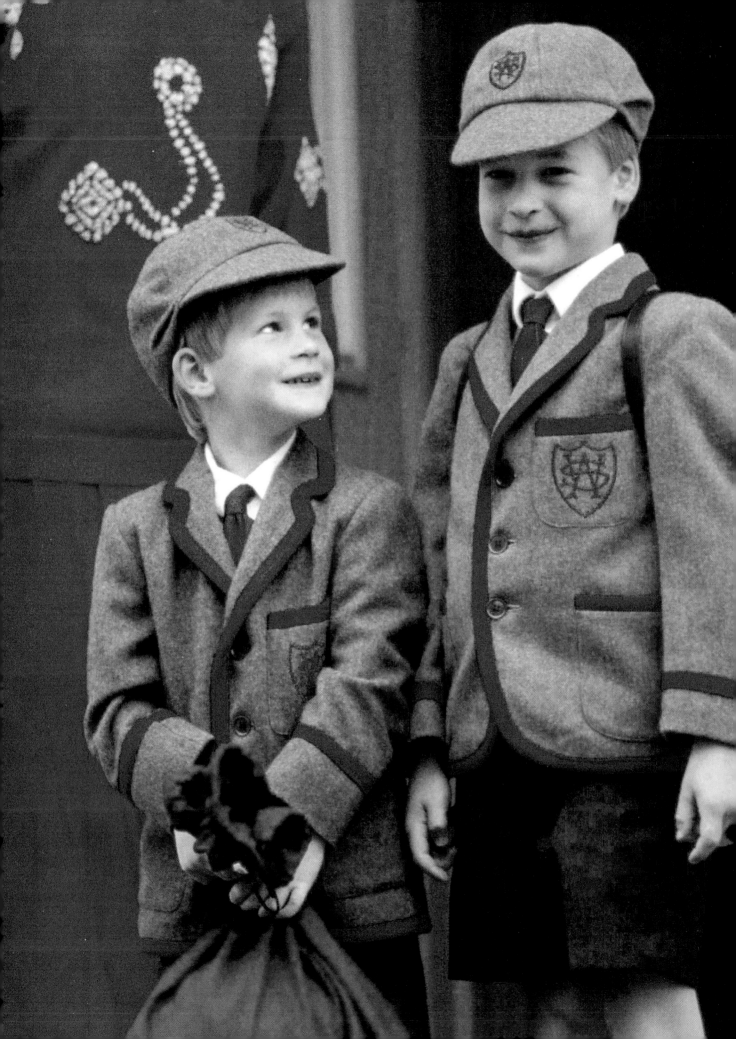

GROWING *up* ROYAL

Granted, there's a tremendous amount of attention, intrusion and paparazzi-dodging, and those snappy grade-school outfits may cause a blush in later years. But the perks—from castles to Klosters and polo ponies to ultraprivate Caribbean getaways with your honey—are really hard to beat

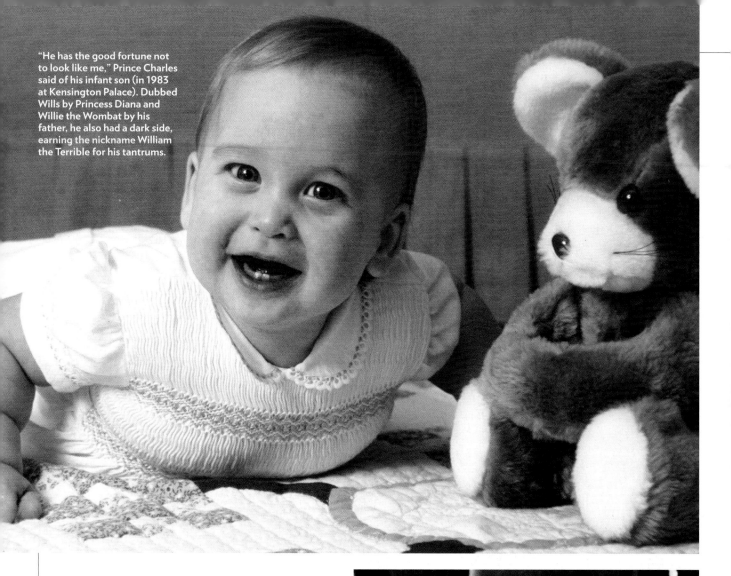

"He has the good fortune not to look like me," Prince Charles said of his infant son (in 1983 at Kensington Palace). Dubbed Wills by Princess Diana and Willie the Wombat by his father, he also had a dark side, earning the nickname William the Terrible for his tantrums.

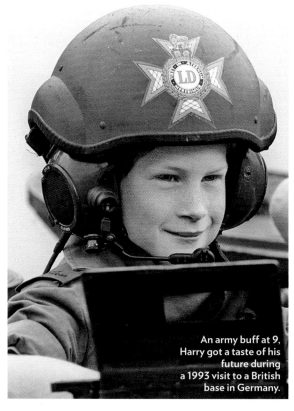

An army buff at 9, Harry got a taste of his future during a 1993 visit to a British base in Germany.

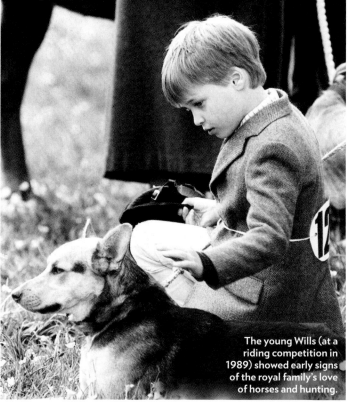

The young Wills (at a riding competition in 1989) showed early signs of the royal family's love of horses and hunting.

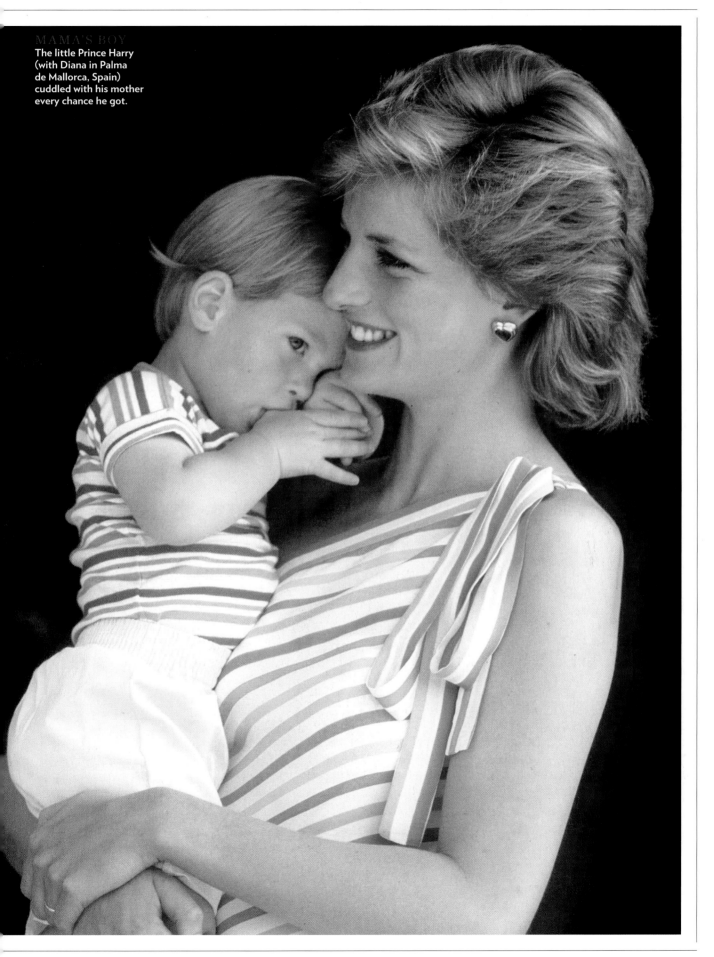

MAMA'S BOY
The little Prince Harry
(with Diana in Palma
de Mallorca, Spain)
cuddled with his mother
every chance he got.

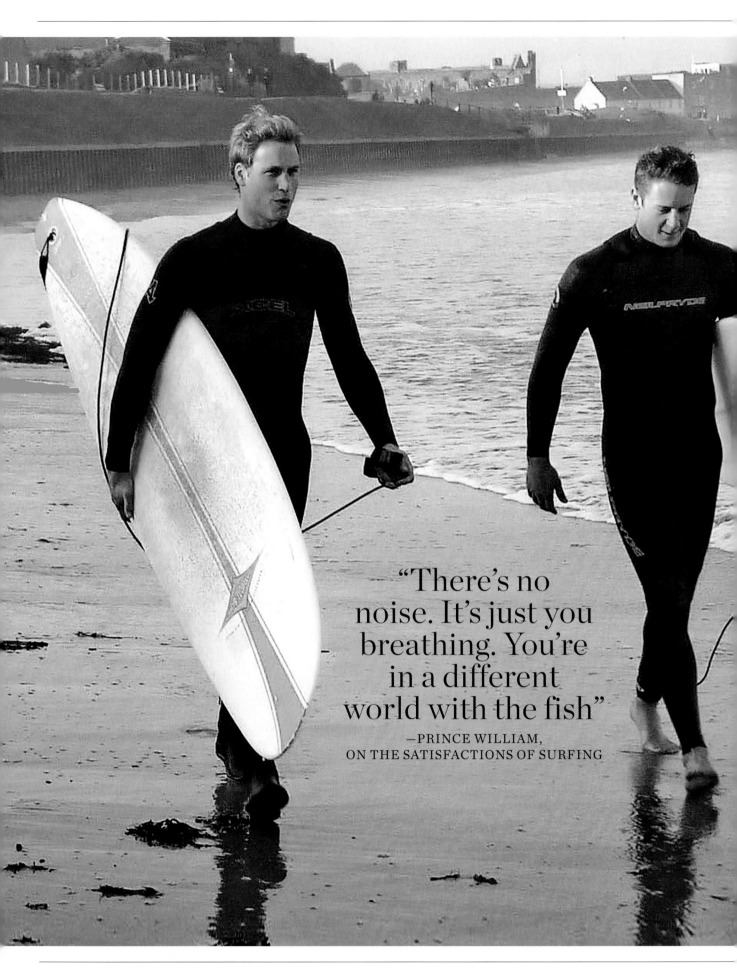

"There's no noise. It's just you breathing. You're in a different world with the fish"
—PRINCE WILLIAM,
ON THE SATISFACTIONS OF SURFING

William could sometimes be found bounding after the hounds until 2005, when fox hunting, symbolic sport of the upper crust, was banned in England.

BRITANNIA RULES THE WAVES?
Prince William took a break from his studies at the University of St. Andrews in October 2004 to test the North Sea surf with pals.

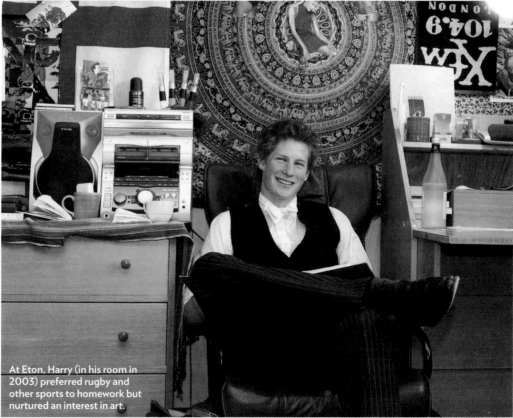

At Eton, Harry (in his room in 2003) preferred rugby and other sports to homework but nurtured an interest in art.

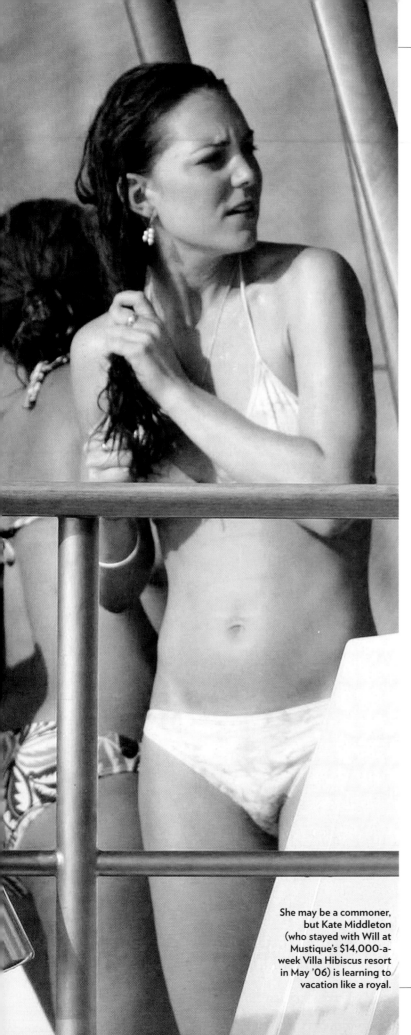

In 2006 Prince William took a flying leap from a yacht off Mustique while vacationing with Middleton. The ultra-chic 1,400-acre island is also a favorite escape for Tom Hanks, Hugh Grant, Denzel Washington and Mick Jagger.

She may be a commoner, but Kate Middleton (who stayed with Will at Mustique's $14,000-a-week Villa Hibiscus resort in May '06) is learning to vacation like a royal.

When temperatures drop, royals escape to the world's swankiest sand. For the Windsors, Mustique, Barbuda and Necker have long been ports of call. The Queen may prefer drafty Balmoral, but William and Harry like Caribbean retreats. There will always be an England, but these boys like the beach

Goal! Harry displayed his love of soccer during a visit to London's Upton Park, home of West Ham United Football Club, in 2002.

Feeding each other's need for speed, Princes William, Charles and Harry spent eight-hour days on Canada's Whistler Mountain (on a rare break from Klosters) in '98. The trio also indulged in the odd snowball fight.

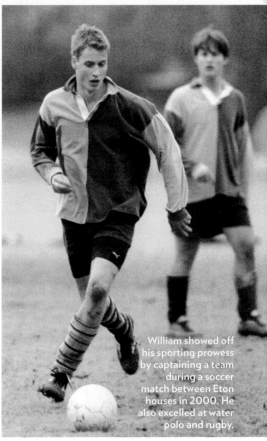

William showed off his sporting prowess by captaining a team during a soccer match between Eton houses in 2000. He also excelled at water polo and rugby.

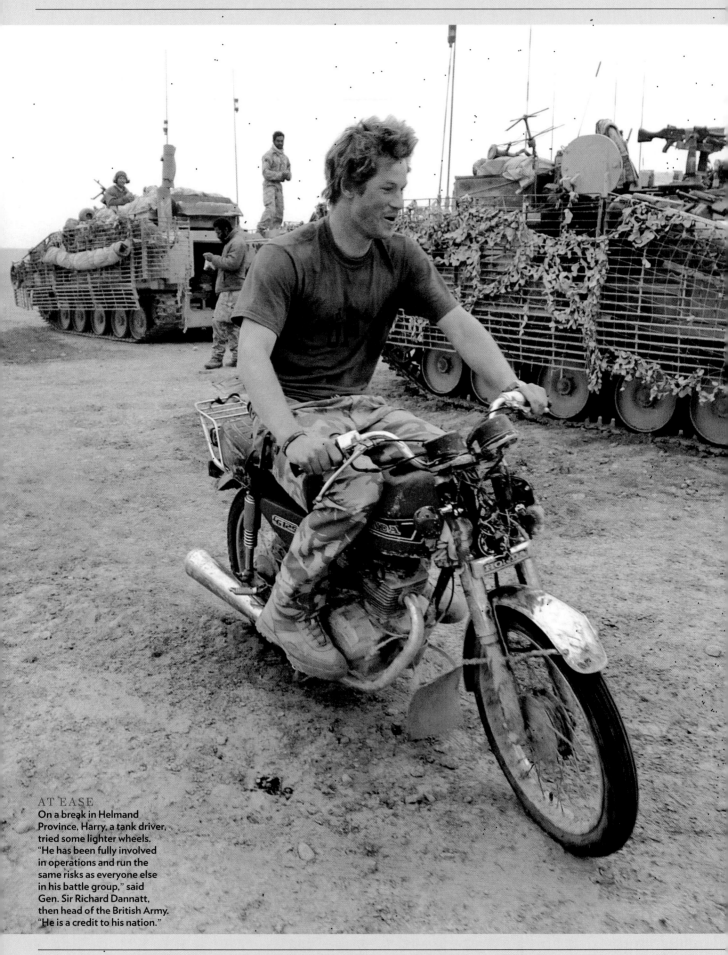

AT EASE
On a break in Helmand Province, Harry, a tank driver, tried some lighter wheels. "He has been fully involved in operations and run the same risks as everyone else in his battle group," said Gen. Sir Richard Dannatt, then head of the British Army. "He is a credit to his nation."

HARRY *goes to* WAR

Bomber pilots knew him as Widow Six Seven, never suspecting that the voice on the radio belonged to a soldier formerly known as Prince. Under a veil of secrecy, 2nd Lt. Harry Wales had slipped out of England in 2007 to serve in Afghanistan

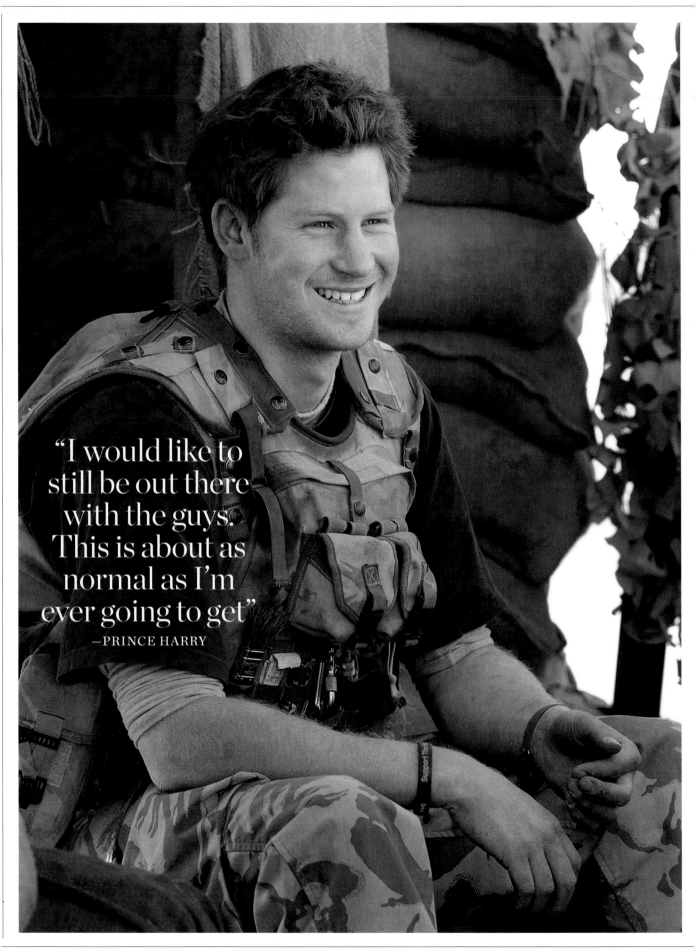

"I would like to still be out there with the guys. This is about as normal as I'm ever going to get"

—PRINCE HARRY

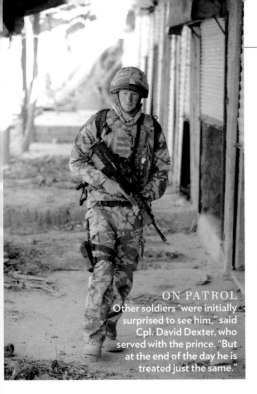

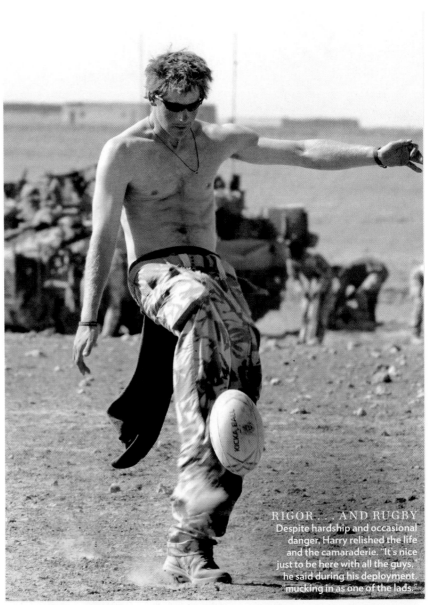

From the beginning, Prince Harry made his position clear. "There is no way," he said, "I'm going to put myself through Sandhurst [Military Academy] and then sit on my arse back home while my boys are out fighting for their country." But getting to the front wasn't easy. A planned 2007 deployment to Iraq was canceled at the last minute after global publicity, army honchos concluded, put the lives of the prince, and soldiers serving with him, at added risk.

The setback proved temporary. In December 2007 Harry was secretly spirited out of Britain to join his unit in Afghanistan. Some news outlets knew of the scheme and agreed to keep it secret; the prince was able to serve 10 weeks of what was supposed to be a four-month tour before some reporters leaked the story and he was ordered back to England.

Harry was frustrated—but hopeful. The secret plan had worked once, he noted, "so I don't see why it can't work again."

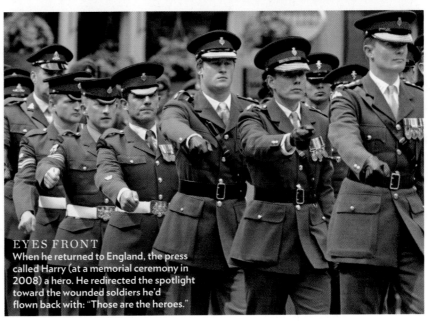

The NEXT GENERATION

Granted, William and Harry get the British lion's share of attention, but there's actually a small, elegant squadron of royal offspring out there, prepping for larger roles—including, in many cases, becoming King or Queen. Most are single—which, given current trends in royal marriages (see p. 38), is good news for anyone looking for love *and* a castle

BORN TO RIDE
As a teen, Princess Caroline's daughter Charlotte (left) participated in equestrian events, including a jumping competition in Boulogne, France, in 2004. Though still mad about horses, she is also a journalist championing ecological issues for the fashion industry.

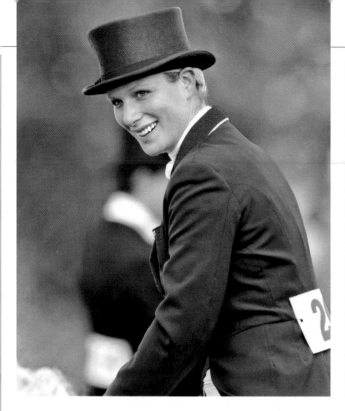

ZARA PHILIPS
GREAT BRITAIN

A very accomplished equestrienne, Zara, 28, the daughter of Princess Anne, became Eventing World Champion in 2006 and in 2008 broke her collarbone in a fall; she could commiserate with her longtime beau, rugby star Mike Tindall, who that year had punctured a lung.

PRINCE AMEDEO
BELGIUM

A prince who looks good in uniform *and* can do his own taxes? Amedeo, 24, son of Princess Astrid of Belgium, is a reserve officer in the Belgian army, a graduate of the London School of Economics and currently works for a financial consulting firm in New York City.

GUILLAUME, HEREDITARY GRAND DUKE, & PRINCESS ALEXANDRA
LUXEMBOURG

Princes, schmintzes. If you want something a little different—say, a hereditary grand duke—you'll want to try Luxembourg, where Guillaume, son of Grand Duke Henri and his Cuba-born wife, Grand Duchess Maria Teresa, is next in line. Guilliame, 28, graduated from Britain's Sandhurst Military Academy and Brunel University, speaks five languages and enjoys soccer. His sister Princess Alexandra, 19, is the only girl among five siblings. Her brother Prince Louis, 23, married a commoner, now known as Princess Tessy; they live in Florida.

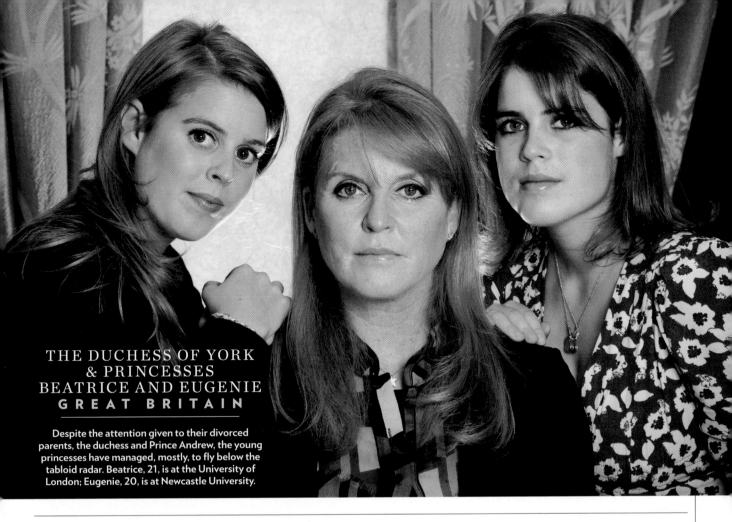

THE DUCHESS OF YORK & PRINCESSES BEATRICE AND EUGENIE
GREAT BRITAIN

Despite the attention given to their divorced parents, the duchess and Prince Andrew, the young princesses have managed, mostly, to fly below the tabloid radar. Beatrice, 21, is at the University of London; Eugenie, 20, is at Newcastle University.

PRINCESS SIRIVANNAVARI
THAILAND

Daughter of King Bhumibol Adulyadej, she has represented her country at badminton at the South East Asian Games, designed her own fashion line (and presented in Paris) and was ranked 6th among "hot young royals" in *Forbes* in 2009—up from 16th in 2008!

PRINCE HASHIM
JORDAN

Son of the late King Hussein and his American-born wife, Queen Noor, Hashim, 28, is at home in the East or West: He attended high school and college in the U.S., graduated from Britain's Royal Military Academy at Sandhurst and is married to the daughter of a Saudi sheik.

PRINCESS THEODORA
GREECE AND DENMARK

Why the geographical split? Her father, Constantine II, is the former King of Greece (which abolished its monarchy in the '70s) and, through his lineage, a prince of Denmark. Theodora, 26, attended Brown University under the name Theodora Greece.

PRINCE CARL PHILIP
SWEDEN

Born in 1979, Carl Philip was first in line to the throne—for seven months, until Sweden changed its laws and older sister Princess Victoria got the nod. The bachelor prince has found solace in auto racing, skiing and graphic design, his professional passion.

ELISABETH, GLORIA, MARIA THERESIA & ALBERT OF THURN UND TAXIS

Gloria had a title but little money before marrying, at 20, Germany's stupendously wealthy Prince Johannes of Thurn und Taxis, 53, in 1980. She became famous in the '80s for wild parties, earning the nickname Princess TNT, but has led a quieter life since the prince's death in 1990.

Their son Albert, 26, inherited the family fortune—which derives originally from his ancestors' monopoly of the Holy Roman Empire's postal system—and is now worth an estimated $2.1 billion. He helps manage the family's 75,000-acre Bavarian forest and enjoys racing cars.

The
GRIMALDIS

Actually, they don't have royal titles. But as Monaco's next generation, Prince Caroline's children with her second husband—the Italian businessman Stefano Casiraghi, who died in a boating accident in 1990—do get a lot of attention. So far the three seem to have avoided the sorts of scandals that have often brought the Grimaldis unsought press.

A handsome hedonist, Andrea, 26, has a reputation as a ladies' man but also makes time for windsurfing and kitesurfing. Pierre, 22, has studied in Milan, where, the Italian press reported, he often pried himself away from his studies to enjoy the city's night life. Charlotte, 23, has so far shown the most public ambition. An avid horsewoman, she participated in the 2009 Global Champions Tour, with stops in Europe and Rio de Janeiro. After completing internships at a French publishing house and with Britain's *Independent* newspaper, she cofounded a freebie magazine, *Ever Manifesto*, that looks at the fashion industry's environmental impact and promotes sustainable practices. Copies were given out at the 2009 Milan and Paris fashion weeks.

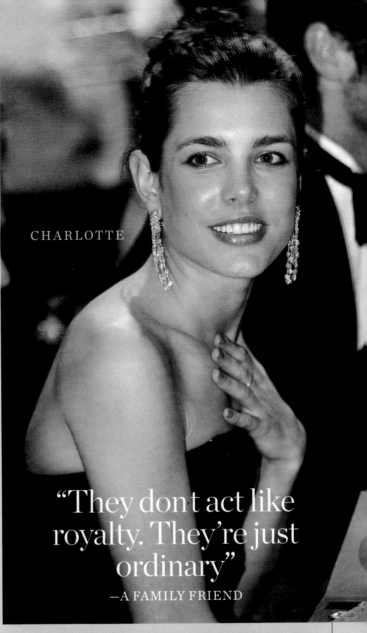

CHARLOTTE

"They don't act like royalty. They're just ordinary"
—A FAMILY FRIEND

PIERRE

ANDREA

ROYAL INTRIGUE

He may look tiny, but don't be fooled: Japan's Prince Hisahito, age 3, is carrying a 2,670-year-old dynasty on his shoulders. And down the road he may find himself in a nasty fight with his cousin Princess Aiko, age 8.

At the heart of the matter is a drama that has riveted Japan: resolving the imperial line of succession. The current Emperor, Akihito, 76, will be followed by his firstborn son, Crown Prince Naruhito, 50—but after that things get murky. Current law requires a male heir—and Naruhito's only child with Crown Princess Masako is daughter Aiko. But in 2006, just as the country began to seriously debate changing the law, Princess Kiko—wife of Naruhito's brother Prince Akishino—gave birth to Hisahito, the first male born to the family in 41 years. The nation rejoiced; conservatives, who favor leaving the law as it is, were thrilled; and Prime Minister Shinzo Abe dropped a proposal to change the system.

But someday, Japan will have to decide whether it will deny Aiko, because she's a girl, and reward Hisahito, simply because he's a boy.

THE PLAYERS IN JAPAN'S ROYAL DRAMA
From left: Princess Aiko; Crown Princess Masako; Crown Prince Naruhito; Princess Mako (standing); Emperor Akihito; Empress Michiko; Princess Kako (standing); Prince Akishino; Prince Hisahito; Princess Kiko. Right: Princess Kiko and Prince Hisahito visited the Emperor and Empress in 2007.

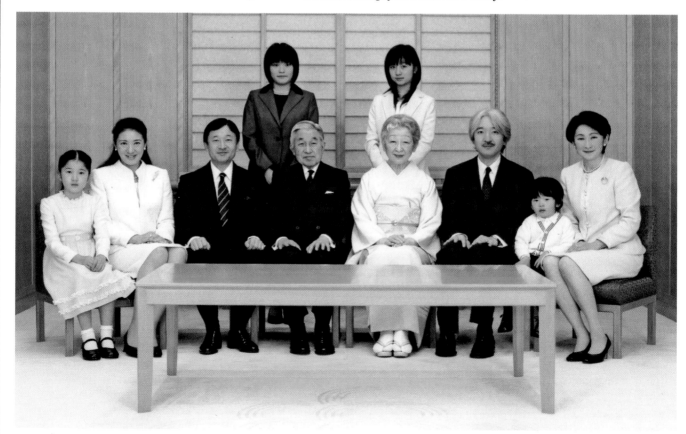

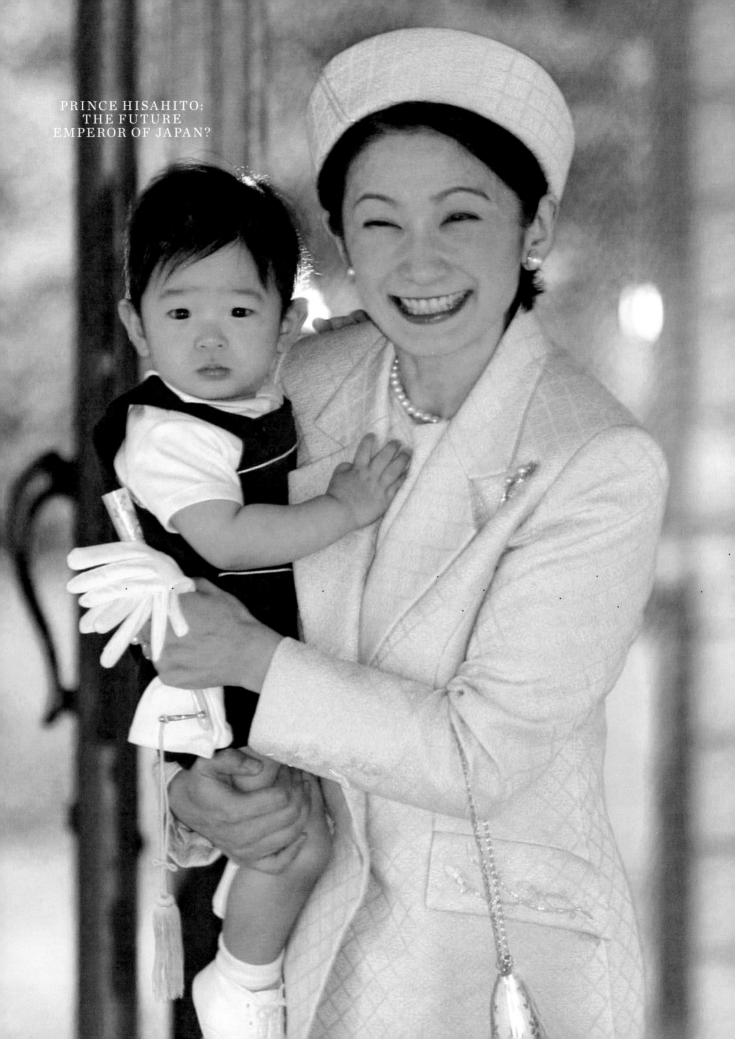

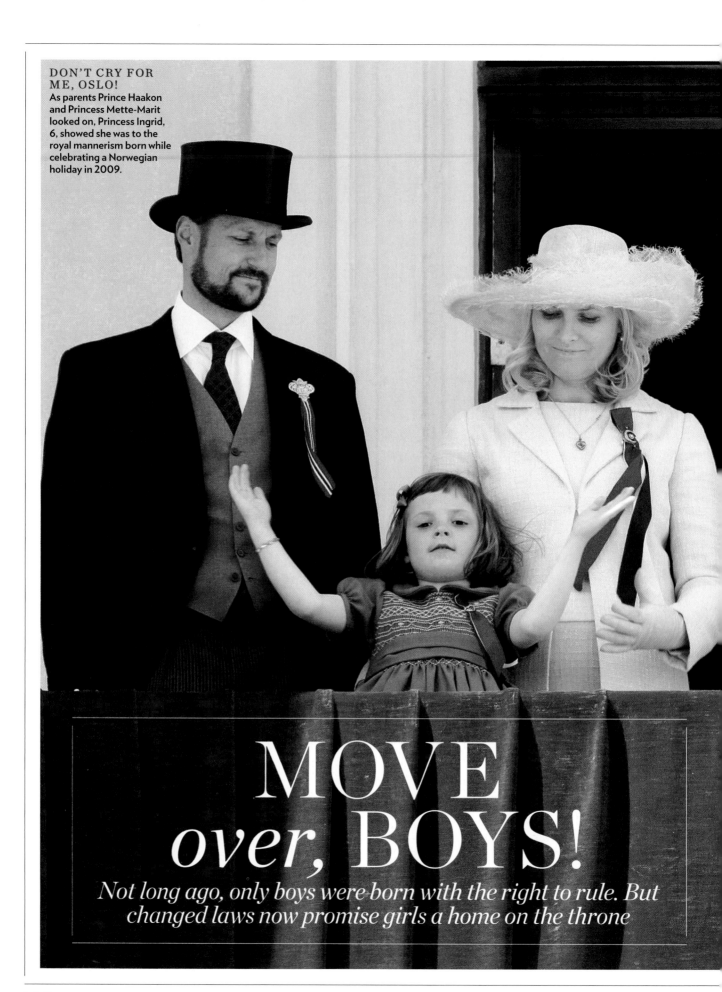

MOVE
over, BOYS!

*Not long ago, only boys were born with the right to rule. But
changed laws now promise girls a home on the throne*

Once upon a time—in fact, until very recently—many European royal houses stuck to the tradition of male primogeniture: Only sons could grow up to rule. But by the late 20th century the world had begun to change, and one by one countries began to move with the times; an army of pink-clad little girls, in effect, began swarming the castle walls. Sweden changed its laws in 1980; the Netherlands in 1983; Norway in 1990; Spain's King Juan Carlos issued a royal decree in 2006; Denmark modified its laws in 1953 and made the change permanent in 2009.

As a result, all the girls pictured may, someday, wield a scepter and wear a crown. Meanwhile, they can tell their little brothers what to do.

THE GIRLS Princess Catharina-Amalia (above, left) may one day be Queen of the Netherlands; Princess Leonor (above, right) could some day rule Spain; Belgium's Princess Elisabeth is a Brussels sprout with a future.

CREDITS

CONTENTS
2-3 Splash News

WILLIAM & HARRY
6-7 Julian Parker/Empics/AbacaUSA; Goff/INF; 8-9 Stephan Rousseau/PA/AP; Paul Ellis PA/AP; 10-11 Splash News; DP/AAD/Star Max; 12-13 (clockwise from top left) Karwai Tang/Alpha/Landov; Goff/INF; Splash News; 14-15 RP/Euroimagen/JPI; Ramey; 16-17 (clockwise from top left) Barcroft/Fame; Toby Melville/Reuters; Tim Rooke/Rex USA

WEDDINGS
18-19 Ipol/Globe; 20-21 Tim Graham/Getty Images; 22-23 Patrick Lichfield/Camera Press/Retna; 24-25 (clockwise from left) Rex USA; Frank Trapper/Corbis Sygma; Rex USA; Snowdon/Camera Press/Retna; Imapress/Globe; Empics; 26-27 Patrick Lichfield/Camera Press/Retna; (head shots from top) Tim Graham/Getty Images; Mark Mawson/Stay Still LTD; Splash News; Matrix/Bauer-Griffin; James Whatling/UK Press; Dominic O'Neil; Thos Robinson/Getty Images; Dominic O'Neil; 28-29 Bettmann/Corbis; 30-31 (from left) Allan Grant/Time-Life Pictures/Getty Images; Bettmann/Corbis; Sipa; 32-33 (clockwise from top) Howell Conant (2); Archives Detaille/Sipa; Topfoto; 34-35 (from left) J.A. Hampton/ Topical Press/Getty Images; Hulton-Deutsch Collection/Corbis; 36-37 (from left) Bettmann/Corbis; Baron/Camera Press/Retna; Getty Images; 38-39 (clockwise from left) Benainous Alain/Gamma; UK Press; Benainous Alain/Gamma; 40-41 (clockwise from top left) Orban Thierry/Corbis Sygma; Peter Busmoke/AP; Binod Joshi/AP; AFP/Getty Images; 42-43 (clockwise from top left) Moroccan Government/AP; Pascal Le Segretain/Getty Images; Robert Patrick/Corbis Sygma; Jerome Delay/AP

CENTURY OF STYLE
44-45 Tim Graham/Corbis; 46-47 (clockwise from right) Snowdon/Camera Press/Retna; Camera Press/Retna (2); Rex USA; 48-49 (from left) Gemma Levine/Camera Press/Retna; Dave Chancellor/Alpha/Globe; Tim Rooke/Rex USA; Jayne Fincher/Getty Images; 50-51 (clockwise from left) Bettmann/Corbis; Patrick Lichfield/Camera Press/Retna; David E. Scherman/Time-Life Pictures/Getty Images; 52-53 (clockwise from left) Cecil Beaton/Camera Press/Retna; Raymond Meier; Patrick Lichfield/Camera Press/Retna; 54-55 (clockwise from left) Globe; Snowdon/Camera Press/Retna (3); 56-57 Howell Conant; 58-59 (from left) Howell Conant; Topfoto; 58-59 (clockwise from left) Howell Conant (2); UK Press; James Andanson/Corbis Sygma; 60-61 (clockwise from left) Howell Conant (2); UK Press; James Andanson/Corbis Sygma; 62-63 (clockwise from top right) Tim Graham/Corbis Sygma; Ian Lloyd; Tim Graham/Corbis Sygma (2); Corbis; Tim Graham/Corbis Sygma; Tim Graham/Corbis; 64-65 (clockwise from left) John Swannell/Camera Press/Retna; Naser Ayoub/Reuters; Retna; UK Press; Balkis Press/Abaca; Sipa; 66-67 (clockwise from top right) Eddie Mulholland/Telegraph Syndication; Courtesy Turnbull & Asser; Justin Leighton/Telegraph Syndication; Tim Graham/Getty Images (2); John Lobb Ltd; Ben Phillips; David Hartley/Rex USA; 68-69 (from left) Stephen Lock/Daily Telegraph; Toby Melville/Reuters; Gary Barnet/GlobelinkUK/Globe; 70-71 (clockwise from top left) Anwar Hussein Collection/Sipa; Rex USA; Davidson/O'Neill/Rex USA; Indigo/Getty Images; Kelvin Bruce/Richard Gillard/Nunn Syndication; 72-73 (Camilla, clockwise from left) Nunn Syndication; Tim Graham; Tim Rooke/Rex USA; Nunn Syndication; (Head Cases, clockwise from top) Tim Graham (2); Francis Dias/Newspix International; Roger Allen/Mirror Pix; UK Press; Anwar Hussein/Empics/AbacaUSA; 74-75 (clockwise from left) Steen Evald/Colourpress/JPI; STLA/Fame Pictures; Steen Brogaard/Colourpress/JPI; DPA/Zuma; Steen Evald/Colourpress/JPI; 76-77 (clockwise from right) Fame; Ramey; DPA/Zuma; Ramey; 78-79 (clockwise from left) Eric Feferberg/Landov; MPAL/Radial Press/Startraks; STLA/Fame; Eliot/Bauer-Griffin;

JEWELS
80-81 Tim Clarke/NPA/Express/PA/AP; 82-83 (from left) Hulton-Deutsch Collection/Corbis; Rex USA; 84-85 (clockwise from right) Alpha/Globe; Rex USA; PA/Empics; Tim Graham/Corbis; PA/Empics; 86-87 (1) Topfoto; (2) Topfoto; (3) Tim Graham/Getty Images; (4) Erich Lessing/Art Resource; (5) Tony Kyriacou/Rex USA; (6) PA/Empics; (7) PA/Empics; (8) Scala/Art Resource; 88-89 The Bridgeman Art Library; Hulton Archive/Getty Images; Topfoto; Tim Graham/Getty Images; 90-91 (clockwise from top left) Anja Niedringhaus/AP; Martial Trezzini/Keystone/AP; PA/AP; Fabian Bimmer/AP; Cathal McNaughton/PA/AP; Peter Macdiarmid/Getty Images

BEHIND PALACE WALLS
92-93 Fridmar Damm/zefa/Corbis; 94-95 (clockwise from top left) Tim Graham; Mark Fiennes/The Royal Collection ©Her Majesty Queen Elizabeth II 2002; Tim Graham; 96-97 Rex USA; 98-99 (clockwise from bottom right) David Secombe/Camera Press/Retna; Fiona Hanson/Empics; Rex USA; Ian Jones; Rex USA (2); John Stillwell/Empics; 100-101 (clockwise from top) Dylan Martinez/Reuters; Anwar Hussein Collection/Getty Images; INFGoff; Daniel Hambury/AP; 102-103 (clockwise from top left) Patrick Lichfield/Camera Press/Retna; Tim Graham/Corbis; Nunn Syndication; Patrick Lichfield/Camera Press/Retna; 104-105 Patrick Lichfield/Camera Press/Retna; 106-107 (clockwise from left) Tim Graham Picture Library; Stefan Rousseau/AP (2); Michael Dunlea/Nunn Syndication

SCANDALS
108-109 (top row from left) Rex USA; Mirrorpix; News of the World; Mathew Polak/Corbis; (middle row from left) Today; Rex USA; John Frost (2); (bottom row from left) Mirrorpix; John Frost; Tim Graham/Corbis; John Frost; 110-111 (clockwise from left) Express Newspapers/Getty Images; Tim Graham; John Frost; Camera Press/Retna; 112-113 (clockwise from top right) PA/Empics; Anwar Hussein/Getty; PA/Empics; People; MAXPPP; Corbis Sygma; 114-115 (clockwise from top right) John Frost; Brendan Beirne/Rex USA; The Sun/PA/AP; George Dekeerle/Getty Images; Hulton Archive/Getty Images; Brown Brothers; 116-117 (clockwise from top left) Rex USA; Hulton Archive/Getty Images; Allen/Tropical Press Agency/Getty Images; OFF/AFP/Getty Images; Keystone/Getty Images; John Frost; 118-119 (clockwise from bottom right) Frederic Meylan/Corbis Sygma; Bettmann/Corbis; Istvan Bajzat/DPA/Corbis; Bauer-Griffin; Jean-Paul Pelissier/Reuters/Corbis; Bauer-Griffin (2); Reflexnews (2); Eliot Press/Bauer-Griffin (2); Reflexnews; Araldo Di Crollalanza/Rex USA; 120-121 (Clockwise from top left) Patrick van Katwijk/DPA/AbacaUSA; Franz Chavaroche/Mazppp/Zuma; Eyewitness/Ramey (2); Rex USA; Tim Graham; Chris Grieve/Mirrorpix; Patrick van Katwijk/ANP/Sipa; Victoria/Southern Press/JPI; Patrick van Katwijk/DPA/AbacaUSA

GROWING UP ROYAL
122-123 Tim Graham; 124-125 (clockwise from top left) Tim Graham/Getty Images; Jason Fraser/Sipa; Anwar Hussein/Sipa; PA/Empics; 126-127 (clockwise from left) Corbis; David Hartley/Rex USA; PA/Empics; 128-129 (clockwise from left) LDP Images (2); Toby Melville/Reuters; Rex USA; Anwar Hussein/Getty Images

HARRY GOES TO WAR
130-131 John Stillwell/PA/Wire/Iphoto; 132-133 PA/Landov; John Stillwell/PA; Newspix International; PA/Landov

GROWING UP ROYAL
134-135 Abaca; 136-137 (clockwise from top left) Bauer-Griffin (2); ITV/Rex USA; Zahran Zahran/Polaris; Oleg Nikishin/WireImage; Royal Press Europe/Action Press/Zuma (2); 138-139 (clockwise from top left) Frederick M. Brown/Getty Images; DPA/Landov; Reuters/Landov; Frederic Nebinger/Abaca; AbacaUSA; Schneider/ Most Wanted; 140-141 (from left) Imperial Household Agency/AP; Kyodo/AP; 142-143 (clockwise from left) Royal Press Europe Action Press/Zuma; DRV; Fotonoticias/Wirelmage; WireImage

Editors J.D. Heyman/Cutler Durkee
Creative Director Sara Williams
Art Director Cass Spencer
Senior Editor Nancy Jeffrey
Picture Editor James Miller
Director of Photography Chris Dougherty
London Bureau Chief Simon Perry
Chief of Reporters Mary Hart
Writers Olivia Abel, Laura Downey, Michelle Green, Molly Lopez, Ericka Souter, Michelle Tauber, Ashley N. Williams, Jennifer Wren
Writer-Reporters Greg Adkins, David Cobb Craig, Marisa Wong
Reporters Rennie Dyball, Deirdre Gallagher, Kristen Mascia, Hugh McCarten, Lesley Messer, John Perra, Beth Perry, Ellen Shapiro, Brooke Bizzell Stachyra, Charlotte Triggs, Melody Wells
Correspondents Karen Nickel Anhalt, Aisha Labi, Peter Mikelbank, Courtney Rubin, Monique Jessen
Photo Researchers Elaine Sutton, Su Smith, Kristi Jell (London), Marie Monteleone
Photo Assistant Florence Nash
Copy Editors Ben Harte (Chief), Aura Davies, Lance Kaplan, Alan Levine, Jennifer Shotz
Production Artists Michael Aponte, Denise Doran, Ivy Lee, Michelle Lockhart, Cynthia Miele, Daniel Neuburger, Ben Zapp
Scanners Brien Foy, Stephen Pabarue
Imaging Director Francis Fitzgerald
Imaging Manager Robert Roszkowski
Imaging Production Manager Charles Guardino
Imaging Coordinator Jeffrey Ingledue
Administrative Assistant Danielle Cruz
Interns Rebecca Ruiz, Danielle Toth
Special thanks to David Barbee, Jane Bealer, Margery Frohlinger, Ean Sheehy, Celine Wojtala, Patrick Yang

TIME INC. HOME ENTERTAINMENT
Publisher Richard Fraiman
General Manager Steven Sandonato
Executive Director, Marketing Services Carol Pittard
Director, Retail & Special Sales Tom Mifsud
Director, New Product Development Peter Harper
Director, Bookazine Marketing Laura Adam
Publishing Director, Brand Marketing Joy Butts
Assistant General Counsel Helen Wan
Book Production Manager Suzanne Janso
Design & Prepress Manager Anne-Michelle Gallero
Brand & Licensing Manager Alexandra Bliss
Assistant Production Manager Brynn Joyce
Assistant Brand Manager Melissa Joy Kong

SPECIAL THANKS to Christine Austin, Jeremy Biloon, Glenn Buonocore, Jim Childs, Susan Chodakiewicz, Rose Cirrincione, Jacqueline Fitzgerald, Carrie Frazier, Lauren Hall, Jennifer Jacobs, Mona Li, Robert Marasco, Amy Migliaccio, Brooke Reger, Dave Rozzelle, Ilene Schreider, Adriana Tierno, Alex Voznesenskiy, Sydney Webber

ISBN 10: 1-60320-166-1
ISBN 13: 978-1-60320-166-7
Library of Congress Control Number: 2006939690
First Printing in 2007